The Art Of Laura Garabedian

Dedicated to all of my friends, family and fans that have
encouraged my art throughout the years, I couldn't do this without you guys.
Thank you all so much.

Art of Laura Garabedian
Copyright 2023 Laura Garabedian

ISBN: 978-1-64150-165-7

Book Design by: Jordan Jennings
Text Edited by: Abi Hernandez
Logo Design by: Anastasia Korochanskaya (Balaa) Modified by Laura Garabedian and Jordan Jennings

All rights reserved. No part of this book may be reproduced or transmitted in any form by any means without
permission in writing from the publisher and/or the author.

For more information about the artist, please visit: www.LauraGarabedian.com

Published by Turrianet

The Art Of
Laura Garabedian

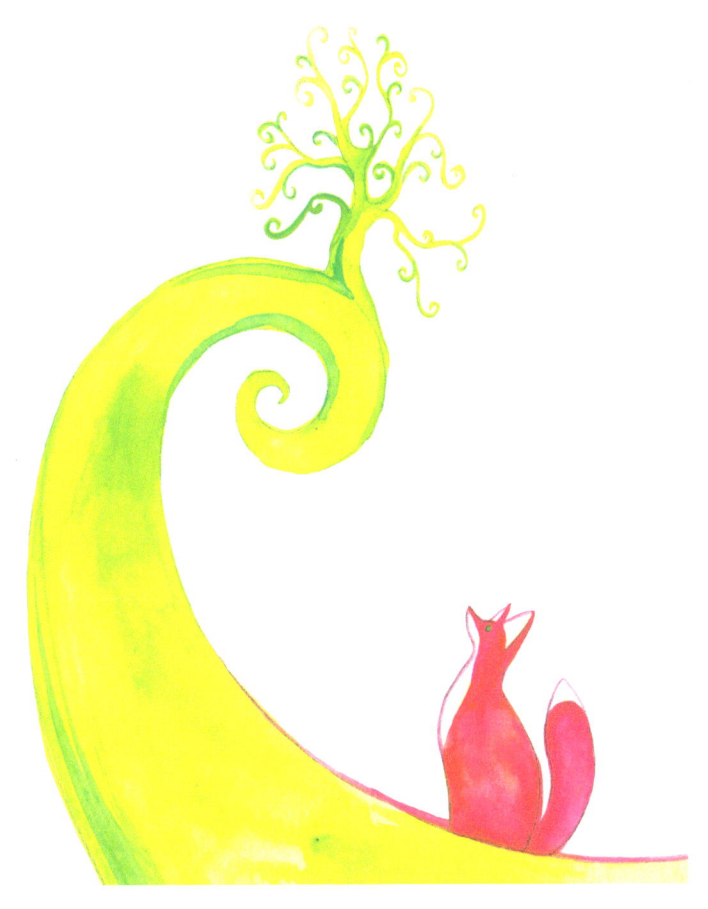

About the Artist

Laura was the kid in elementary school who drew on everything. While also a very engaged student, her only detentions arose from drawing horses on her math tests (after the work was complete mind you). She was lucky enough to grow up in a family who was supportive of her artistic inclinations, if rather concerned about the long term viability of such an endeavor.

After graduating from Texas A&M University – Commerce, with a degree in Illustration, Laura went through a brief stint as a creative director for small companies. When the whims of fate launched her out on her own she took it as a sign to do what she had always dreamed of, create art for a living.

Since starting out on this adventure, Laura has come to truly appreciate the love and dedication it takes to be an artist. Traveling to various conventions, interacting with amazing people, and getting a chance to bring to life anything from hookah smoking foxes, pet portraits, life in Afghanistan, to even turning children's rooms into groves of flighty forest creatures; has taught Laura about the diversity an artist can experience.

Currently living in Colorado, the state she truly loves, she takes the chance to travel whenever possible, enjoying the ability that this career grants her to take in all of the wonders this world has to offer. When she isn't painting she tends to be out, rock climbing or hiking with her friends and her dog (a llama – afghan cross), or possibly enjoying an evening in with friends watching Doctor Who or playing board games. These activities help keep her a happy artist, striving to constantly experience anything and everything life throws in her direction.

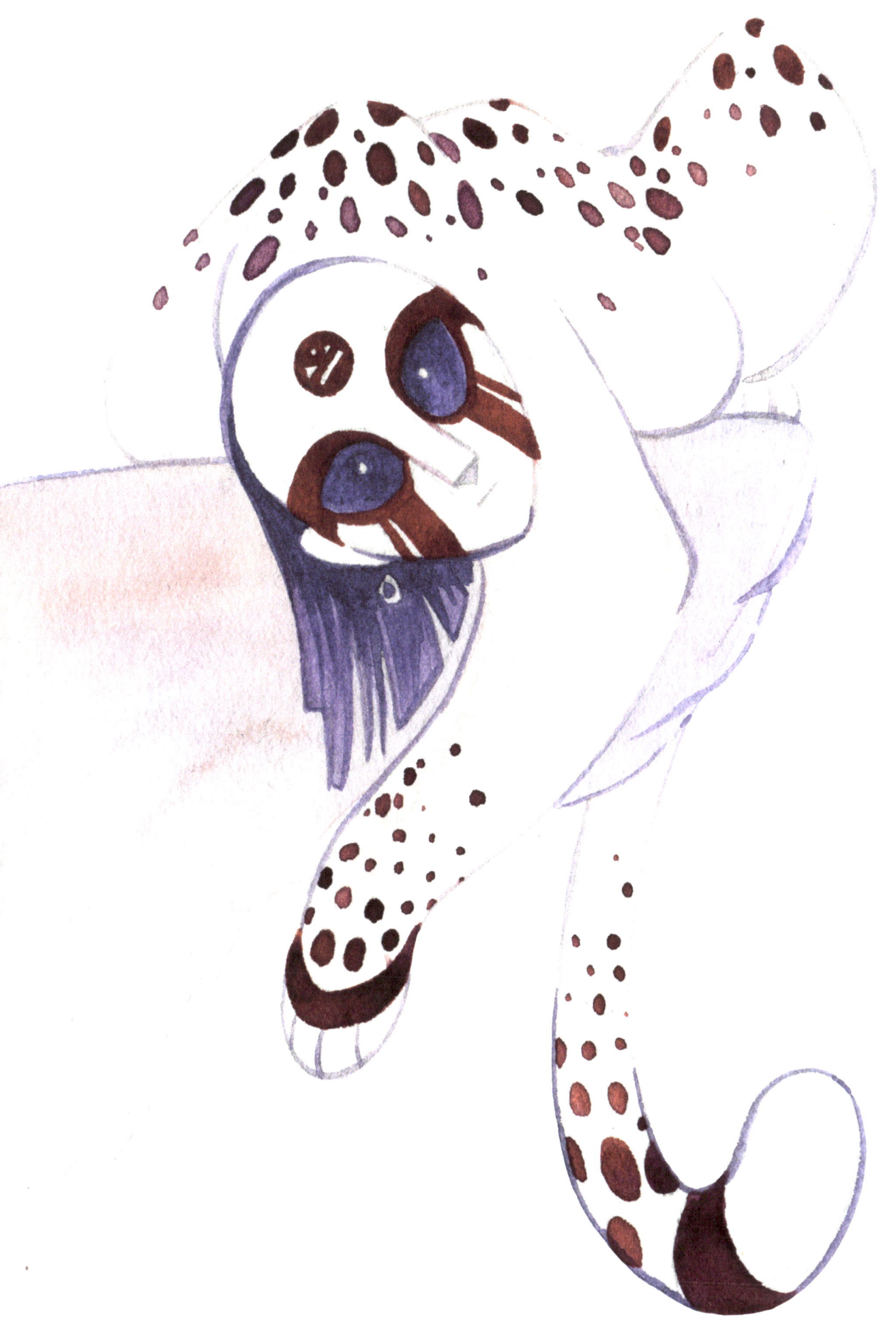

When Trees Walk

The twisting roads of America will, at times, wend their way through forests, and in these dark woods, sometimes the trees are known to walk. The shapes come alive, taking on strange, living forms. The kudzu-engulfed oak in West Virginia forms the back of a lion. The bare branches of a maple walk on as a wolf. I see them in my travels, careful to stay out from under their ponderous legs, knowing that my brief trip through their enormous expanse is less than the blink of an eye to their arcane lives.

I have always loved finding shapes in nature, in trees, in clouds, in the rocks on a mountain, and have drawn from that for this series of my art. The fact that viewers take as much joy from this 'hunt' in the trees as I do is incredibly gratifying. That I have caused physical double-takes at conventions is quite satisfying as well.

Enjoy your walk through my forests,
and watch your step...

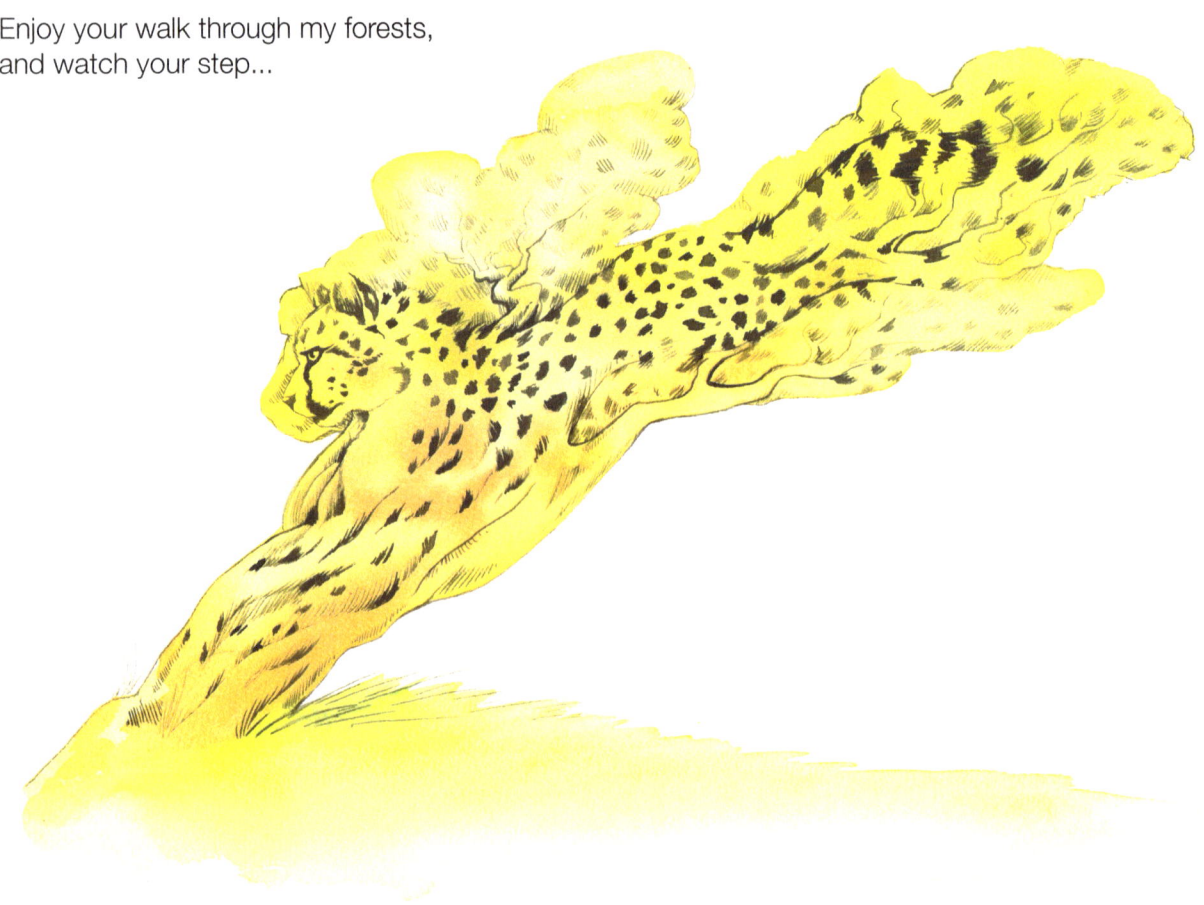

TreeCheetah - watercolor/ink - 2011

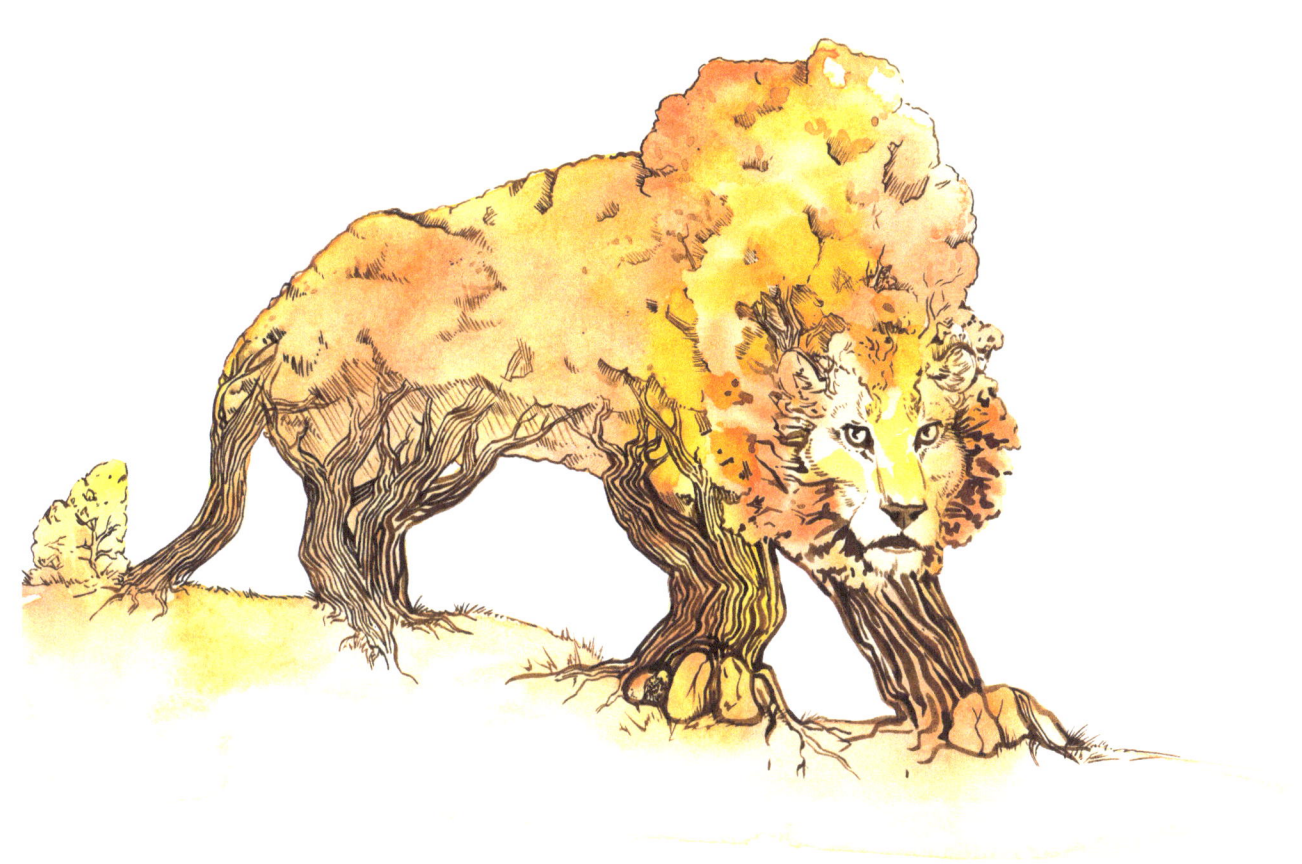
TreeLion in Fall - watercolor/ink - 2012

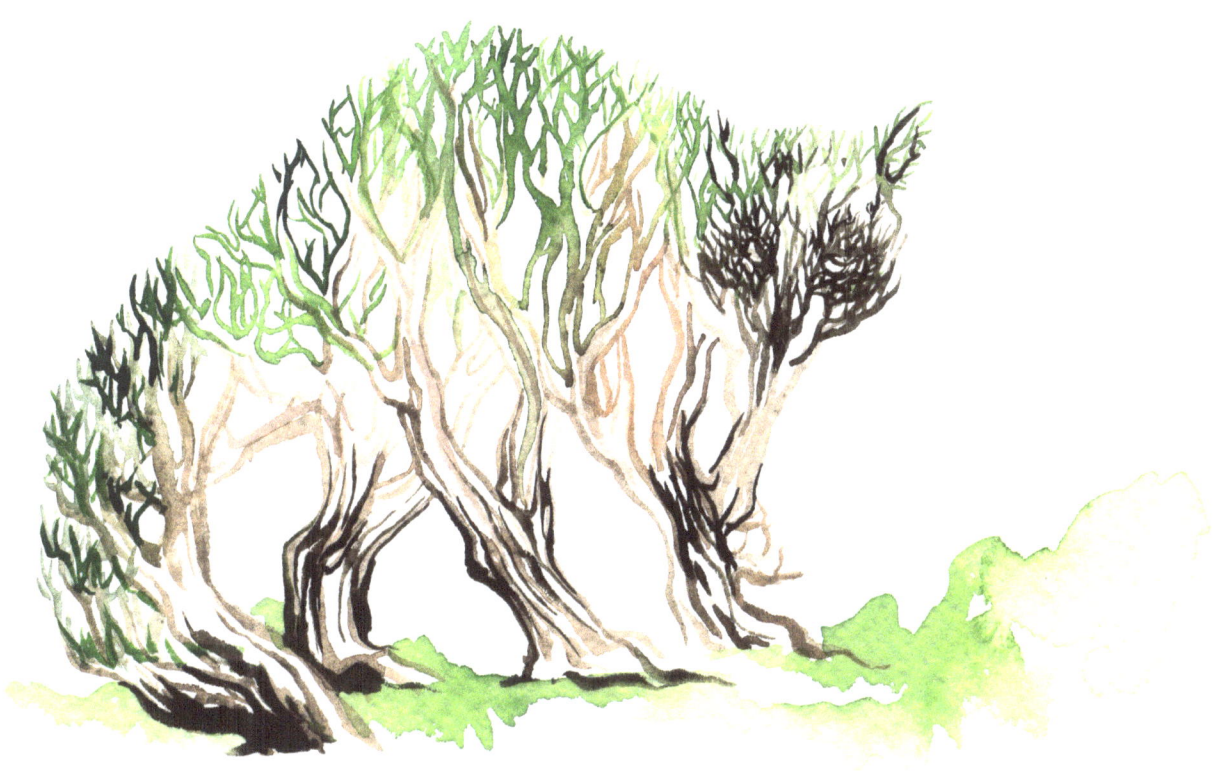
TreeRaccoon - watercolor - 2010

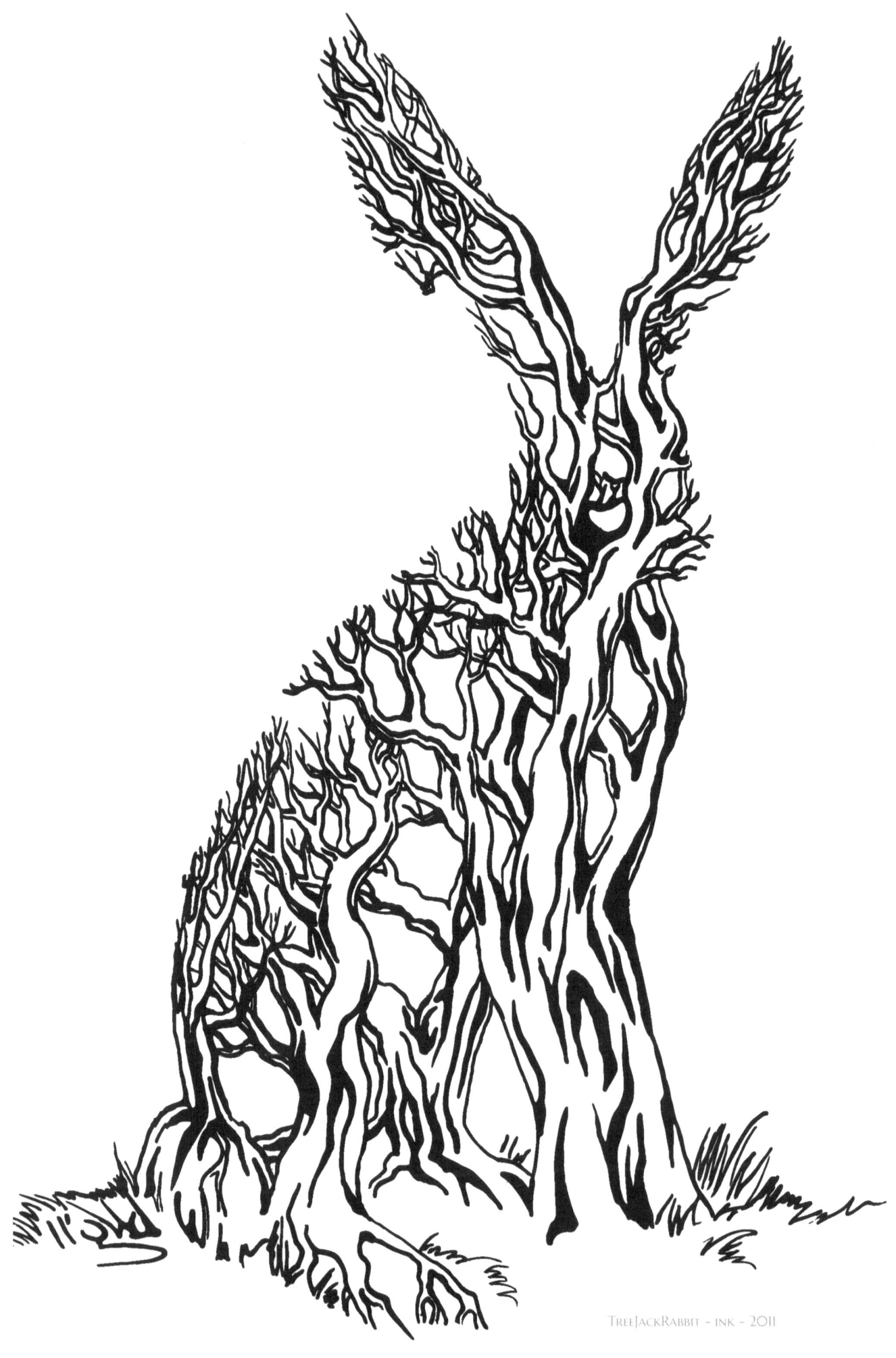

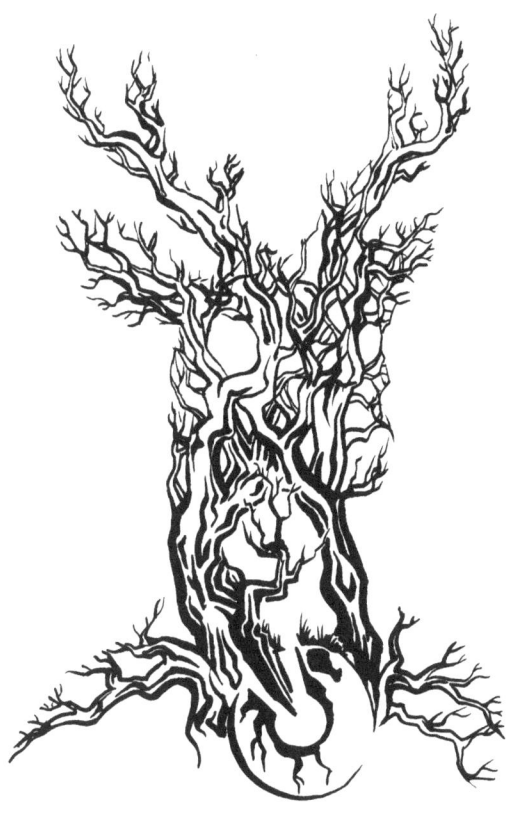

TreeBuck - ink - 2012

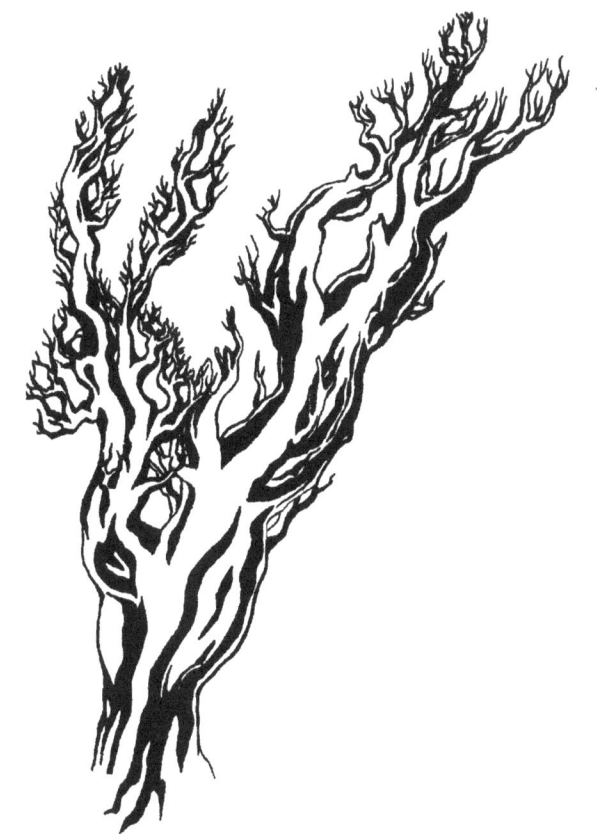

TreeHare - ink - 2010

TreeWolf - ink - 2010

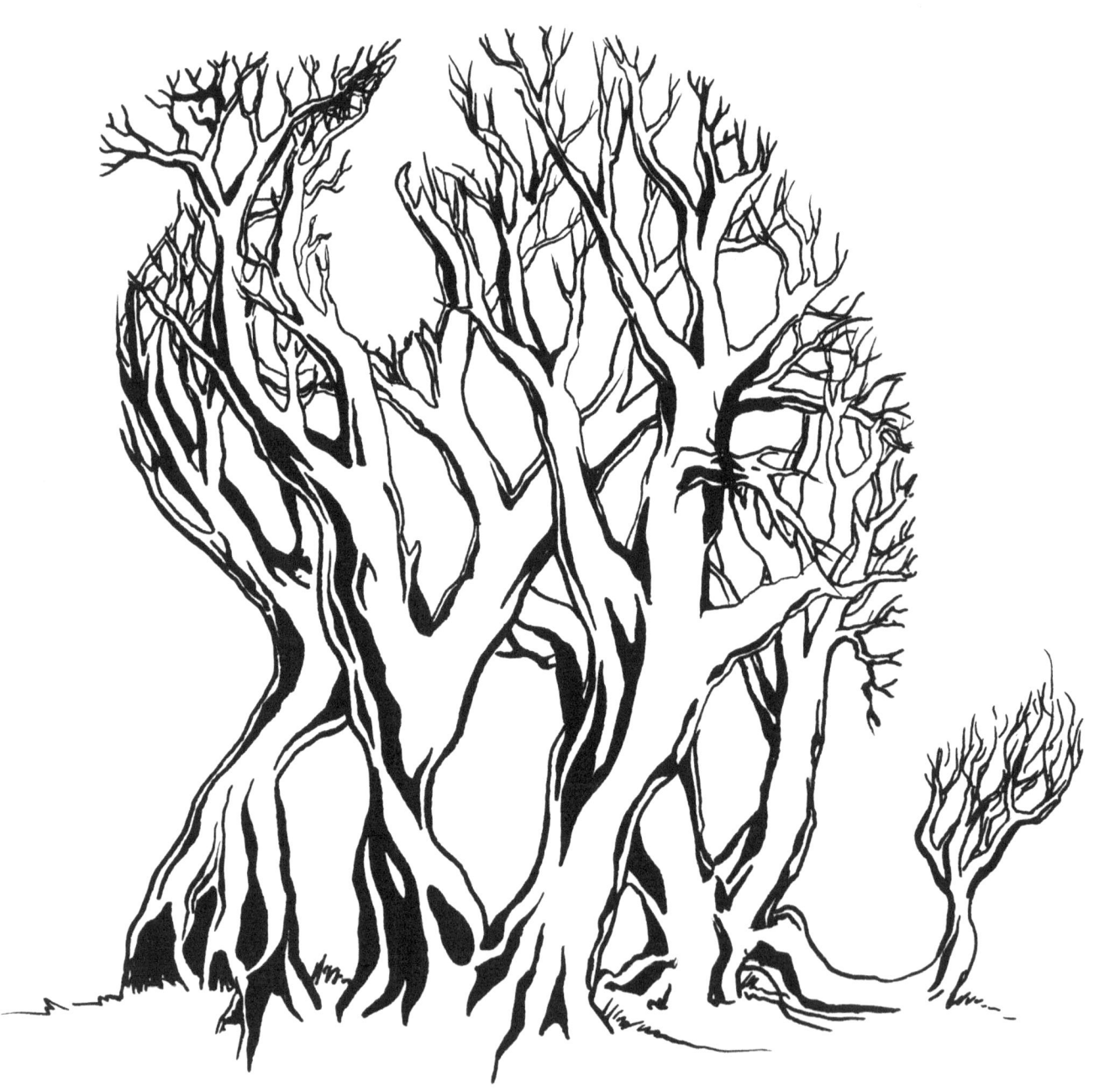

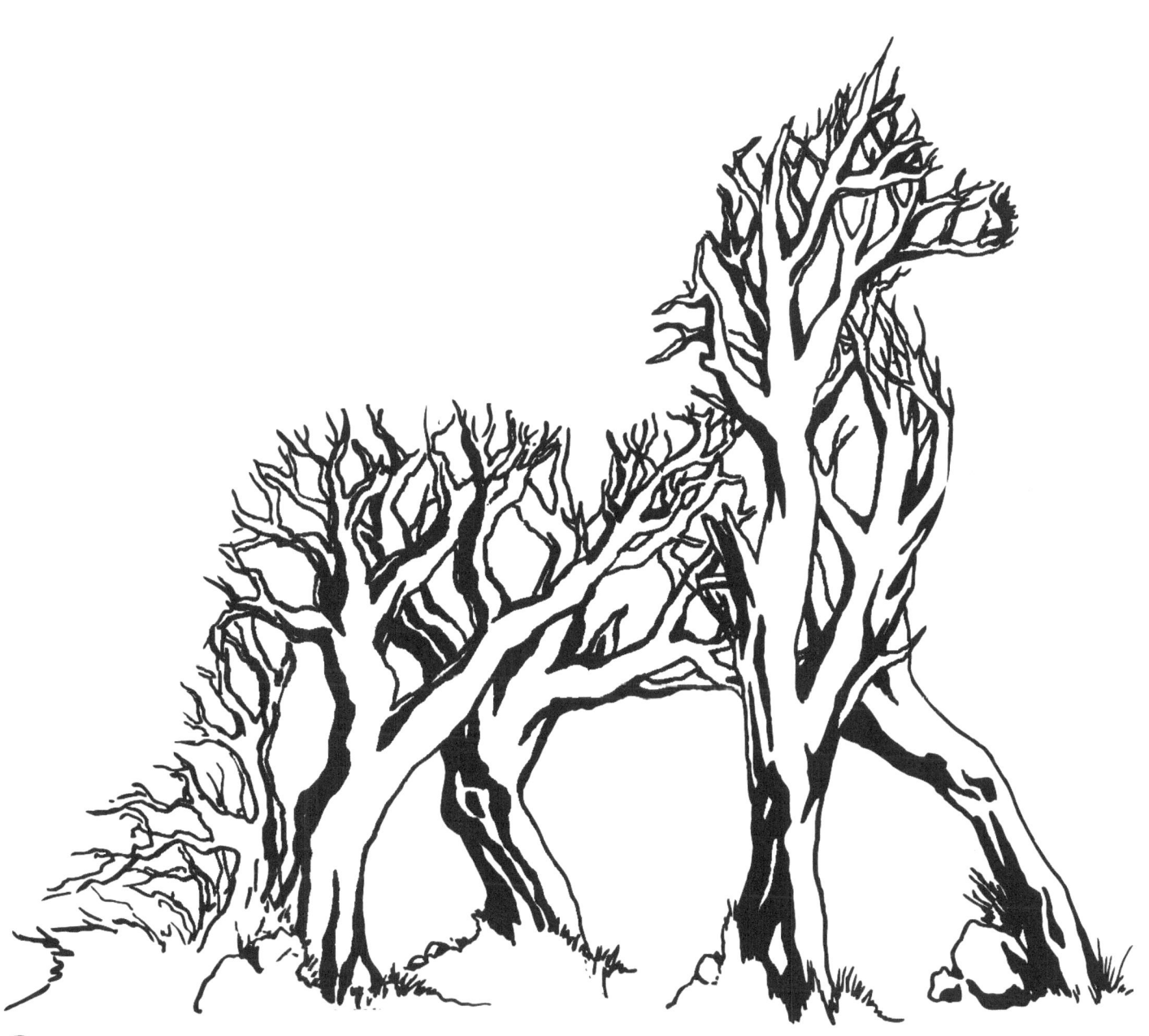

TreeHorse - ink - 2010

TreeFox and Hare – ink – 2012

TreeLion Face – ink – 2011

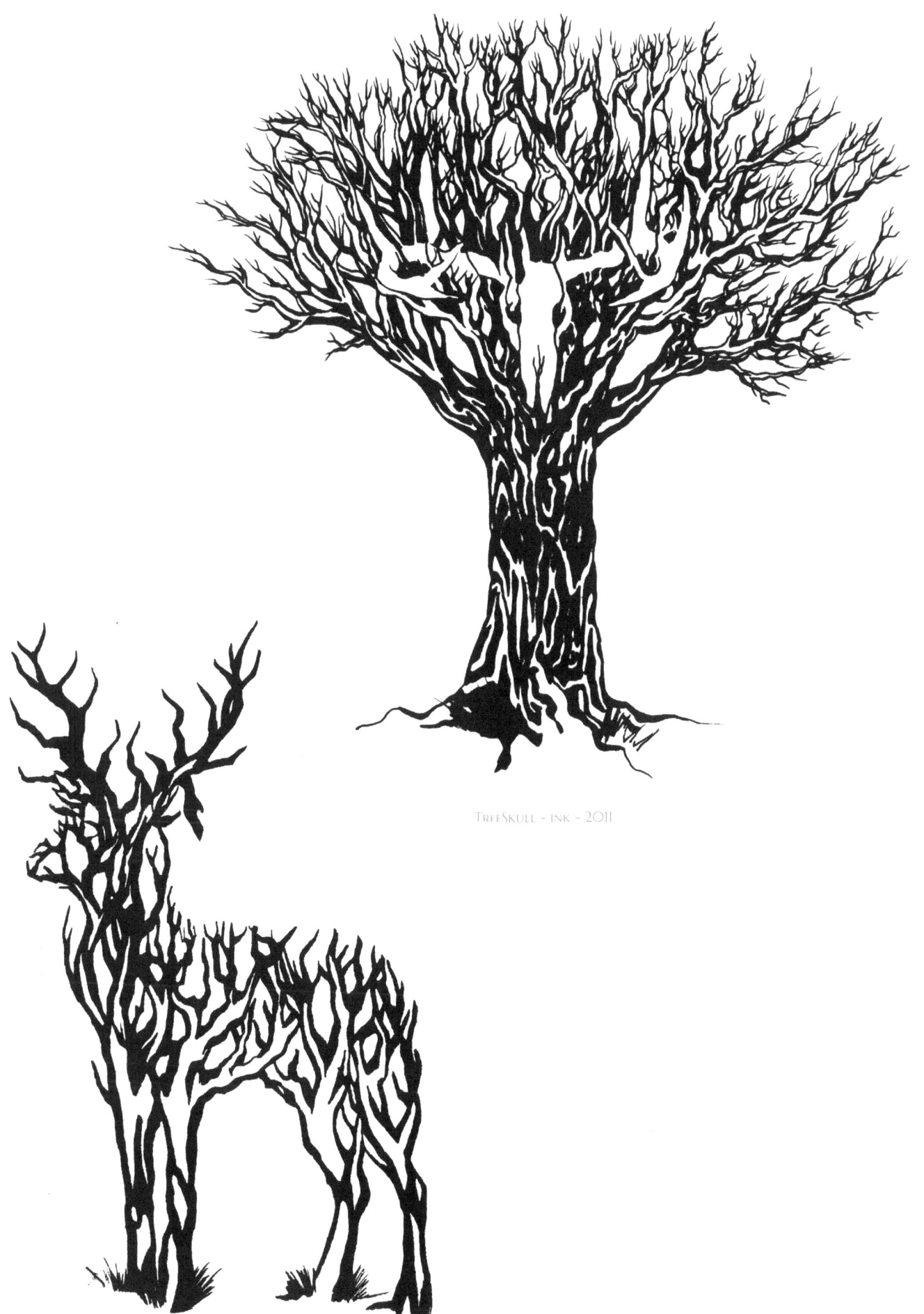

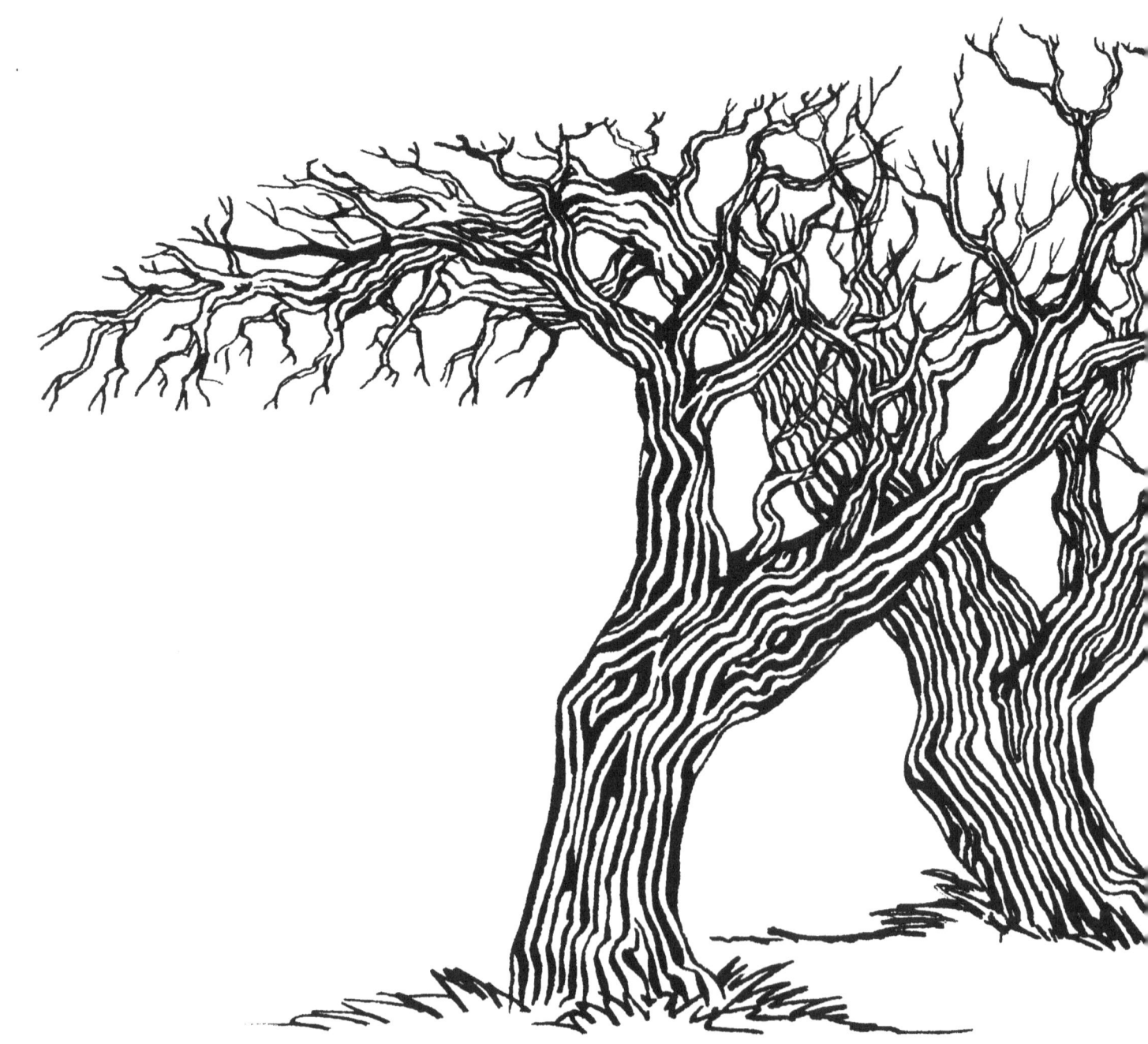

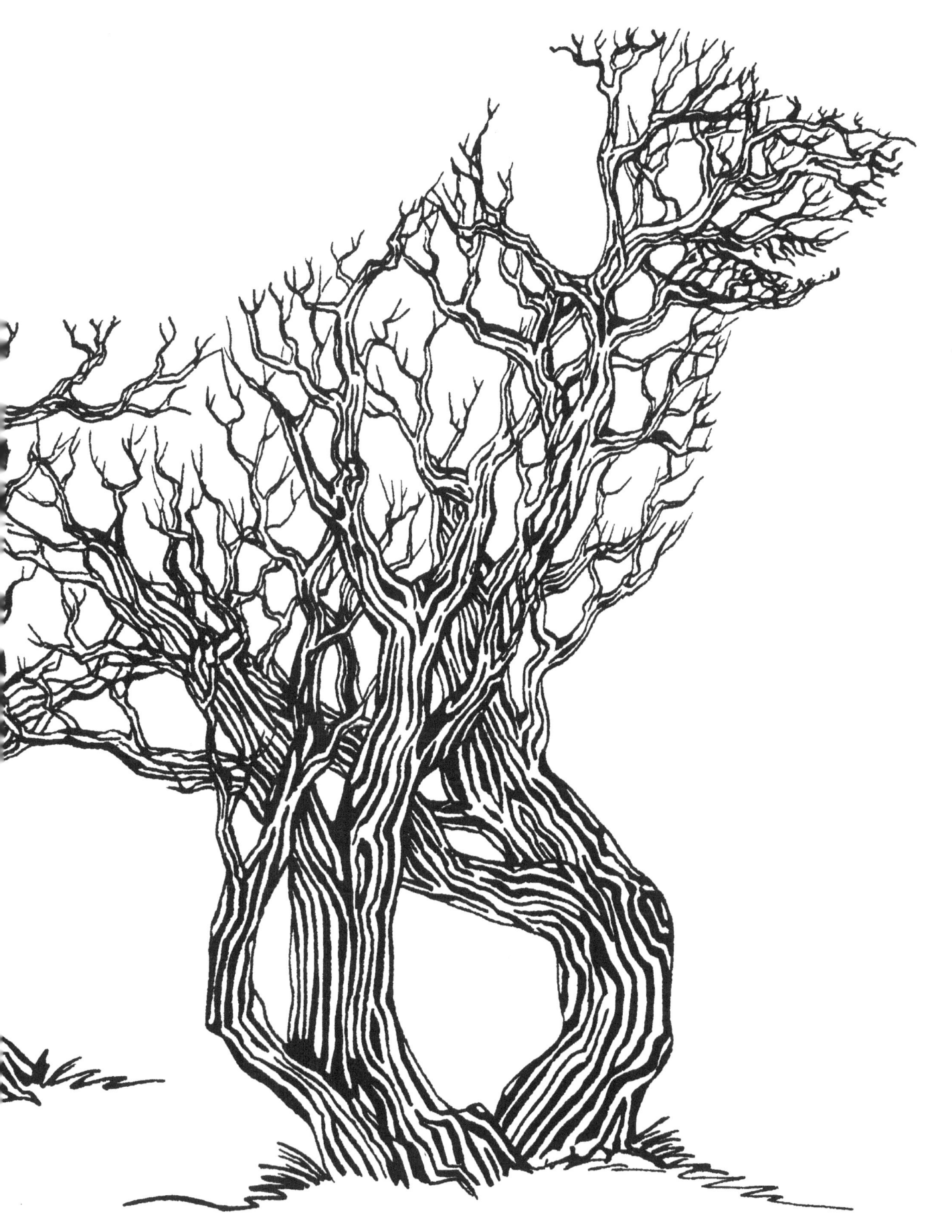

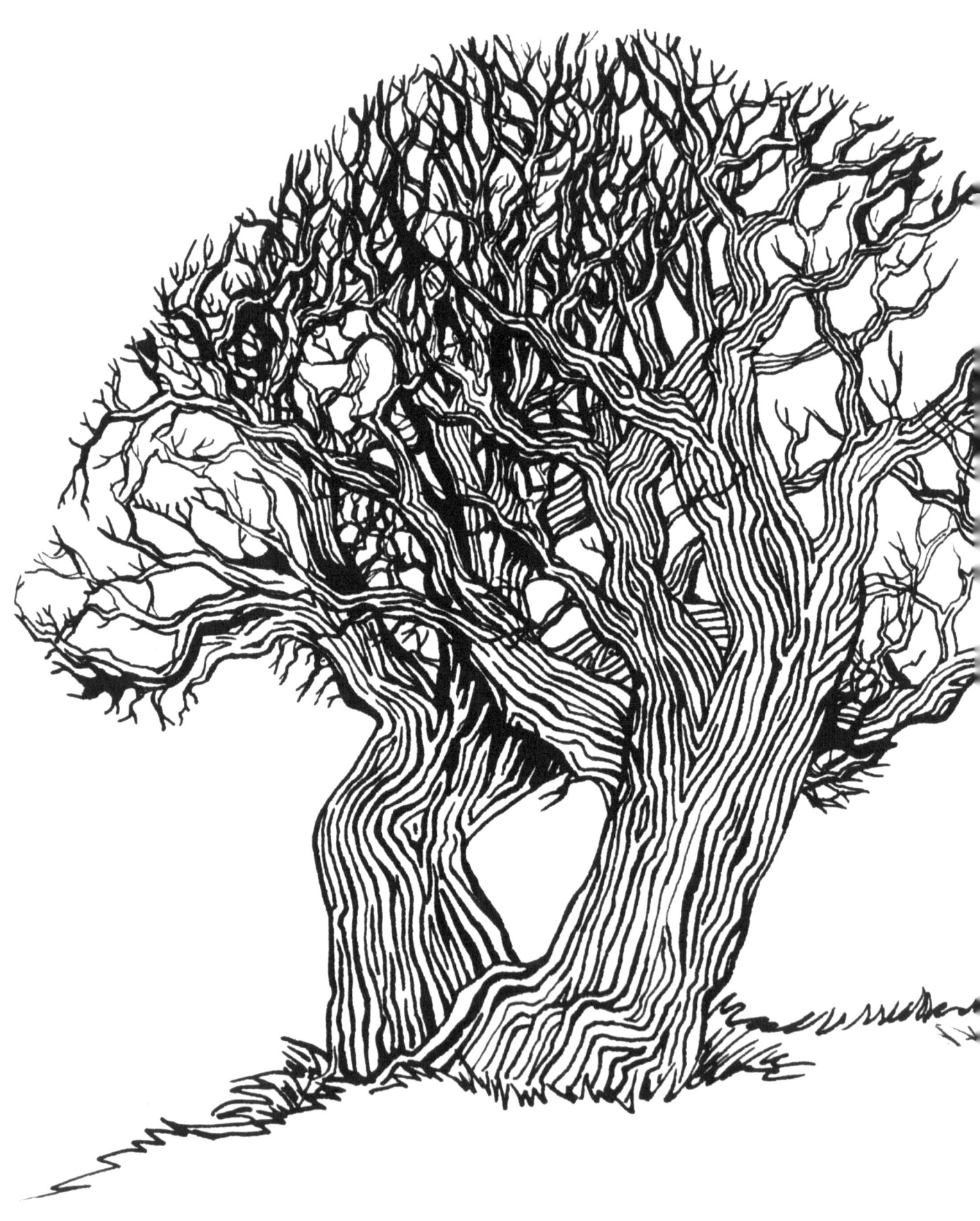

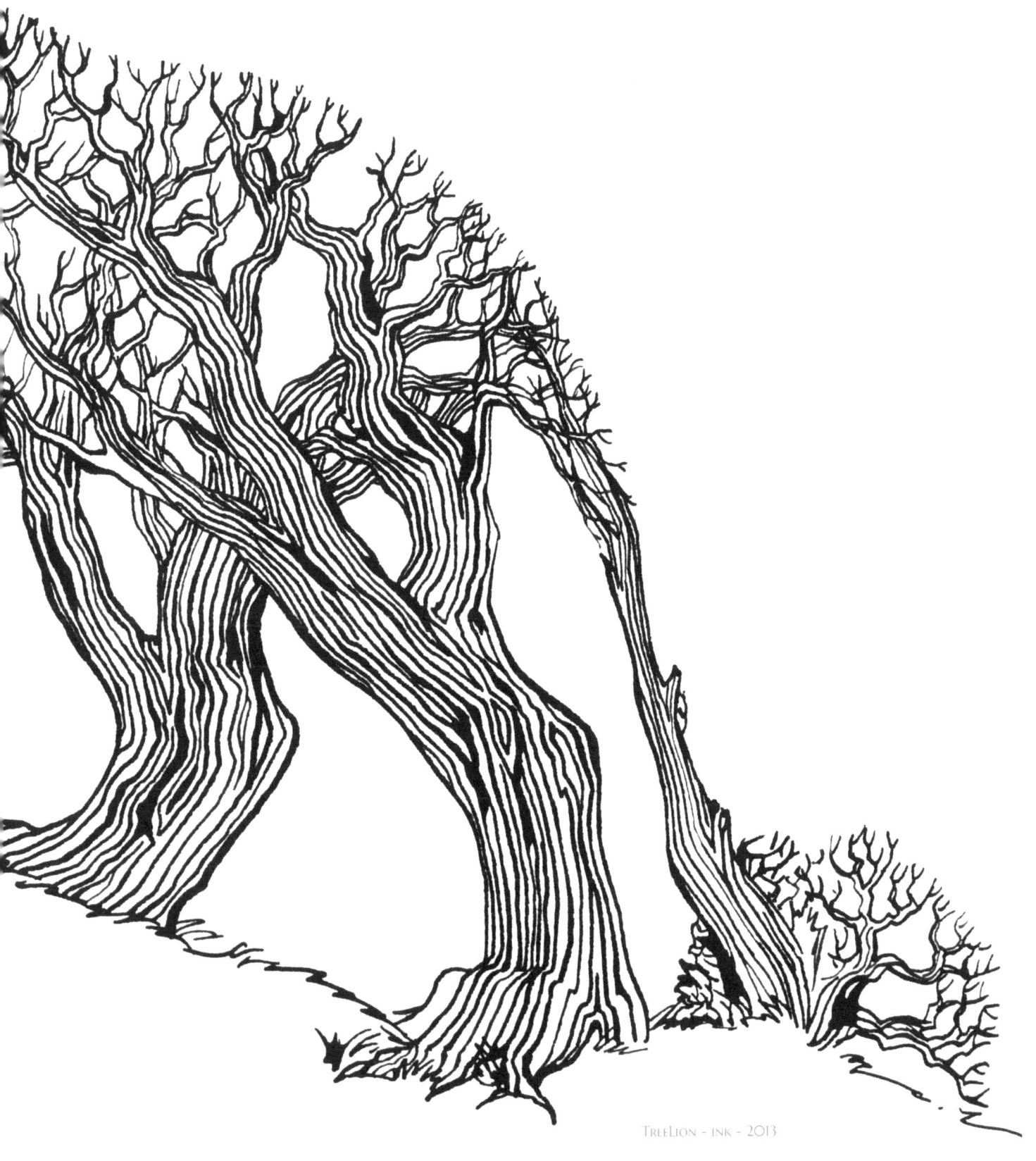

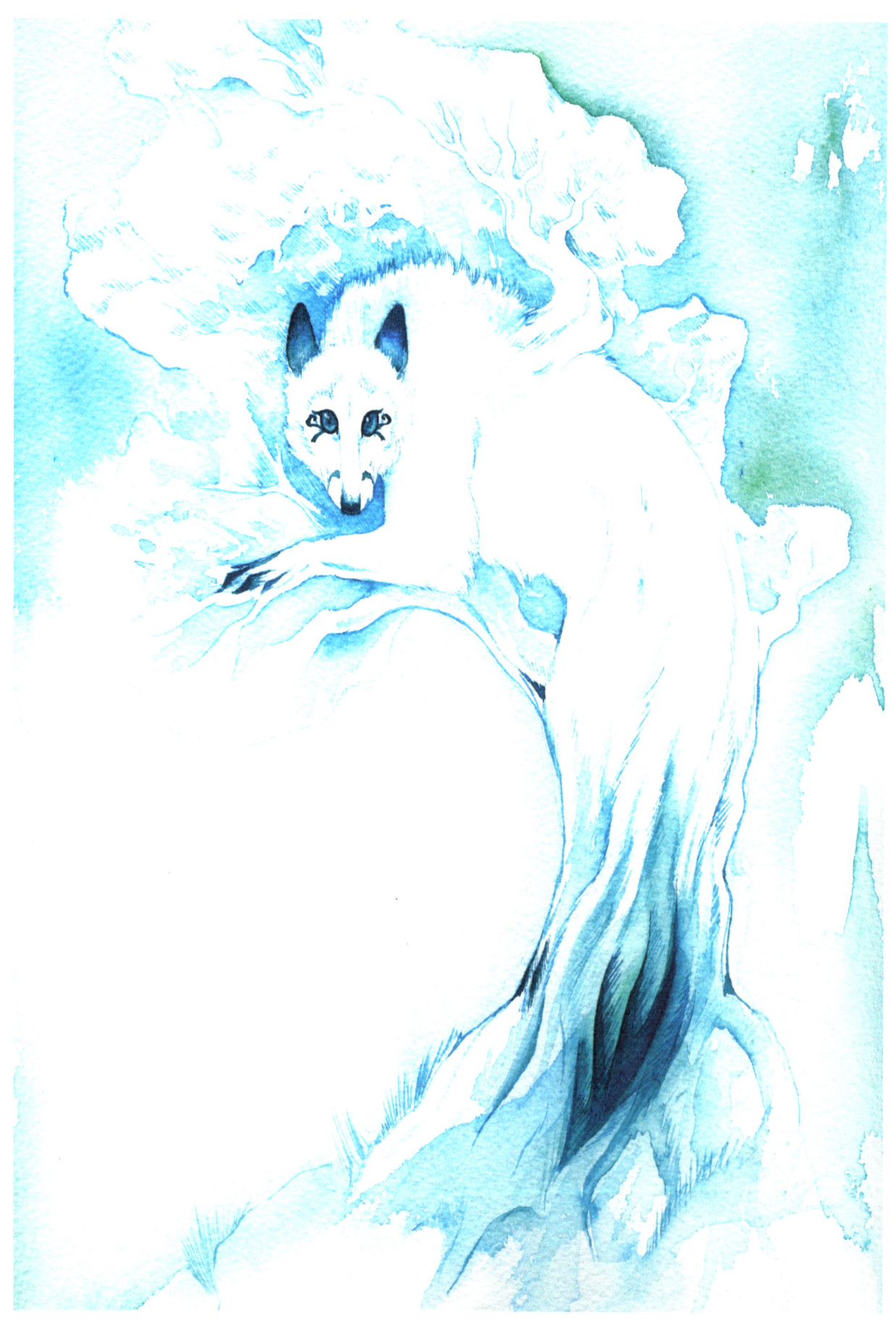

Winter TreeWolf - watercolor/ink - 2011

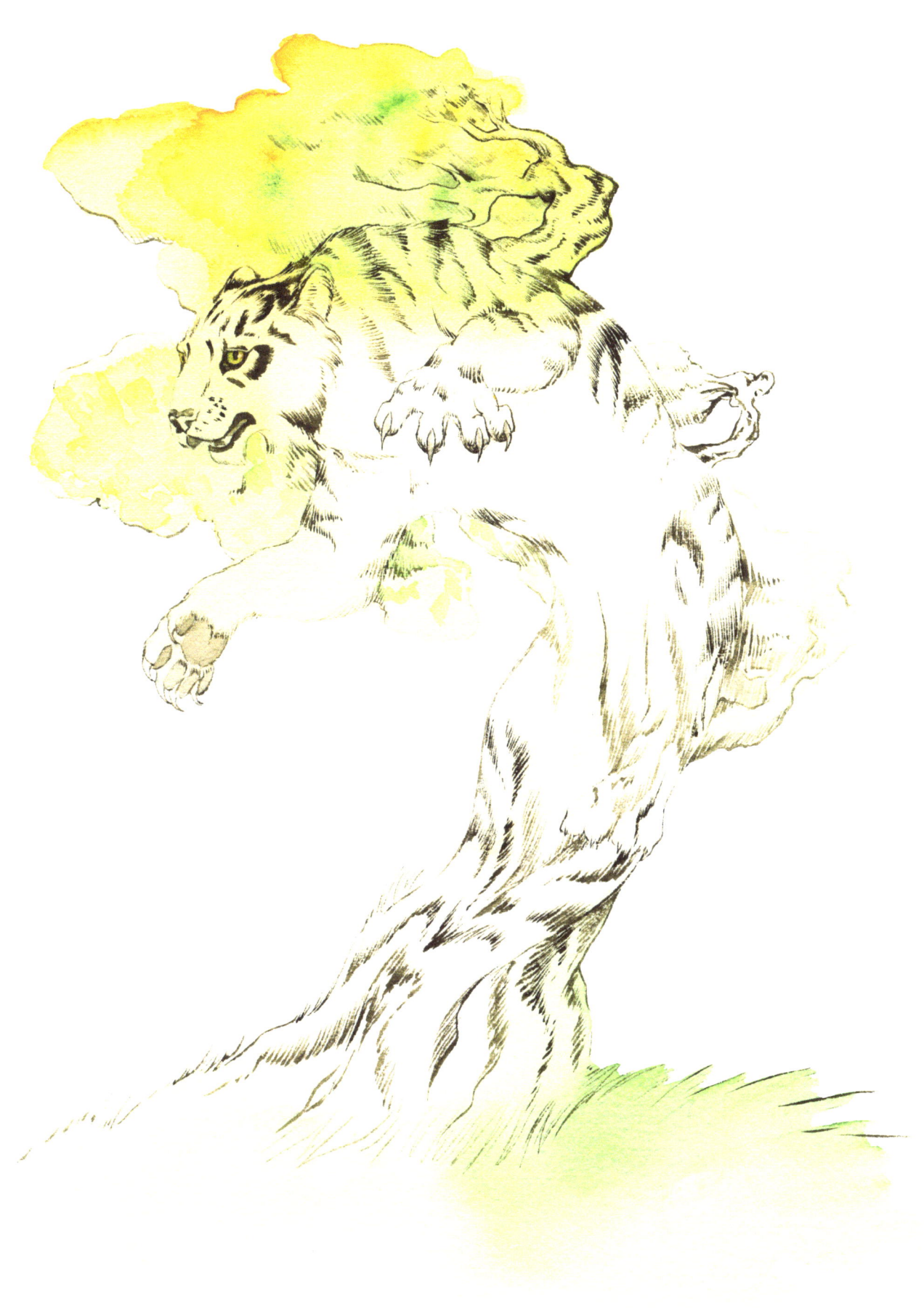

TreeTiger – watercolor/ink – 2011

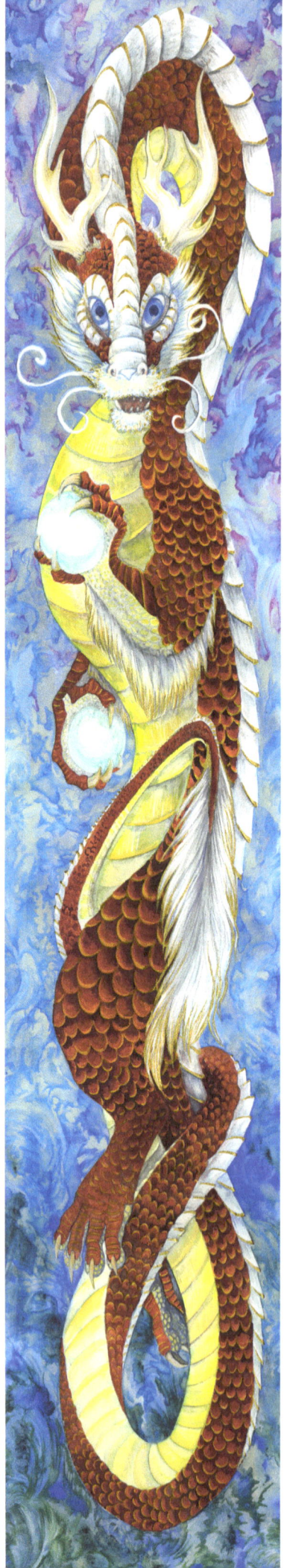

LIVING PIGMENTS

There is a new and wondrous life that begins every time a wet brush is applied to a page. To feel it start breathing under your brush is a gift and a joy. Ever since I was a child I have wanted to create fantastical creatures with whom I could explore unknown worlds. From gryphons to unicorns, pink chickens to strange hybrid creatures of unknown origin, I love creating life through my art. The pigment that brings these things to life is almost always watercolor. This seems appropriate, since watercolor certainly has a life of its own. Trying to predict the path of a wet on wet wash is like trying to determine the way a feather will fall. You may have some idea, but it will often surprise you.

The creatures and characters in the following pages often live in different worlds, though I like to think we could somehow visit them. That in one particular shadow-steeped alley, in one particular fall of a sunbeam, if you step into it from just that perfect angle, you could be transported to that world, and oh, what wonders we would behold...

THE WISE ONE - WATERCOLOR/ACRYLIC/GOUACHE - 2013

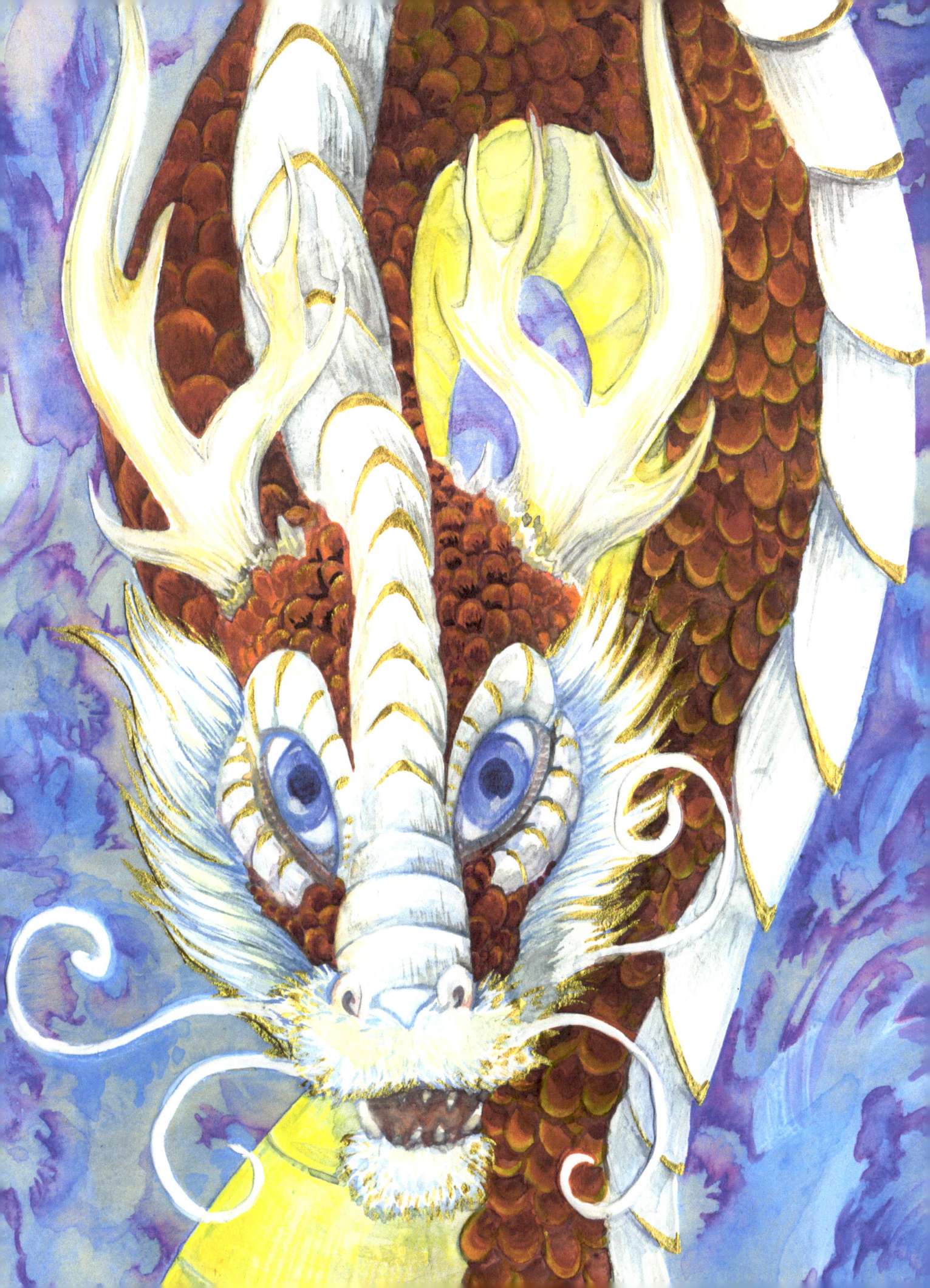

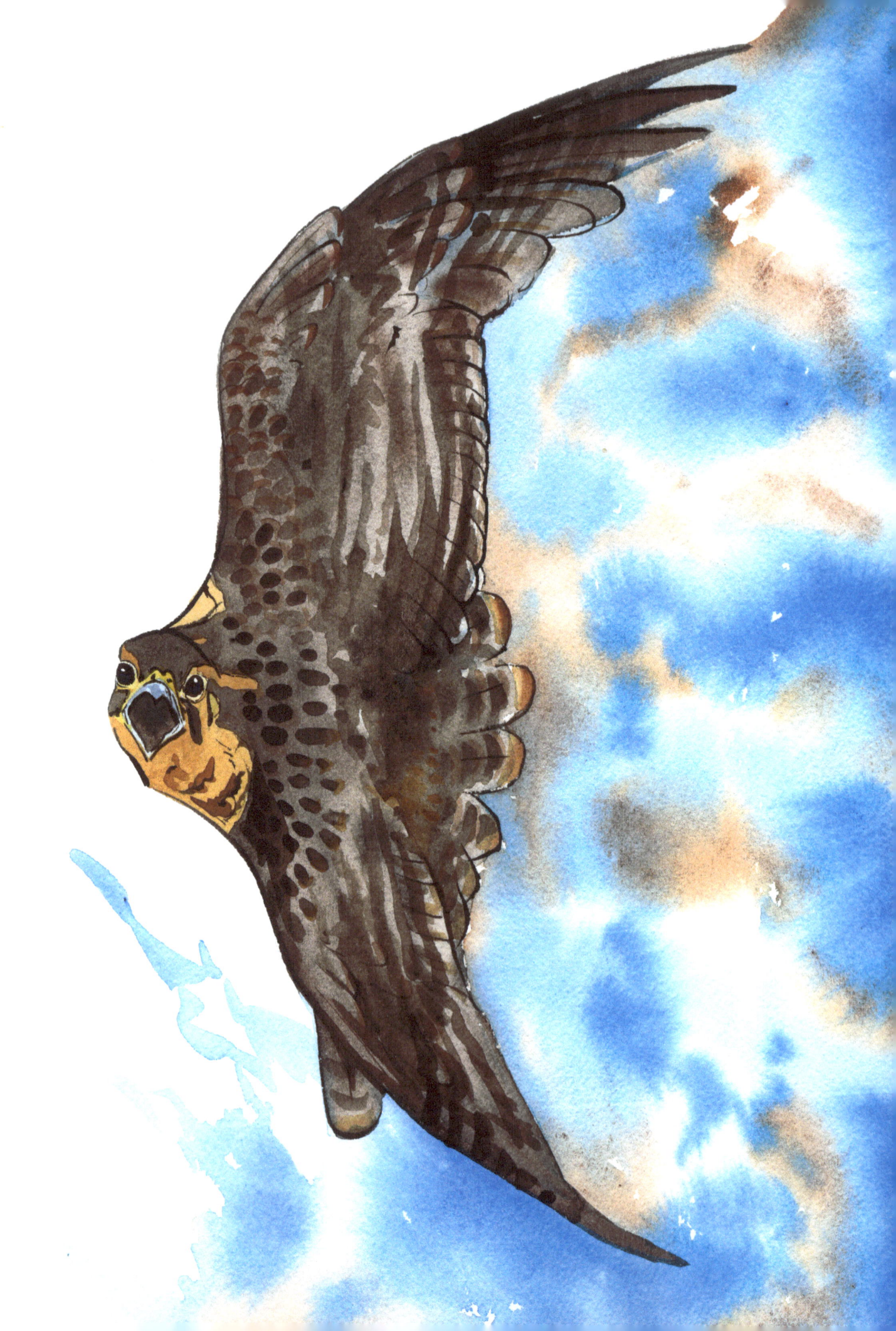

Letting It Flow

There is a strange freedom to just let paint do as it wishes.
To flow where it will and blend as it likes.
Then it is just a matter of crossing your fingers and hoping
that the result is close to what you were hoping for...

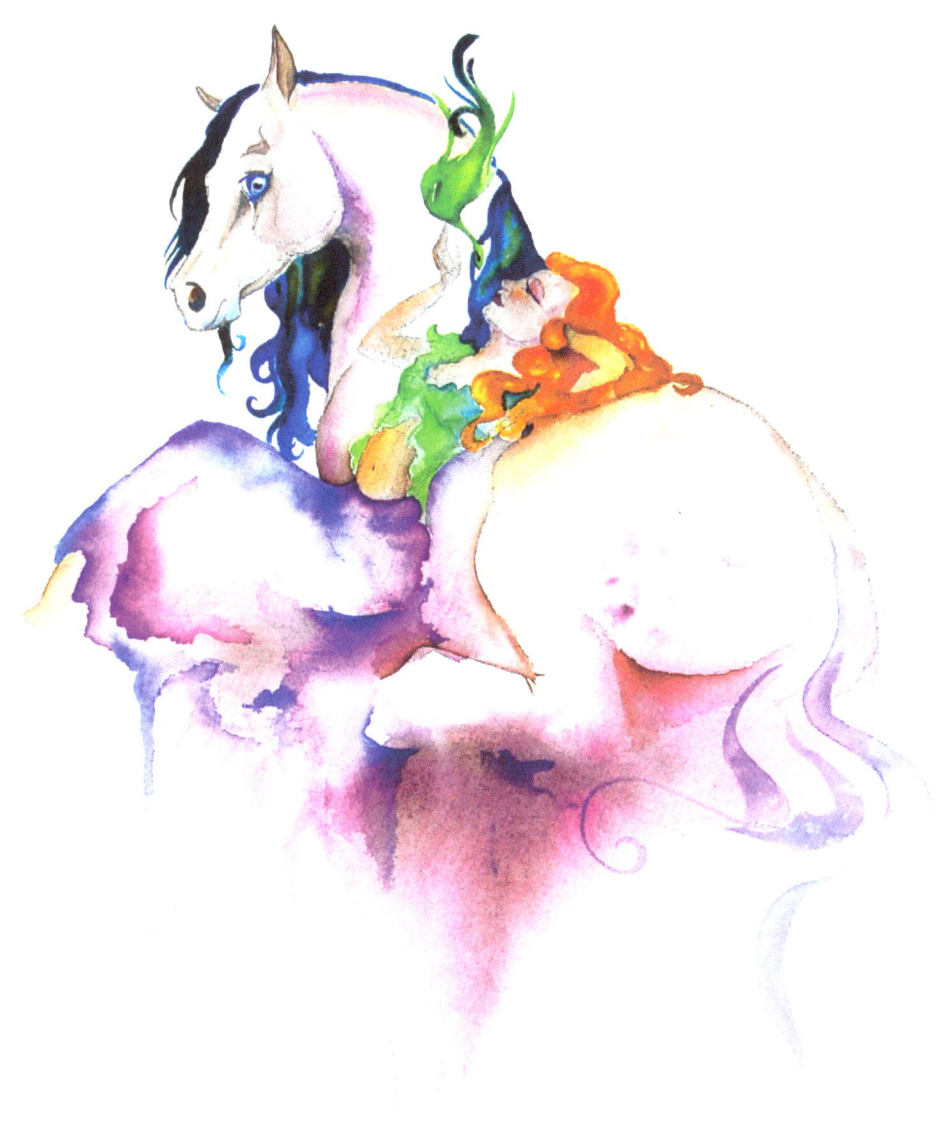

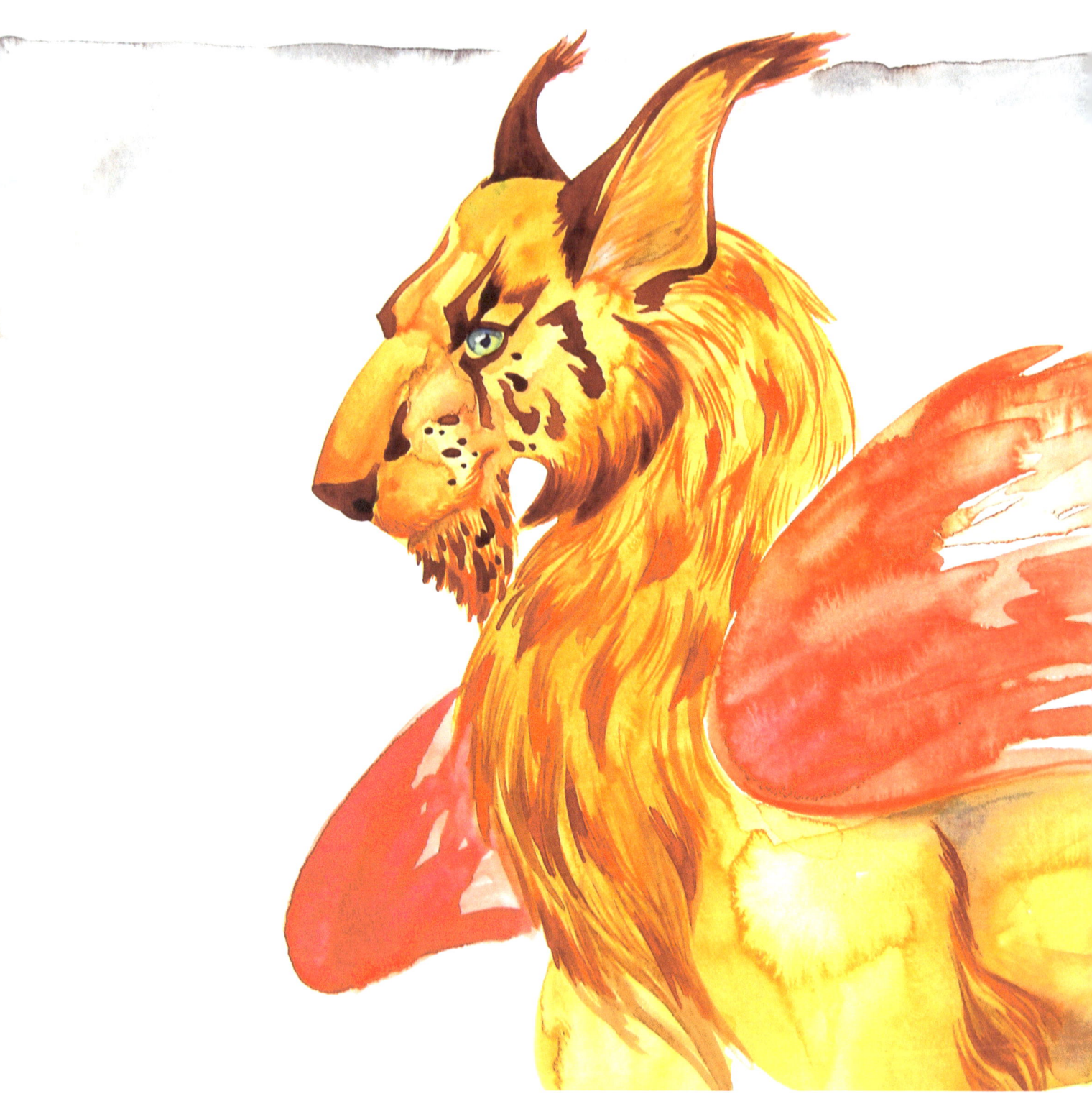

Wings - watercolor - 2009

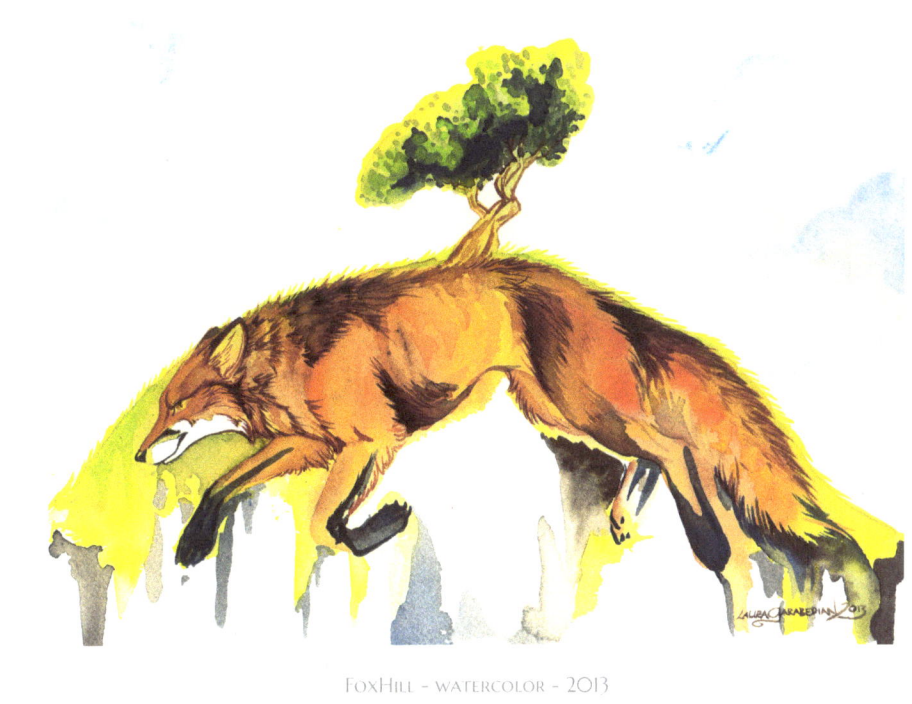
FoxHill - watercolor - 2013

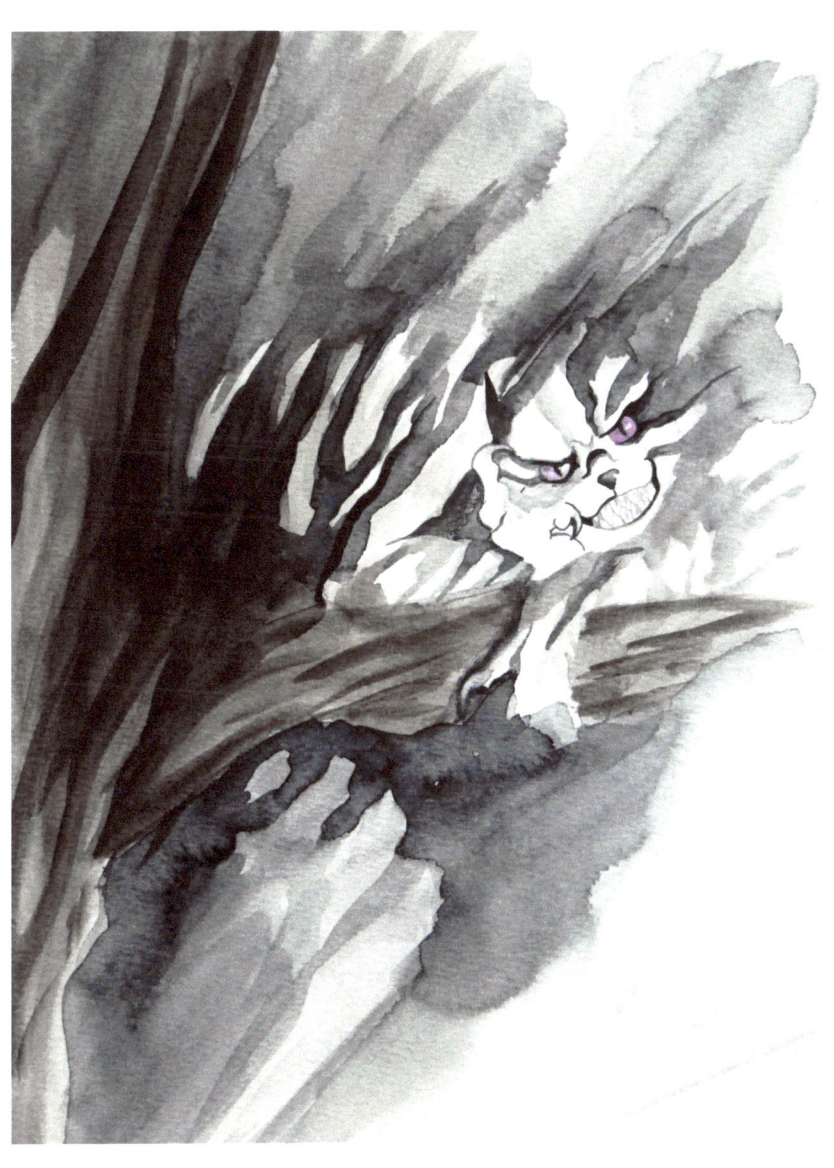
Cheshire Smoke - watercolor - 2010

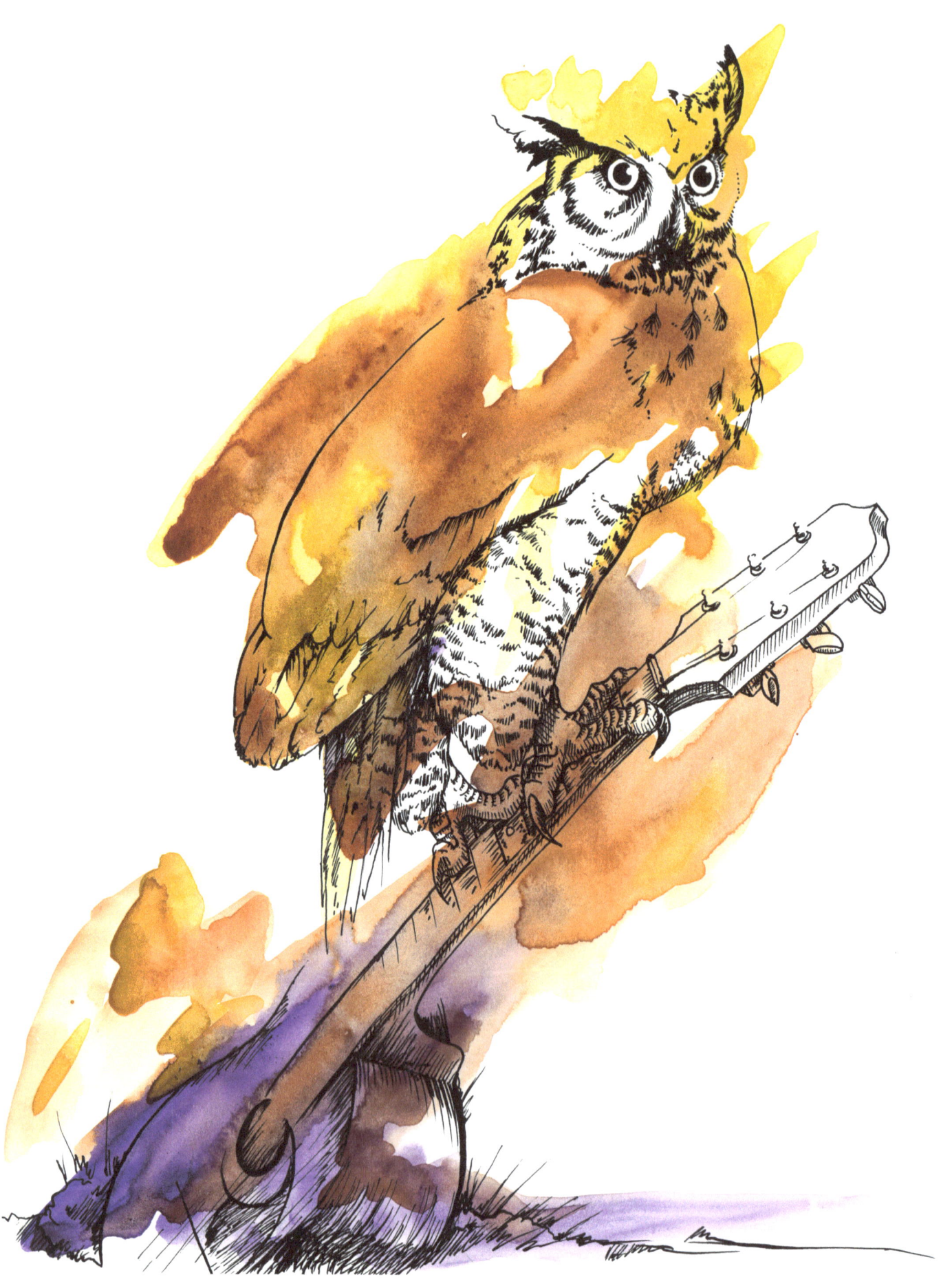
Owl and Guitar – watercolor/ink – 2010

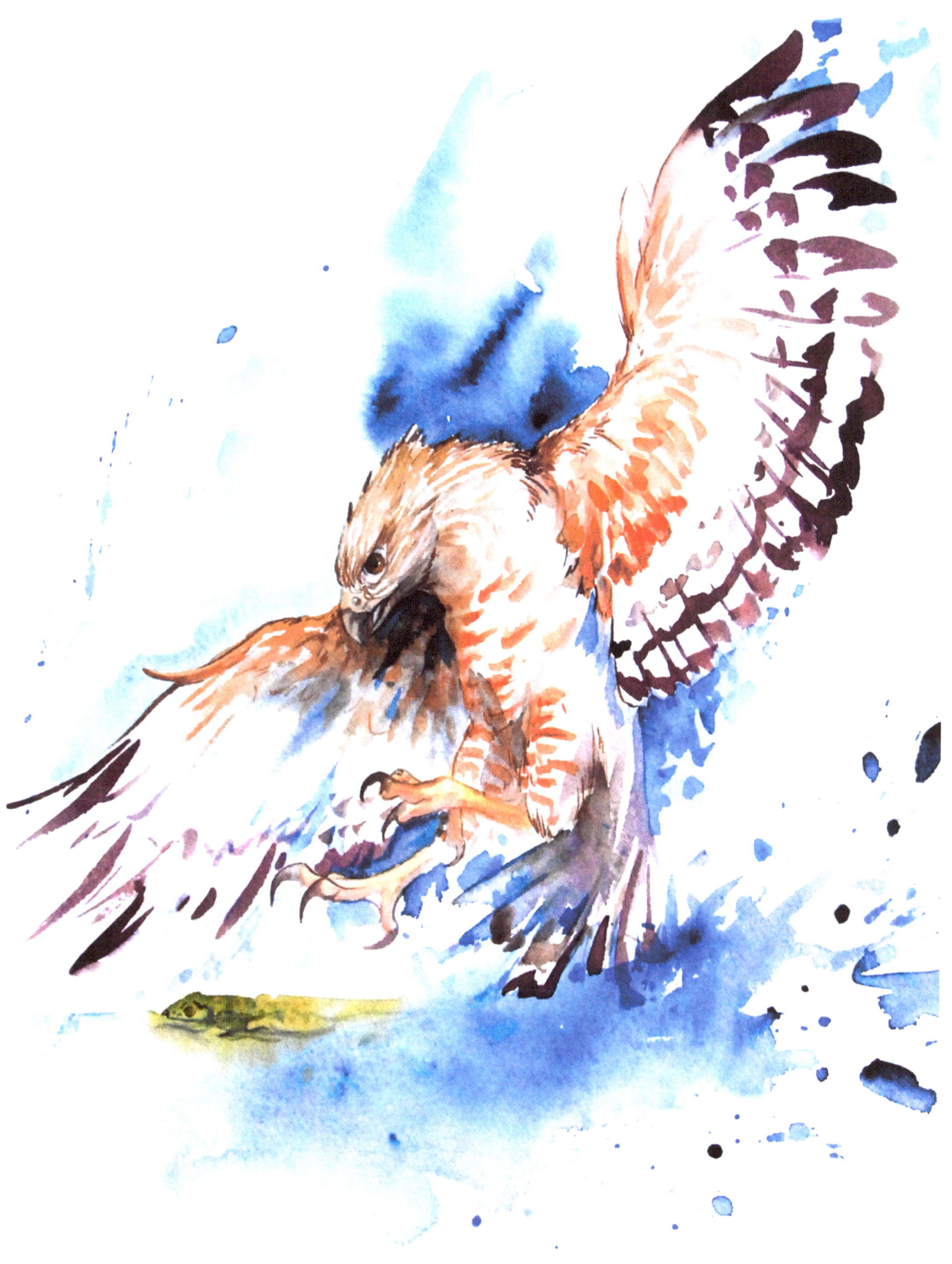

Red Shouldered Hawk - watercolor - 2010

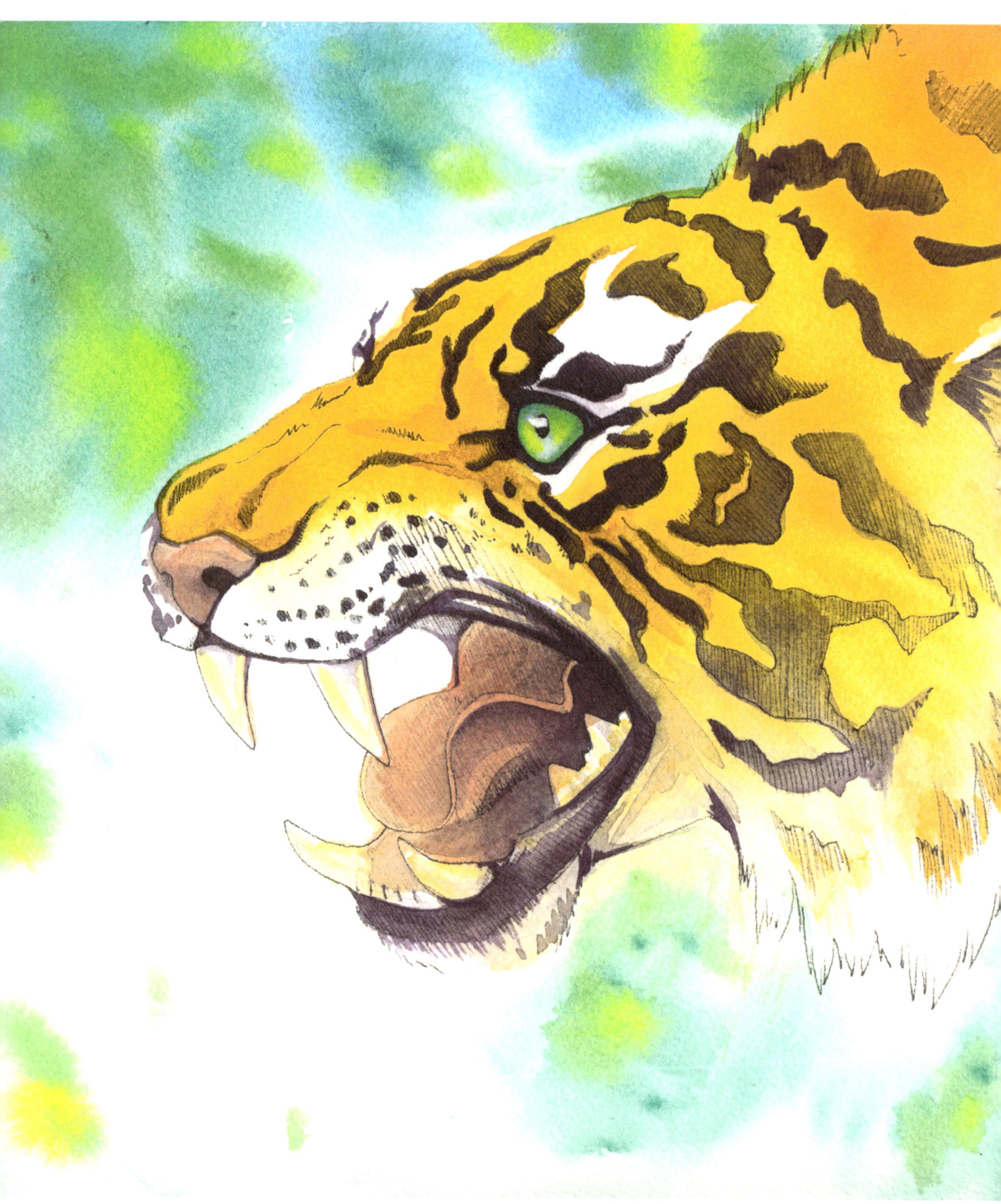

Snarling Tiger – watercolor/ink – 2011

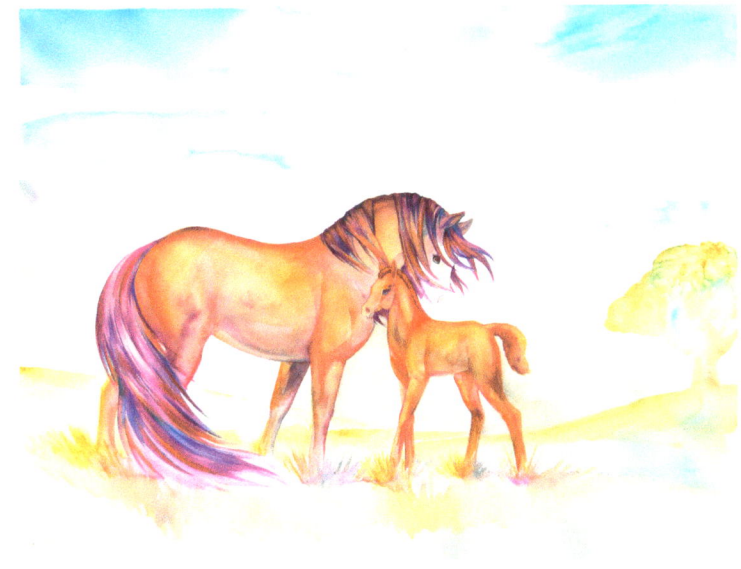

Mare and Foal - watercolor - 2011

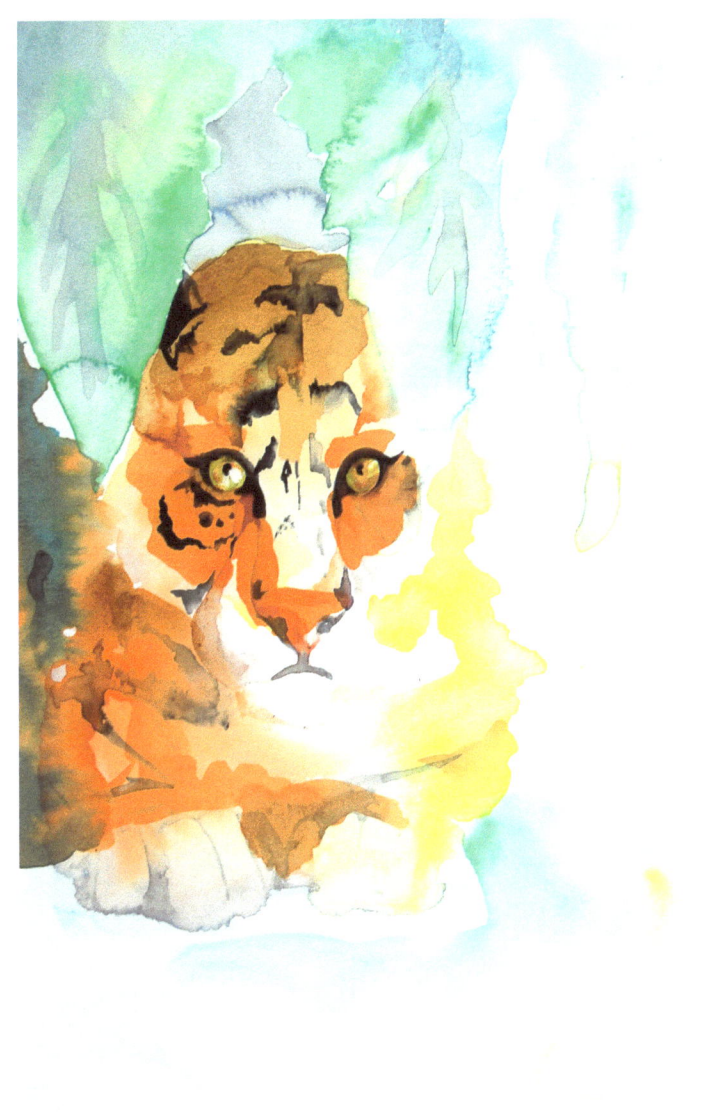

Hidden - watercolor - 2009

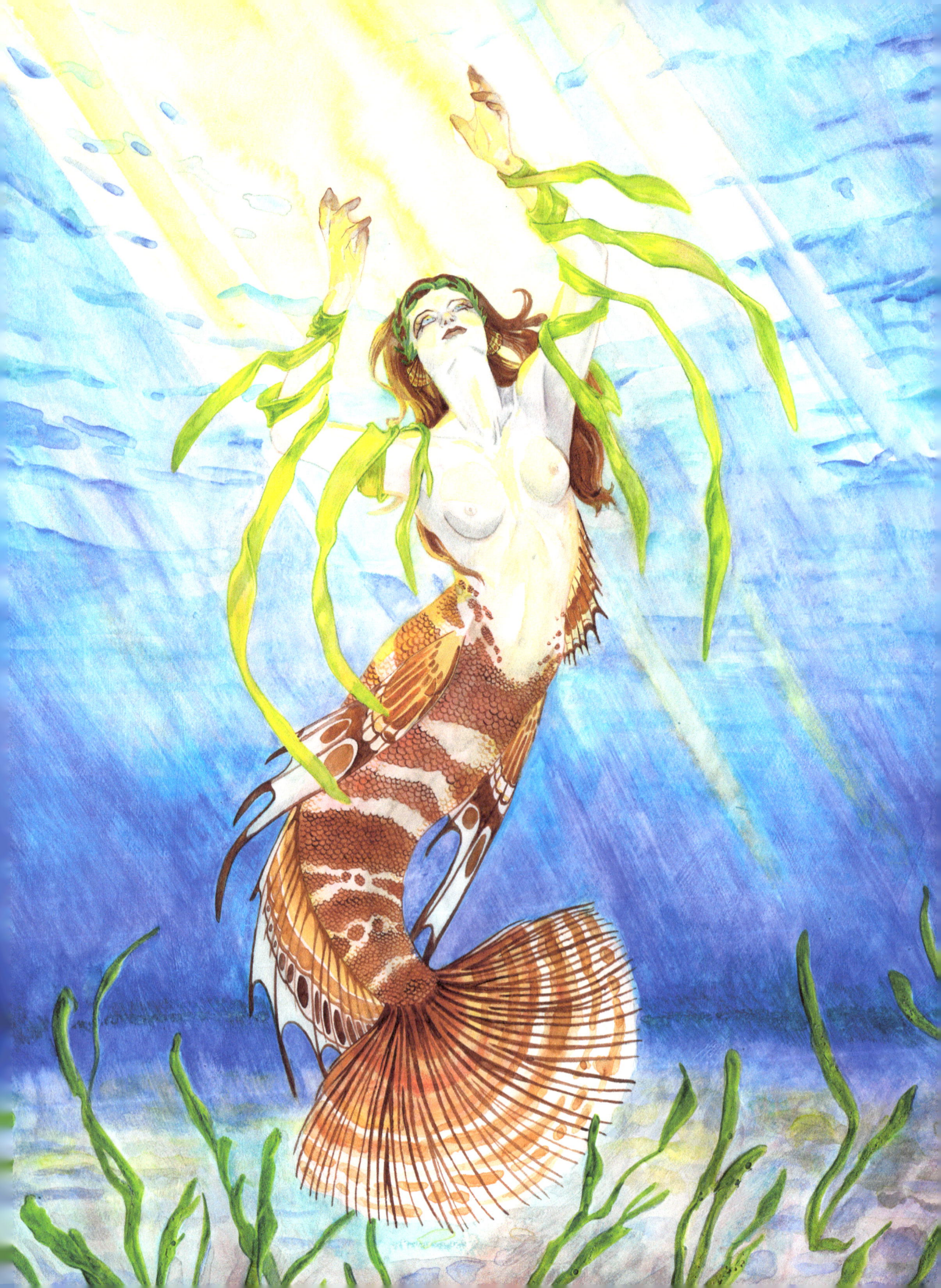

The Illusion of Control

In stark contrast to just letting paint do what it will, sometimes I have a distinct story I want to tell; a specific way I want the light and pigment to interact with the characters.
In these instances, I attempt to bridle the naturally wild tendencies of watercolor into something structured and tame.

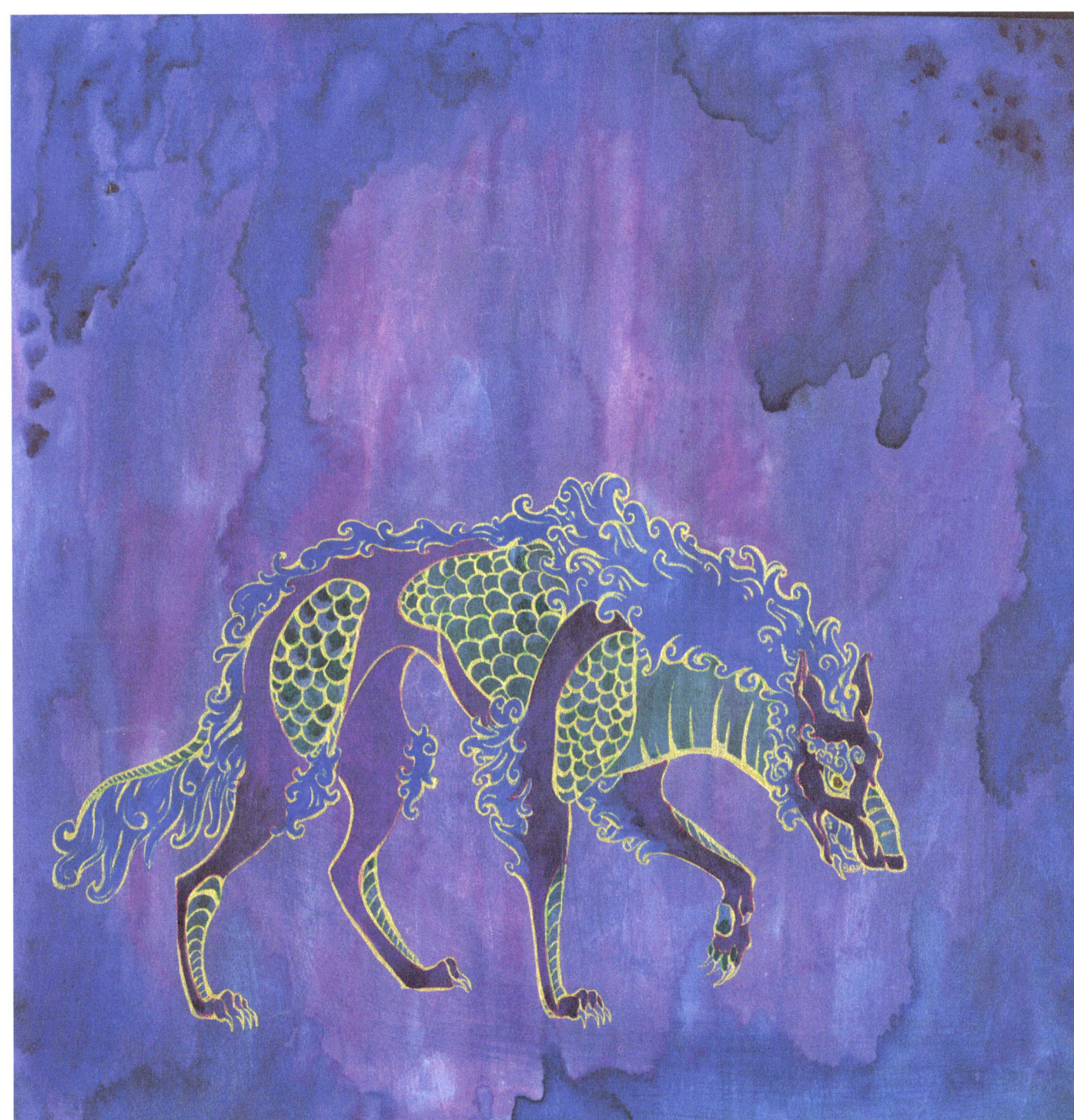

Zoi Foo Dog - watercolor/ink - 2012

Ascension - watercolor - 2013

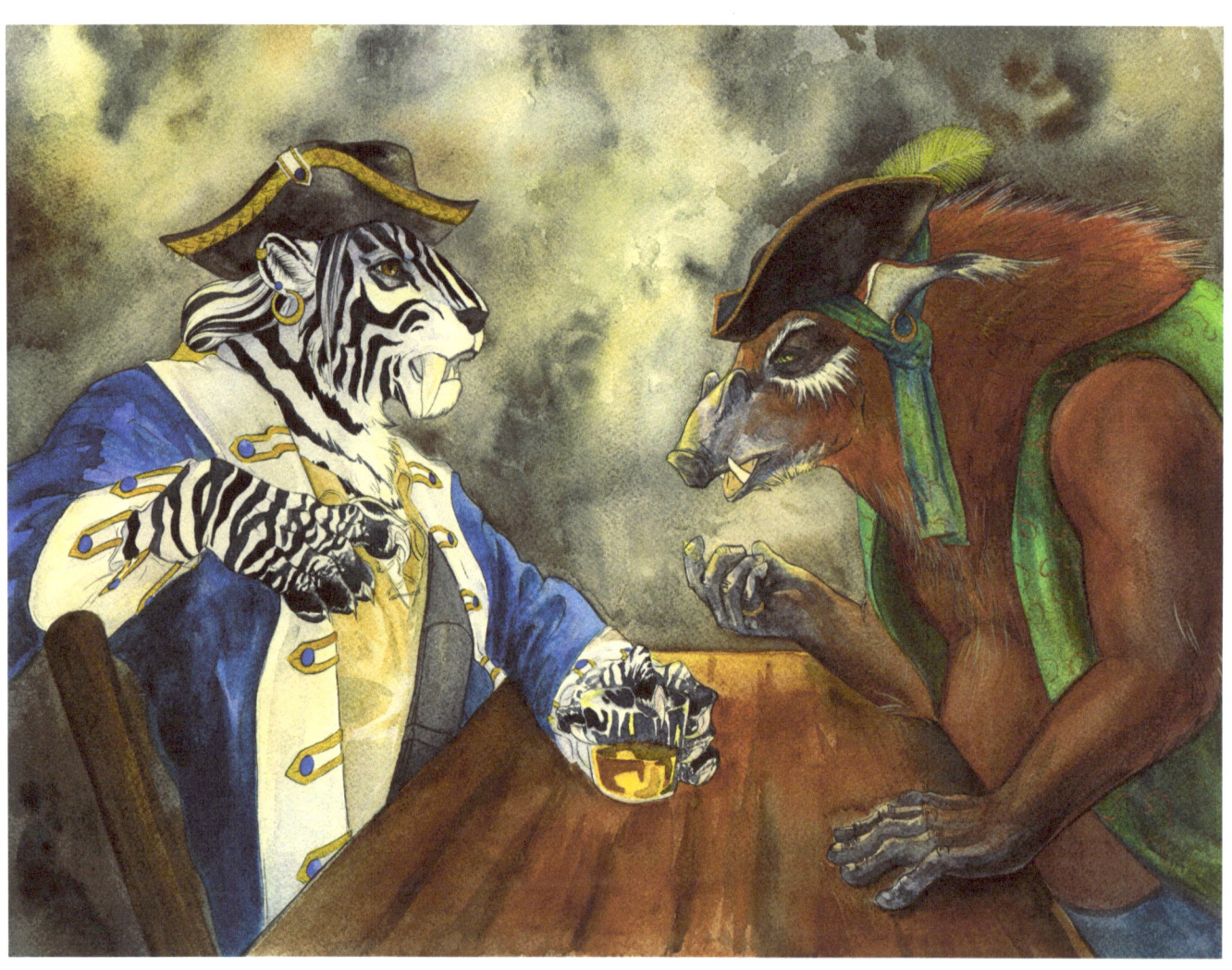

A Pirate's Meeting - watercolor - 2012

Exotic - watercolor/gouache - 2013

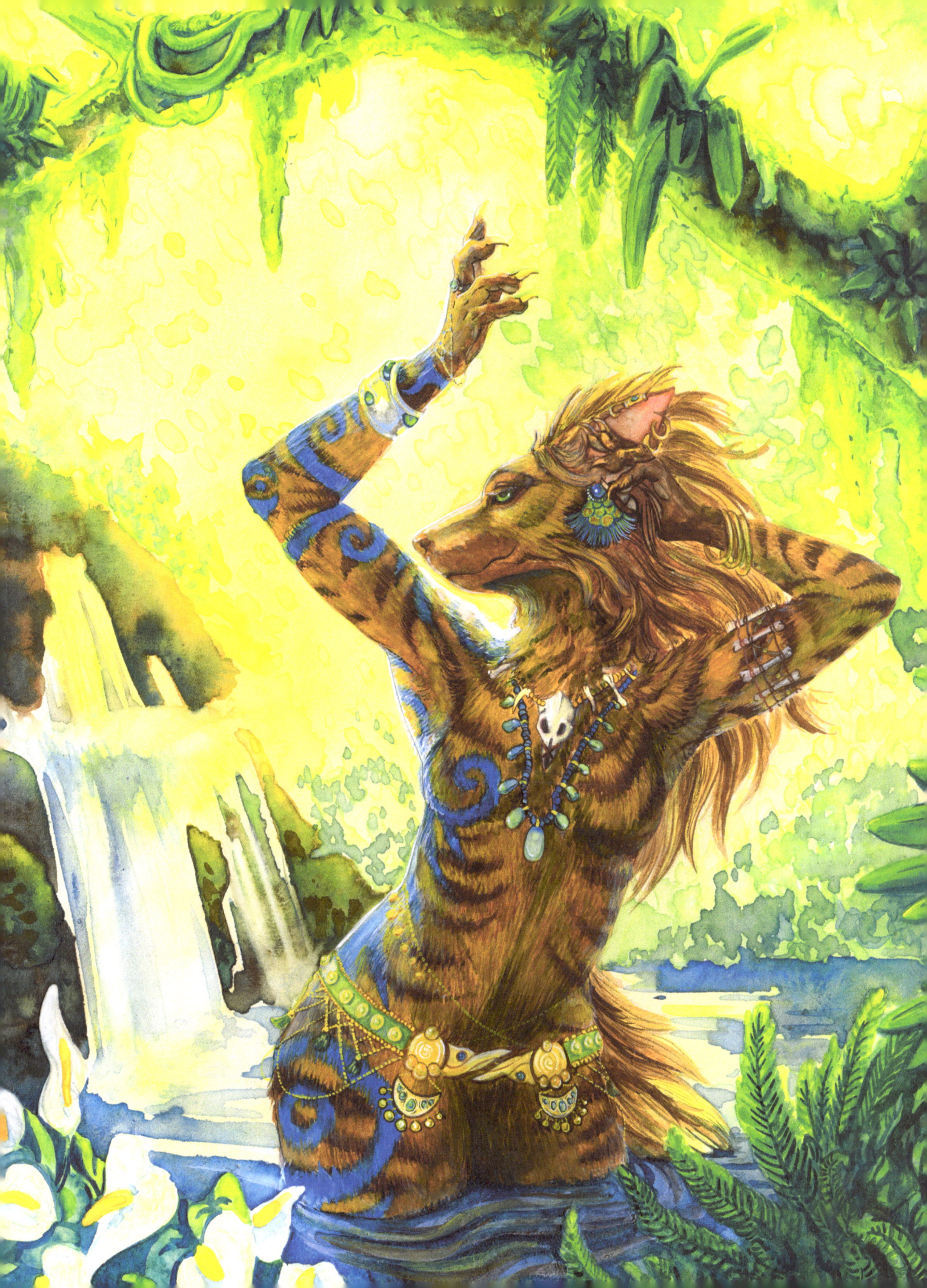

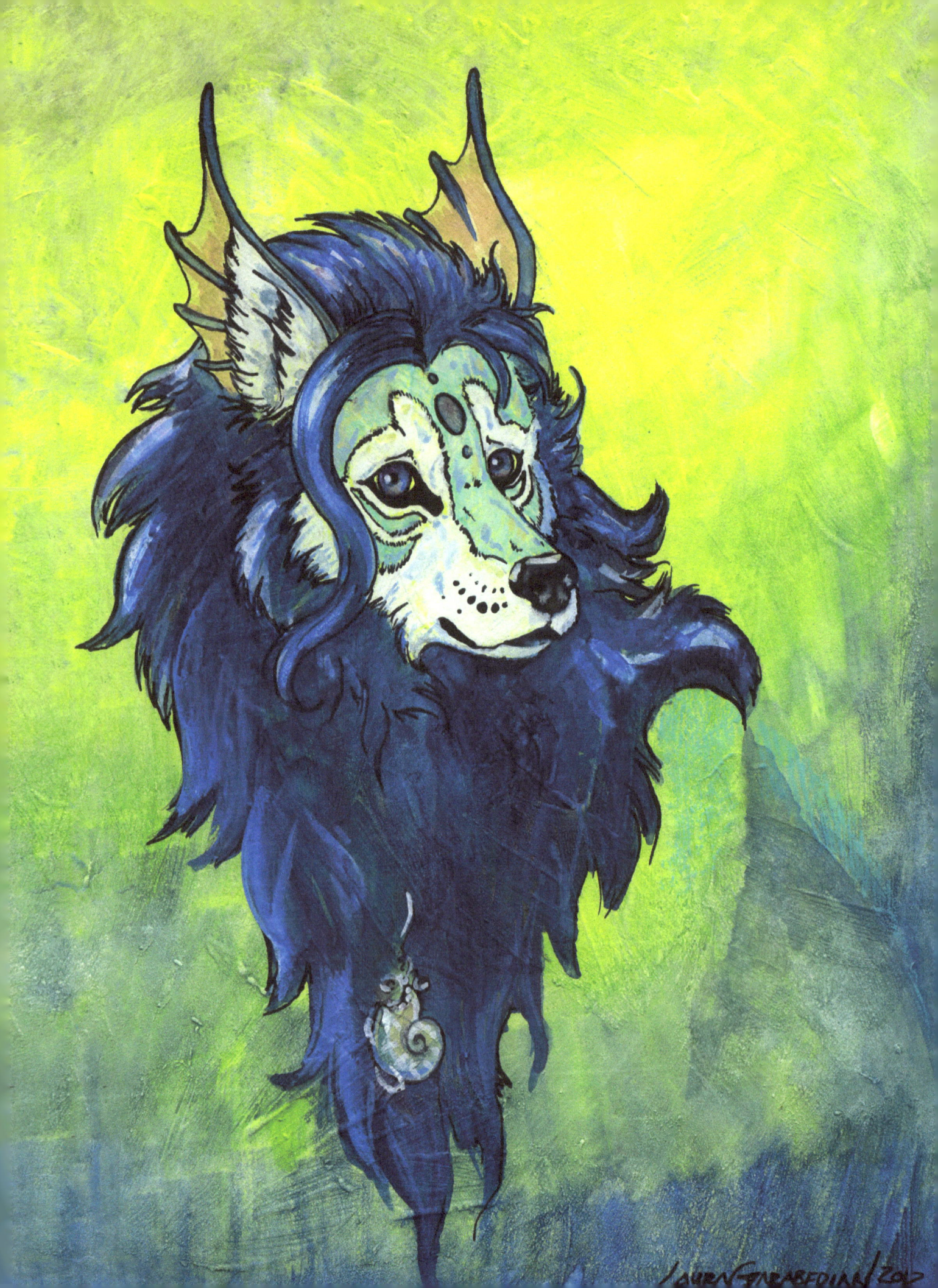

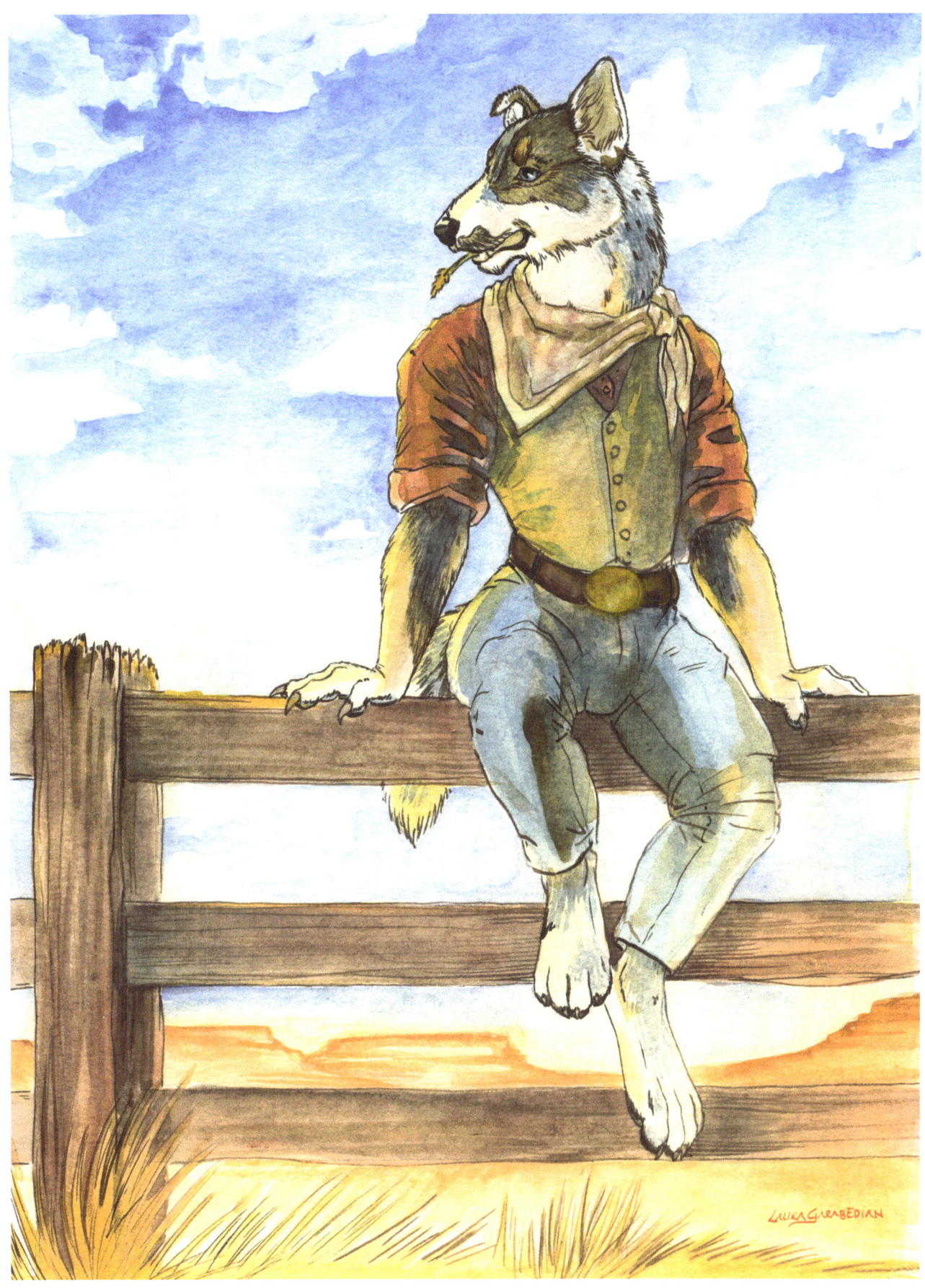

Relaxing on the Range - watercolor - 2013

Vantid Portrait - watercolor/gouache - 2012

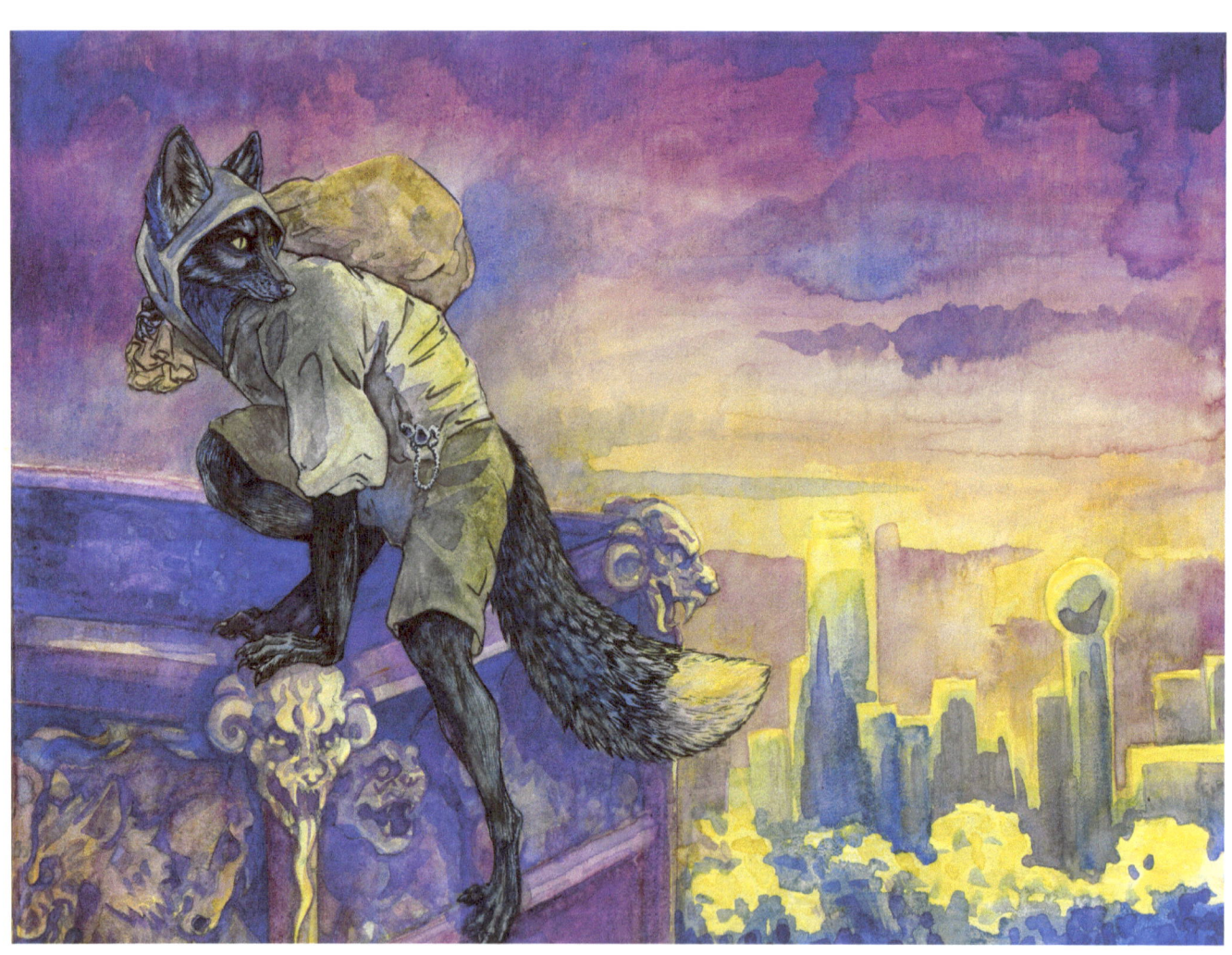

Gone By Sunrise - watercolor - 2013

Red Tail Over the Mountains - watercolor - 2011

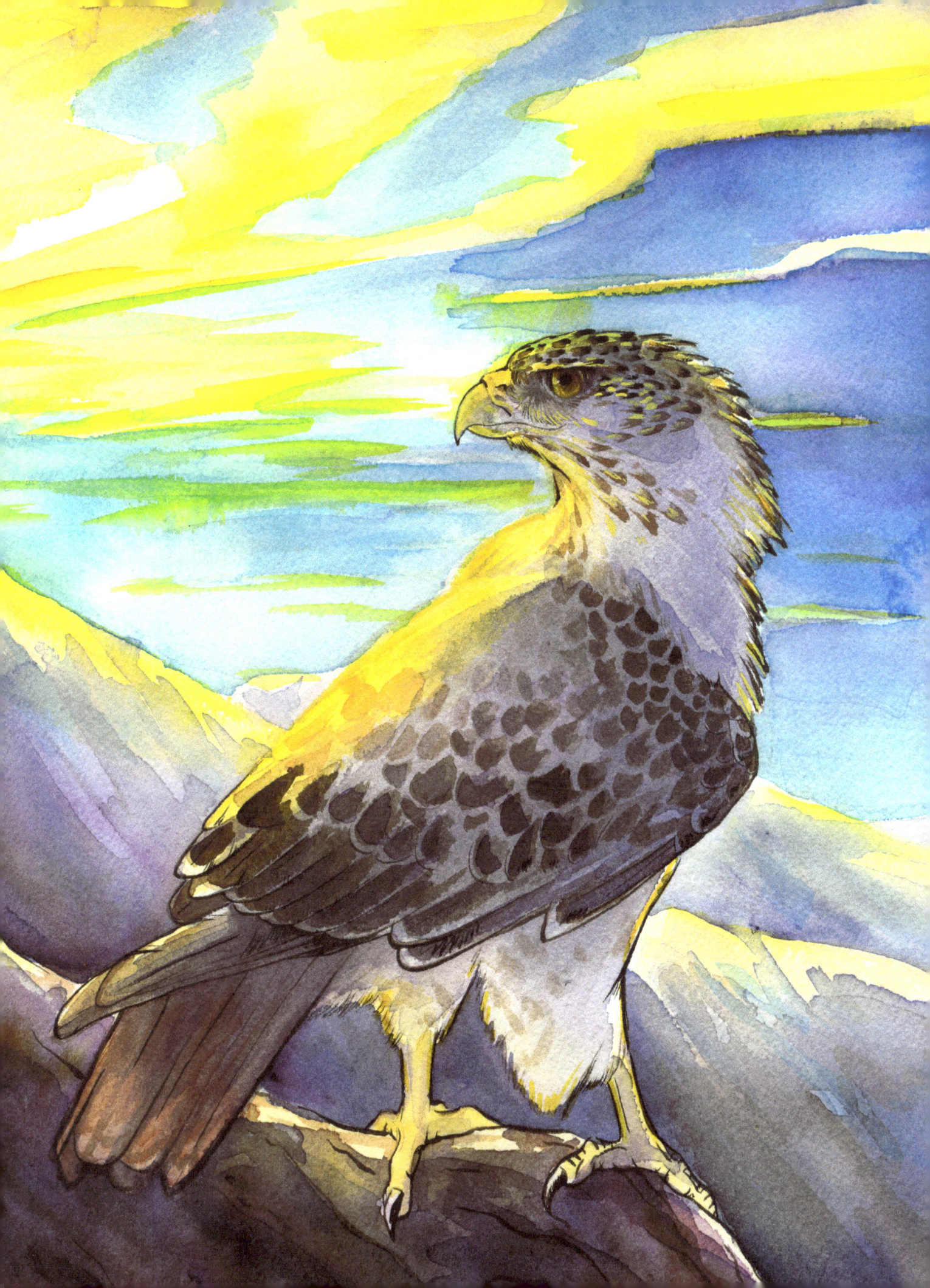

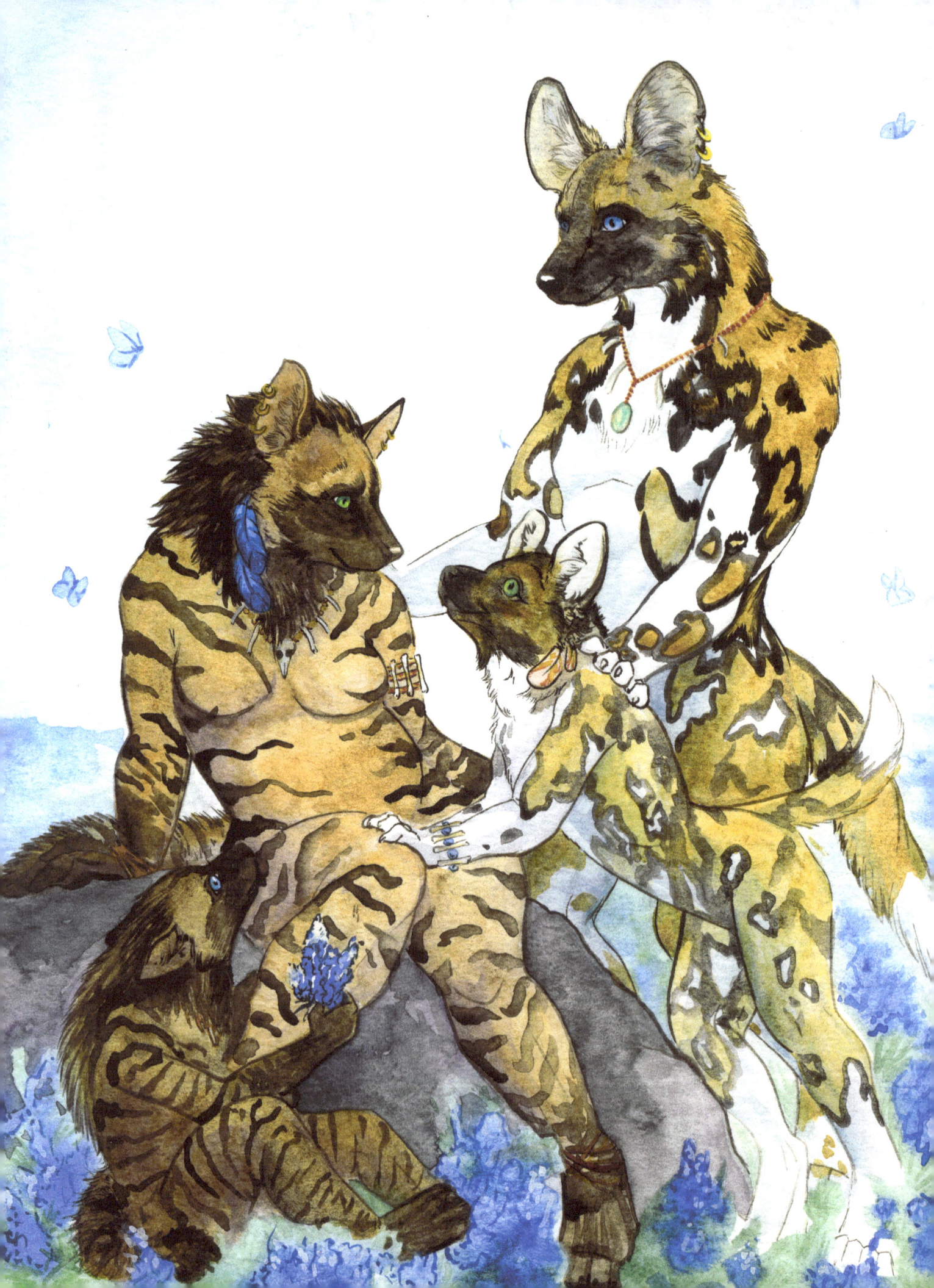

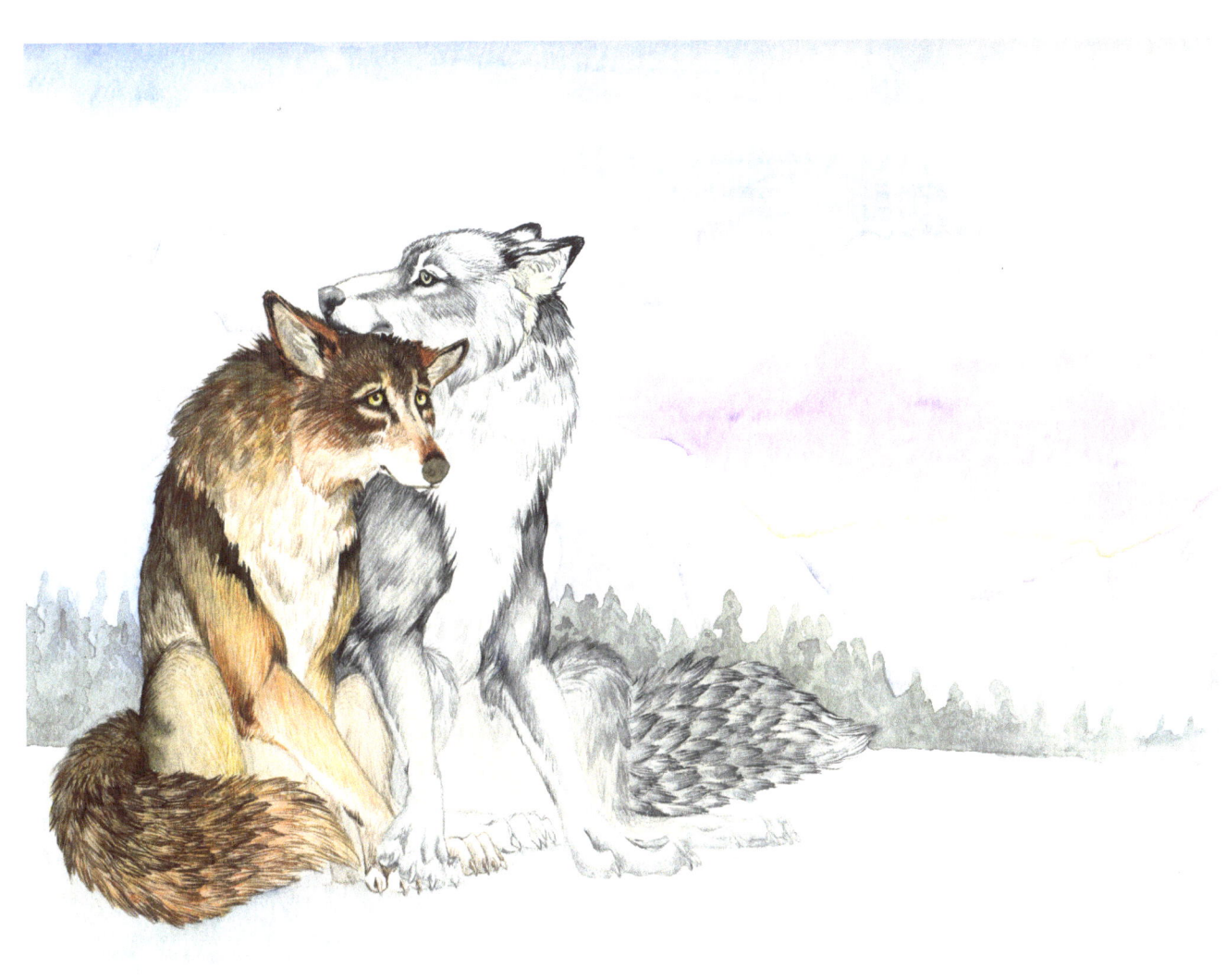

Arctic Weres - watercolor - 2010

Family Outing - watercolor/gouache - 2012

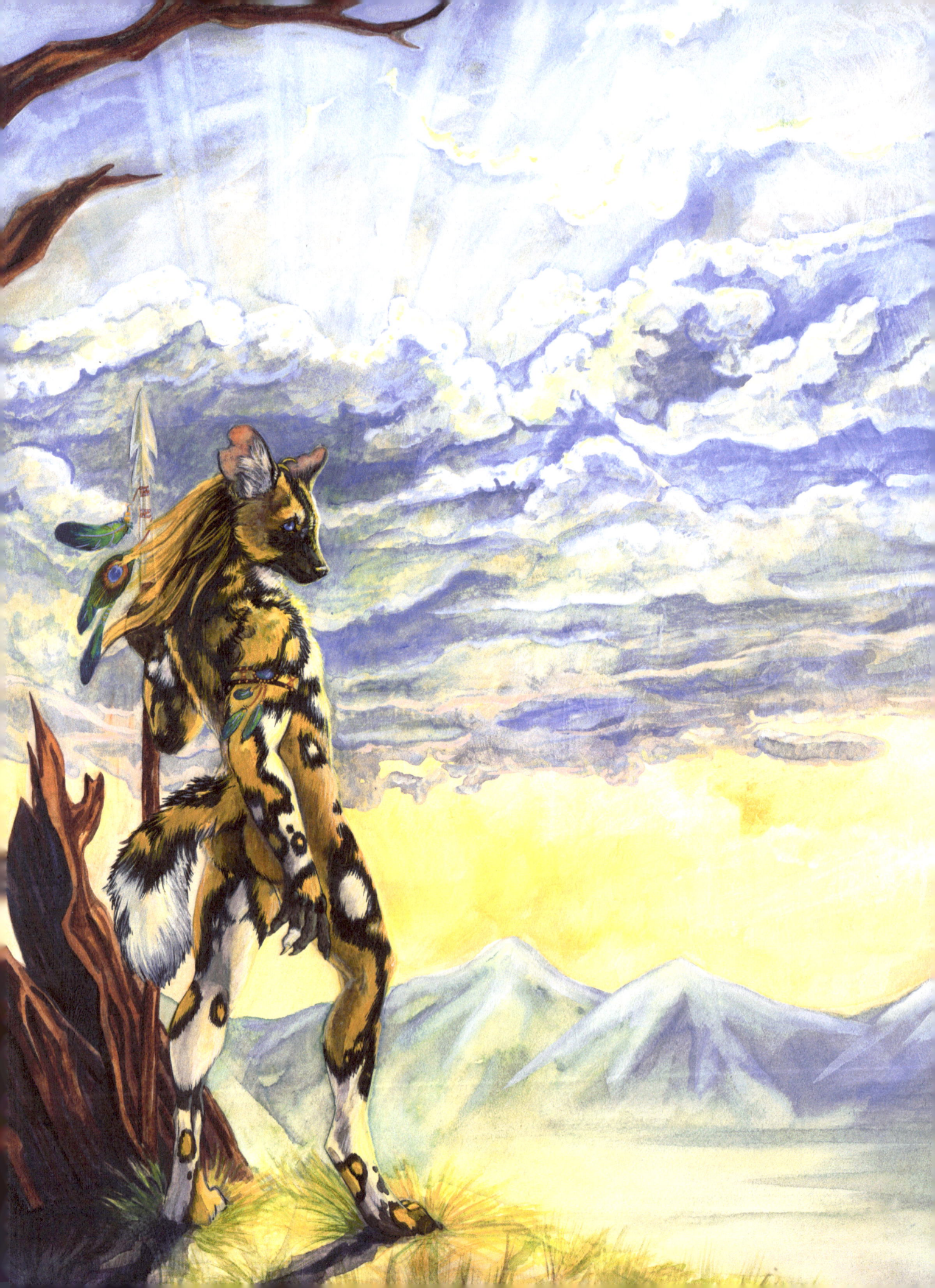

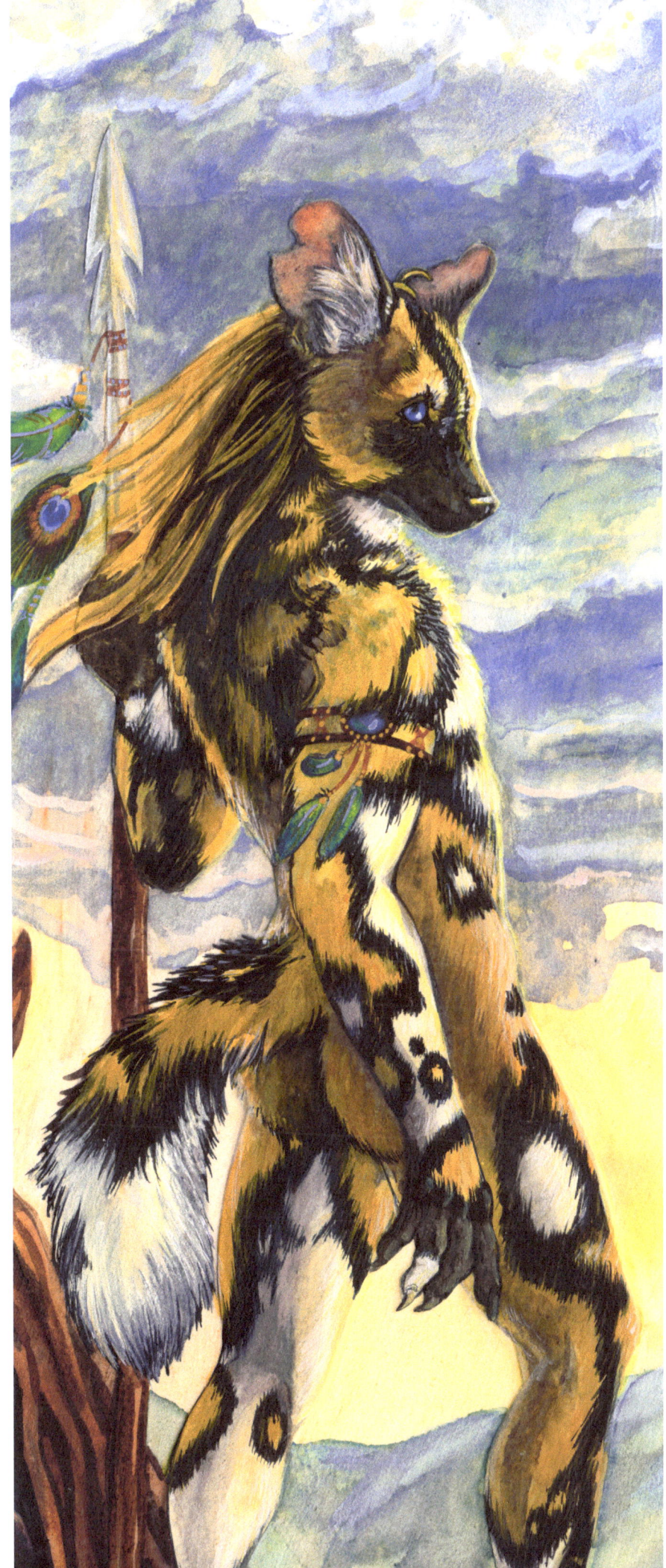

Evening Watch - watercolor/gouache - 2013

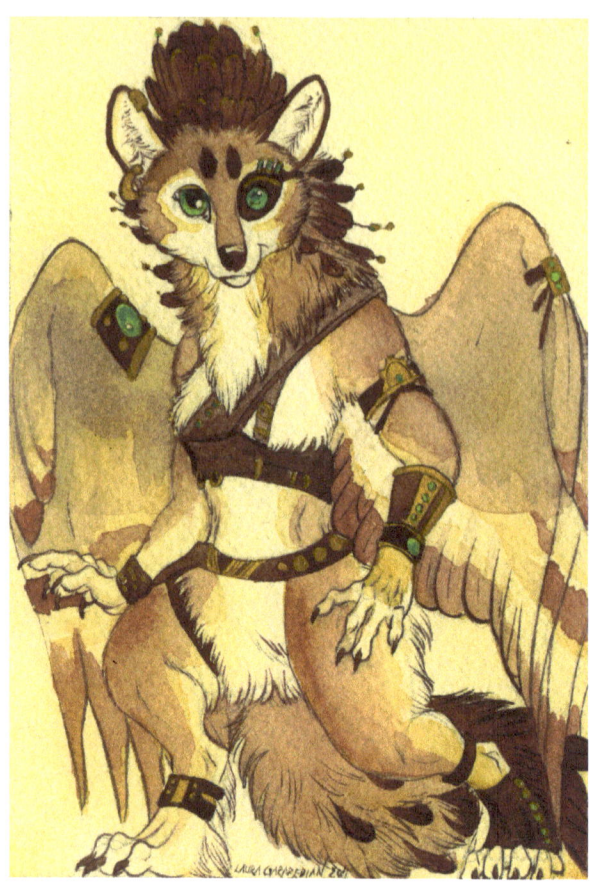
Steampunk Nym - watercolor/ink - 2011

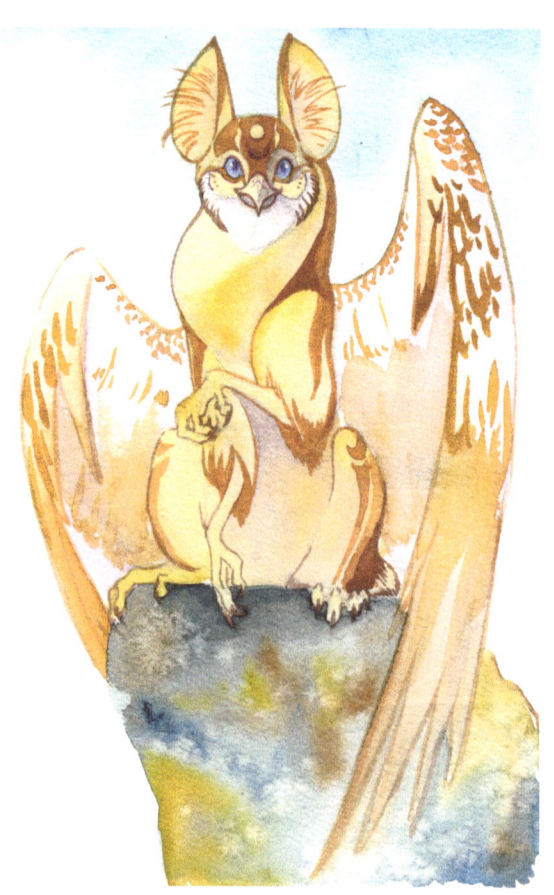
Chee - watercolor - 2013

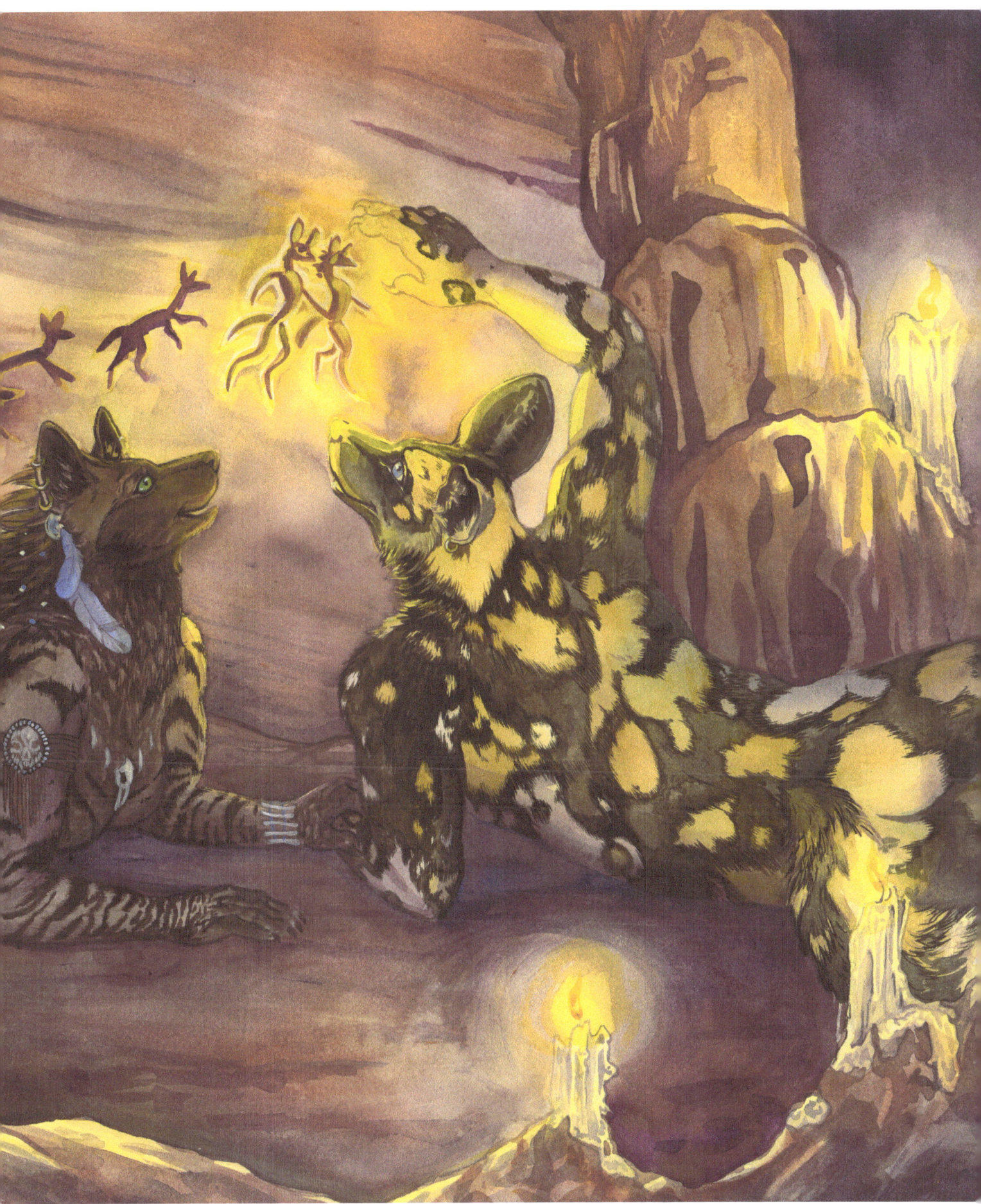

Origins - watercolor/gouache - 2012

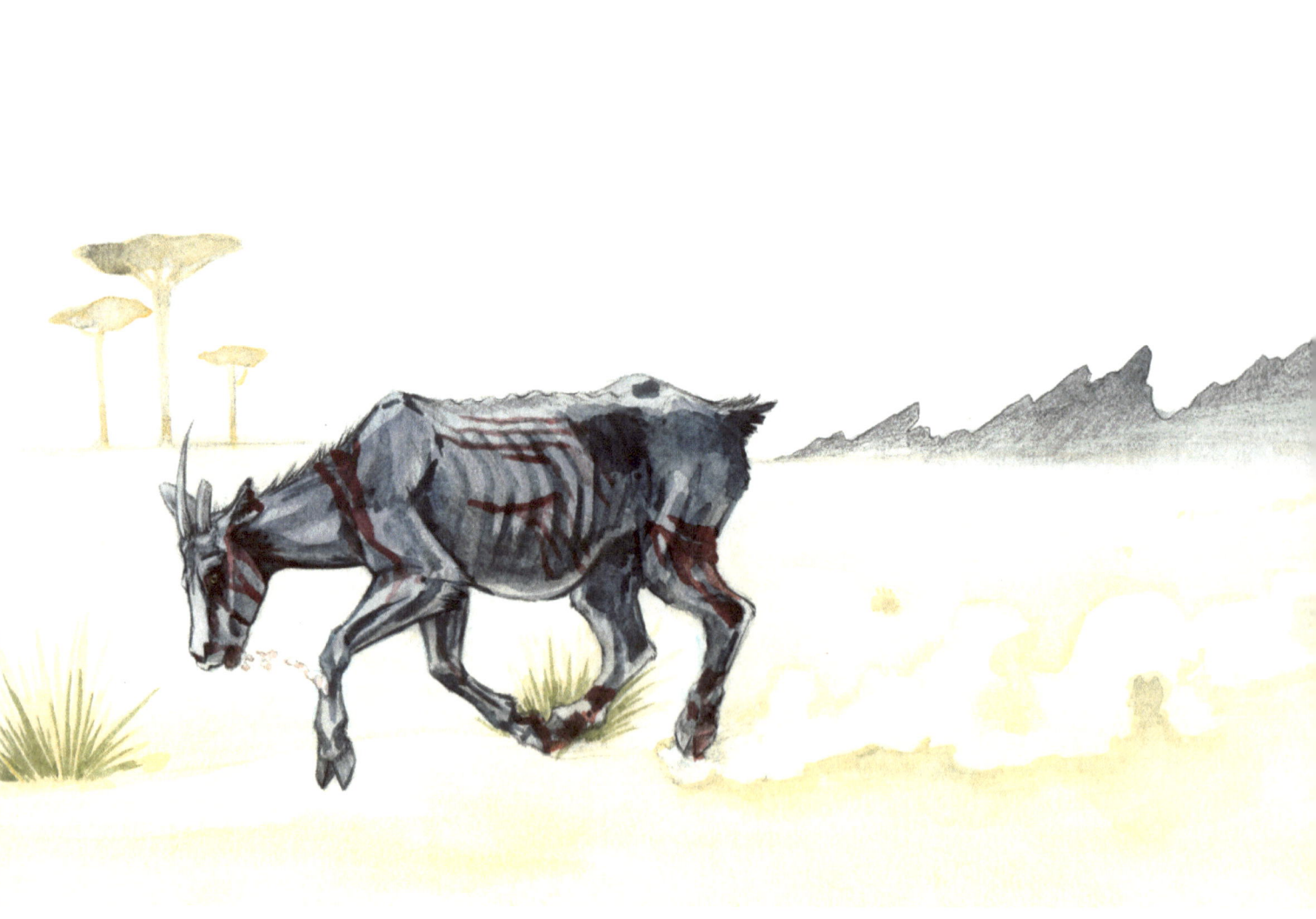

The Escape - watercolor/pencil - 2013

Grey Ghost - watercolor/pencil - 2013

Steampunk Lion - watercolor - 2011

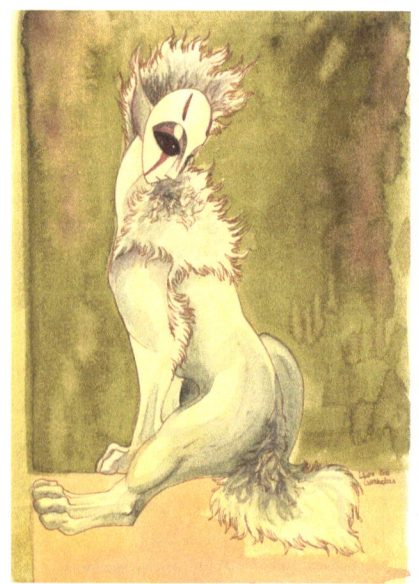

Melancholy Sphinx
watercolor/ink - 2011

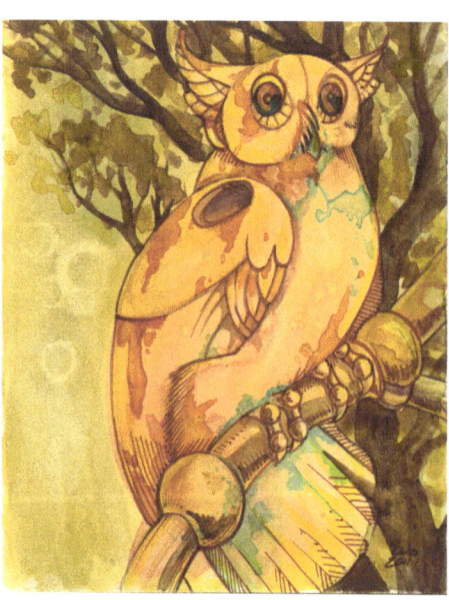

Steampunk Owl
watercolor/ink - 2011

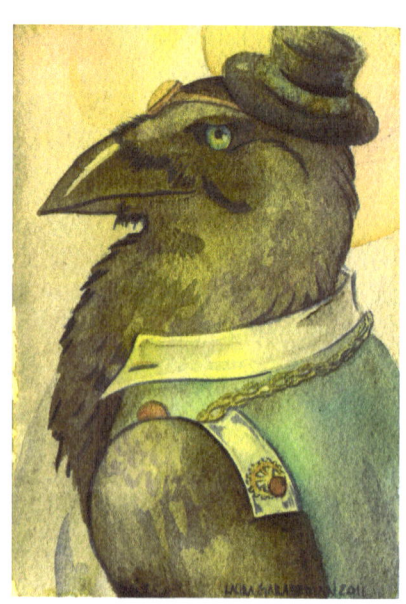

Dapper Crow
watercolor/ink - 2011

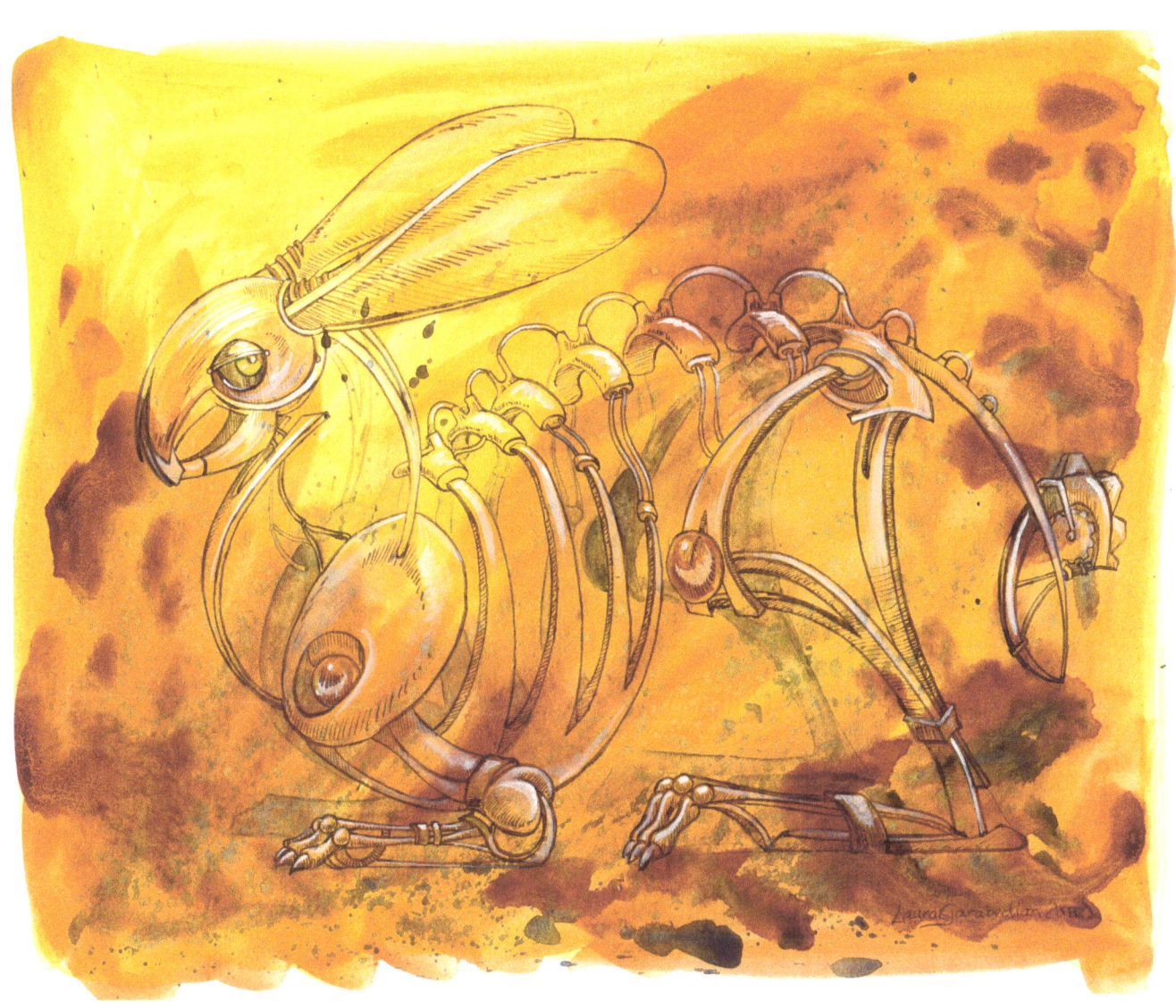

Steampunk Rabbit – watercolor/ink – 2011

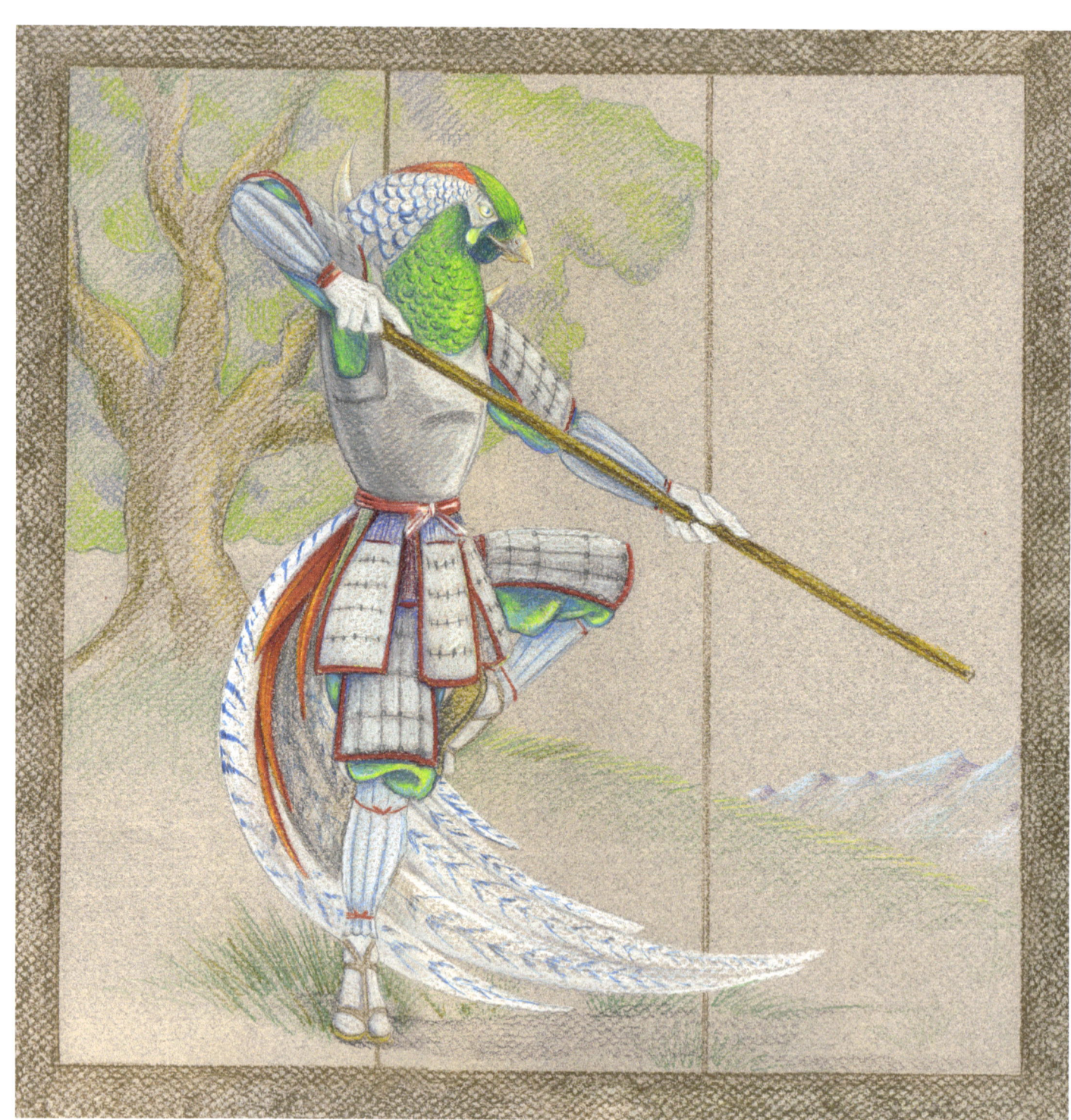

The Teacher - prismacolor - 2011

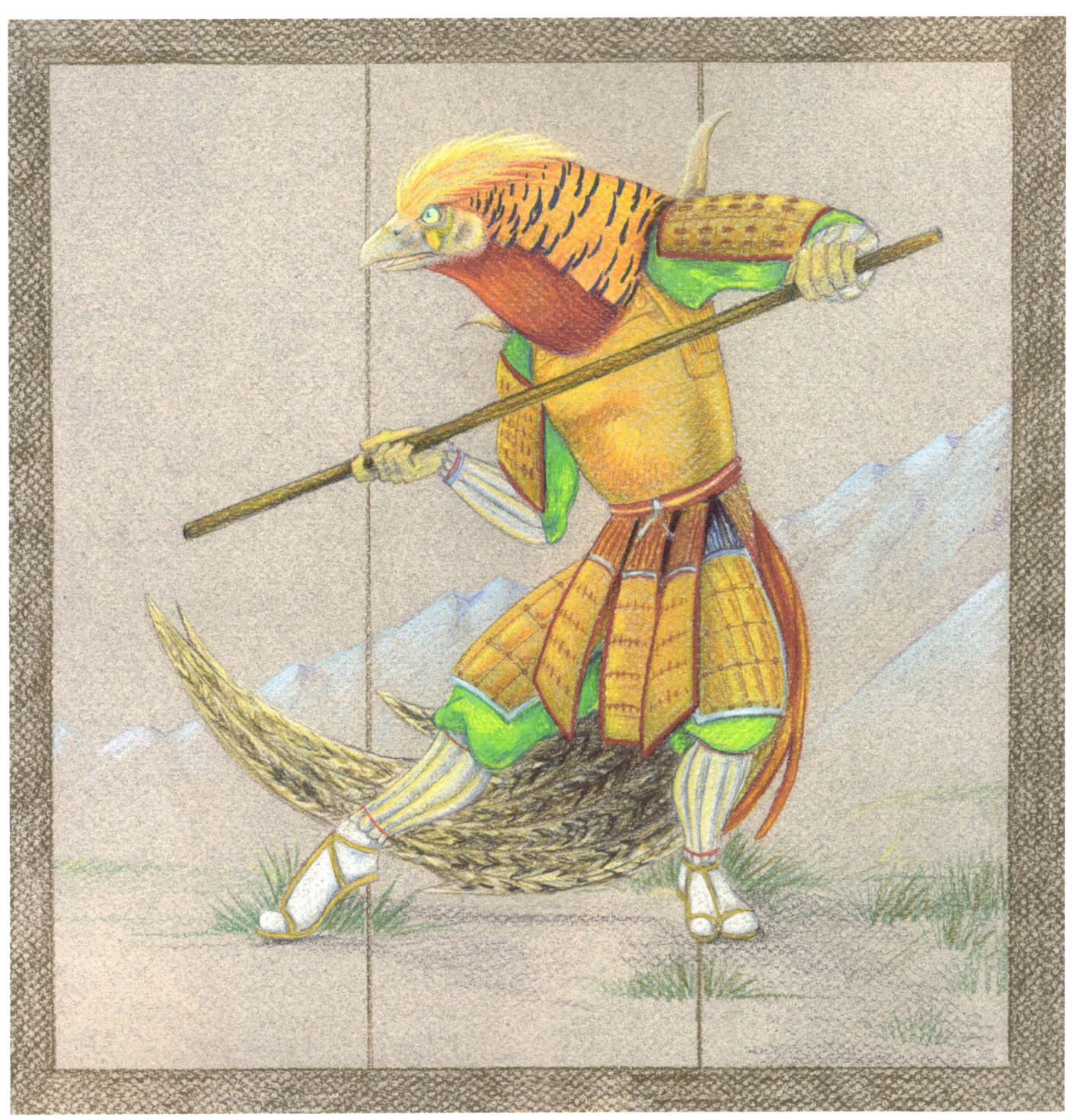

The Student - prismacolor - 2011

Tribal Life

Music sings in a simple line. Carved out indelibly in ink, a form warps the space around it, just so. To bring the essence of a being out through the fewest brush strokes possible—simple shapes, clean lines. In that juxtaposition lies a strange magic that cultures throughout the world have embraced.

Tribal art has always fascinated me, from Mayan to Northwestern Native American, Aboriginal to Celt. The rhythm of tribal style art and its striking appeal is undeniable. While I certainly draw from many cultures and let them influence my work, as time goes on I am settling into a style that is sharply myself; slightly more intricate and often with abstract washes as a contrast to the starkness of black and white.

Tribal Platypus - watercolor/ink - 2011

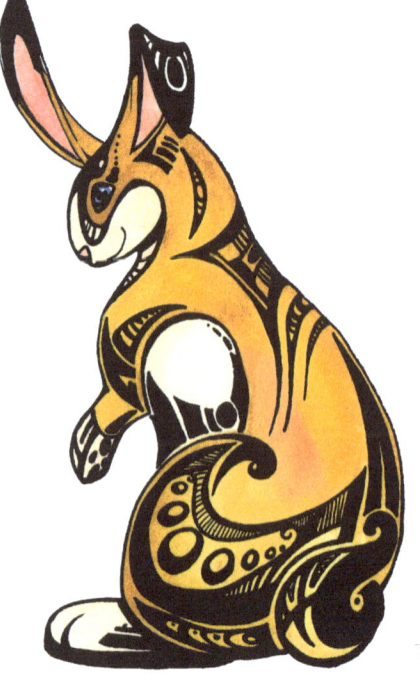

Tribal Bud the Bunny - watercolor/ink - 2012

Tribal Corgi - watercolor/ink - 2012

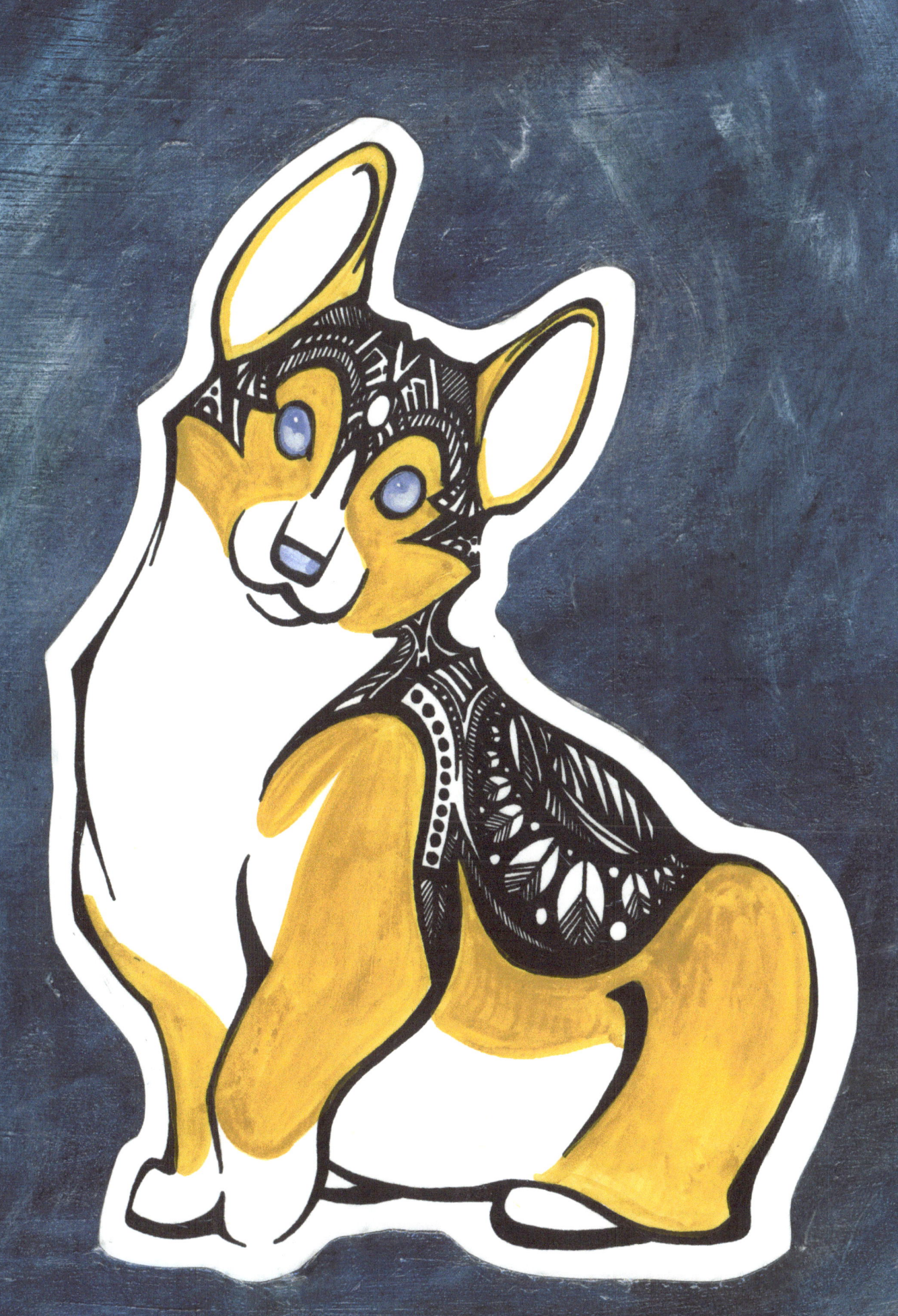

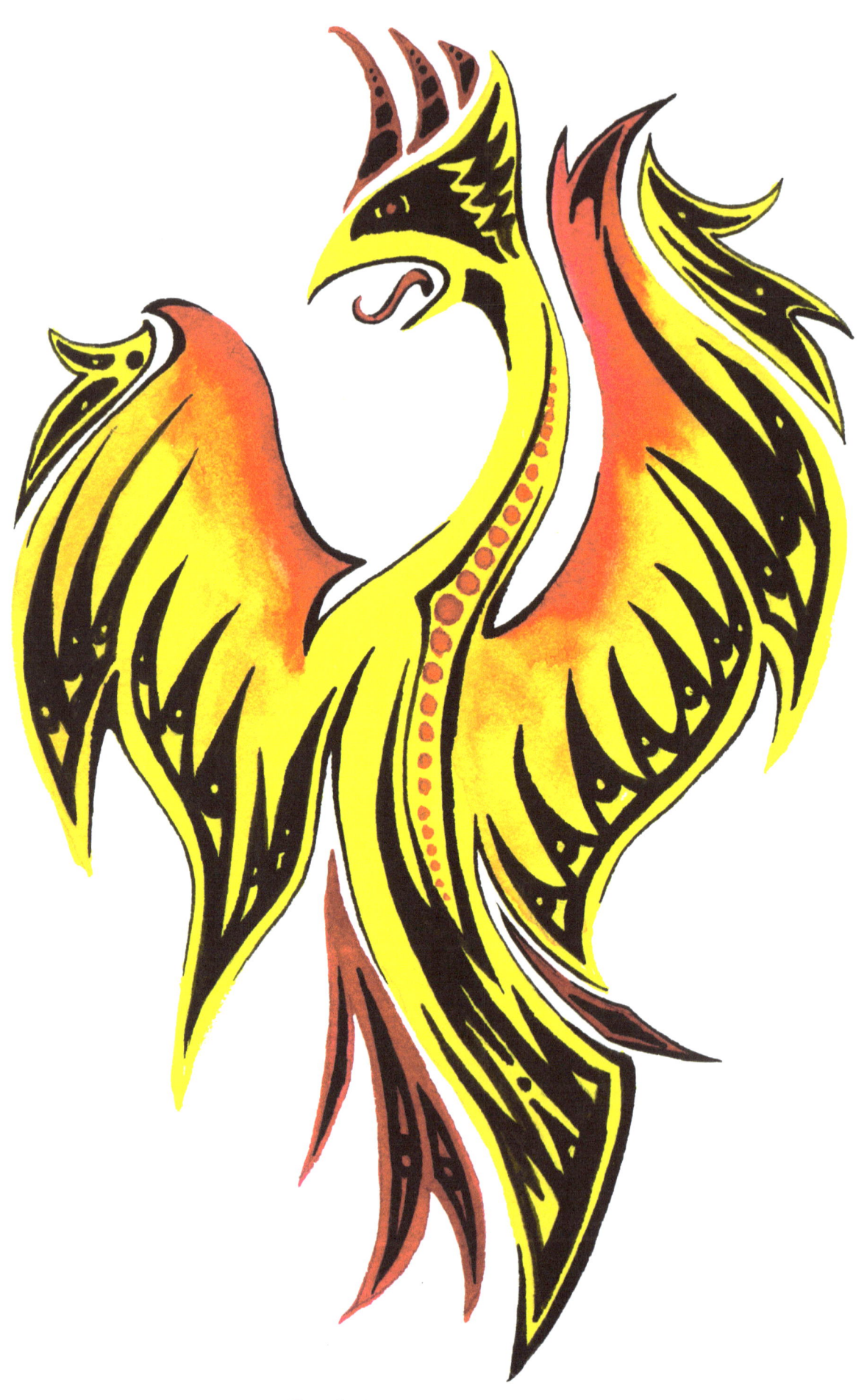
Tribal FireBird - watercolor/ink - 2011

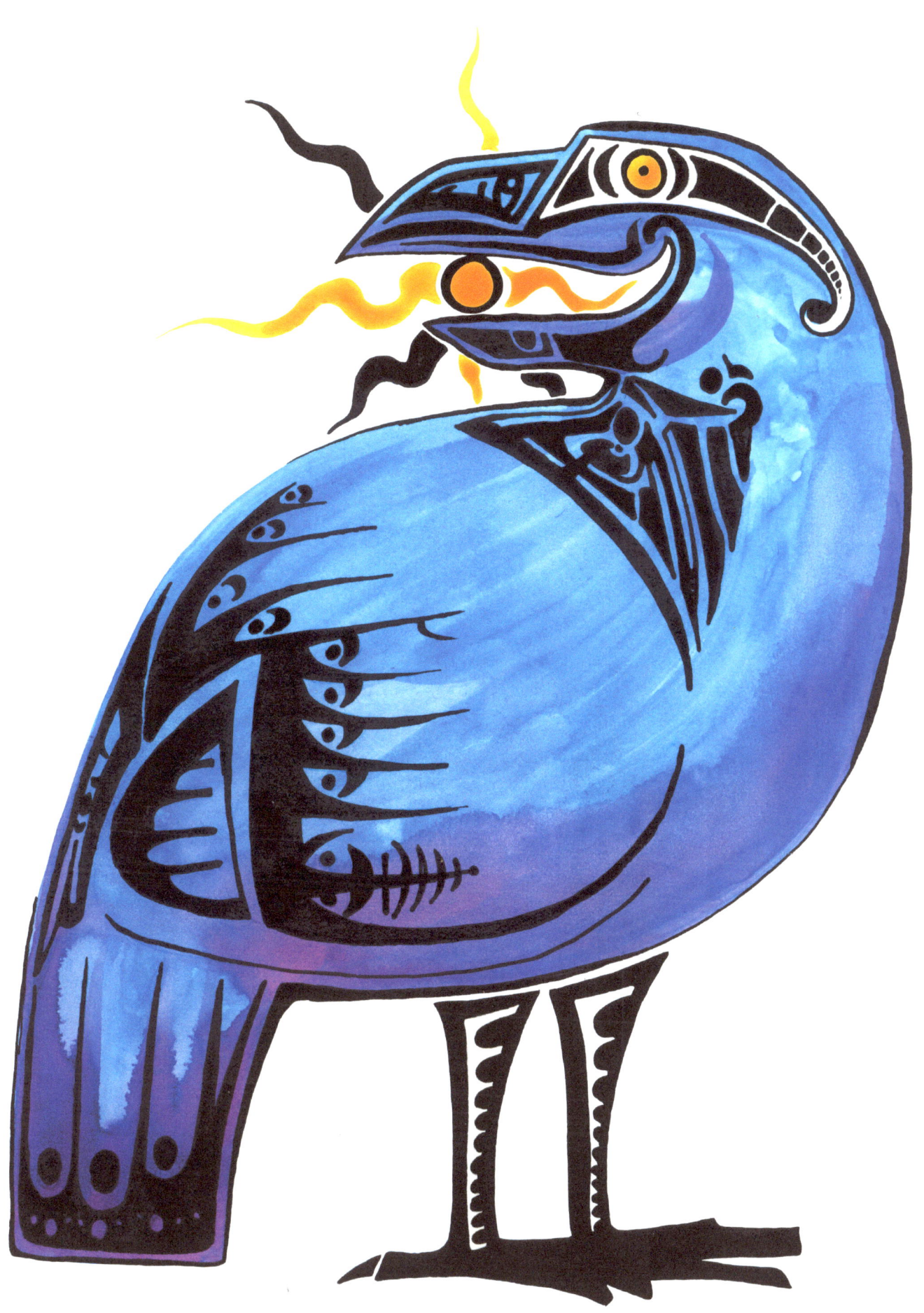

Tribal Raven Steals the Sun – watercolor/ink – 2012

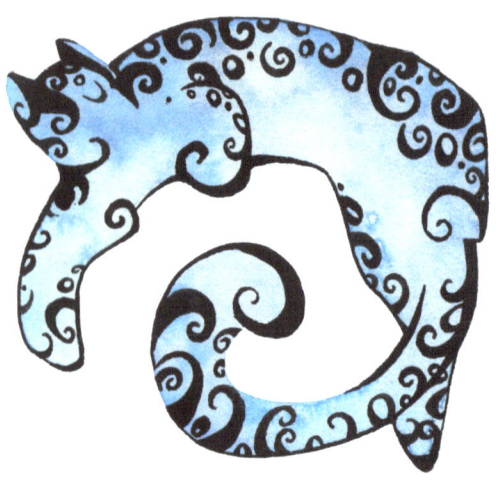

Tribal Snow Leopard
watercolor/ink – 2011

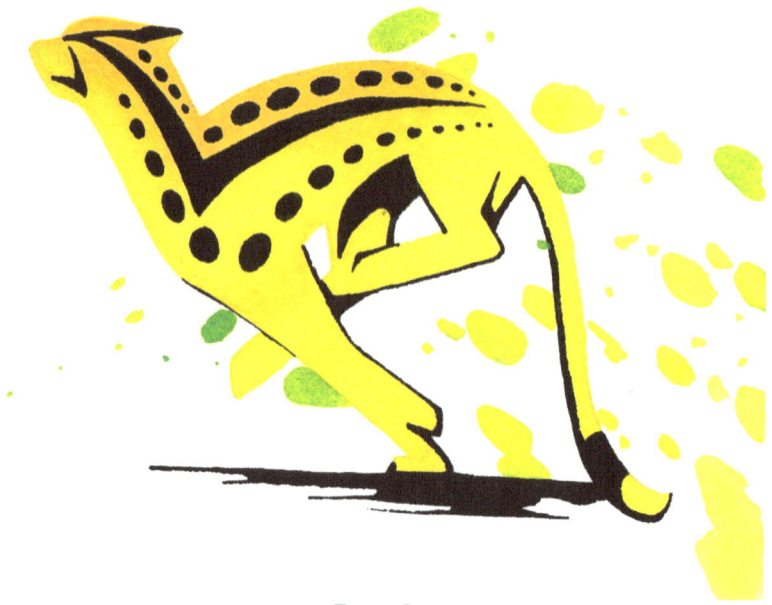

Tribal Cheetah
watercolor/ink – 2011

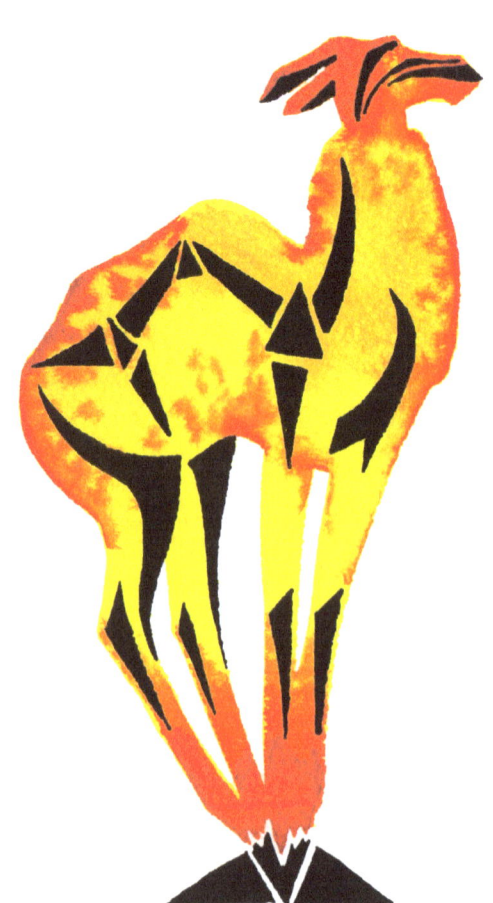

Tribal Llama
watercolor/ink – 2011

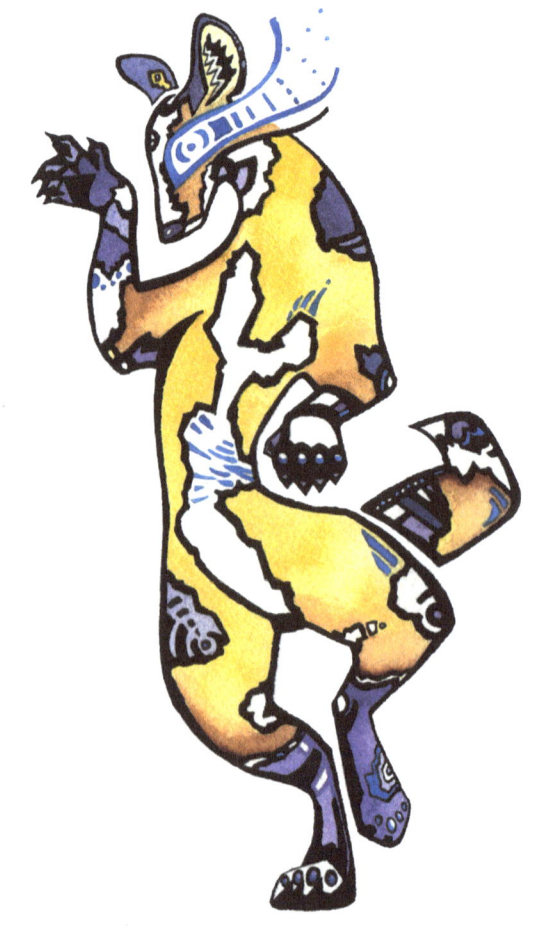

Tribal African Wild Dog
watercolor/ink – 2012

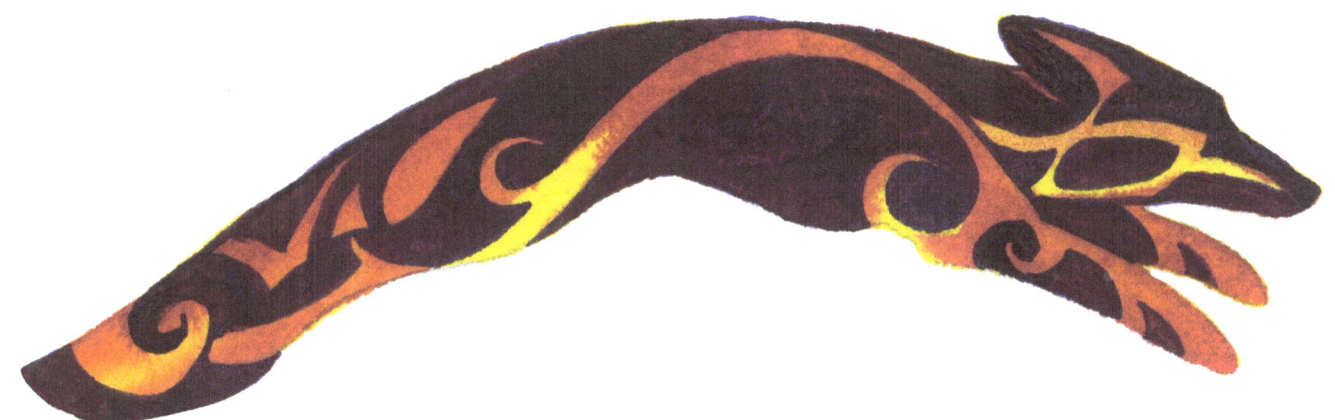

Tribal Fox Running - watercolor - 2011

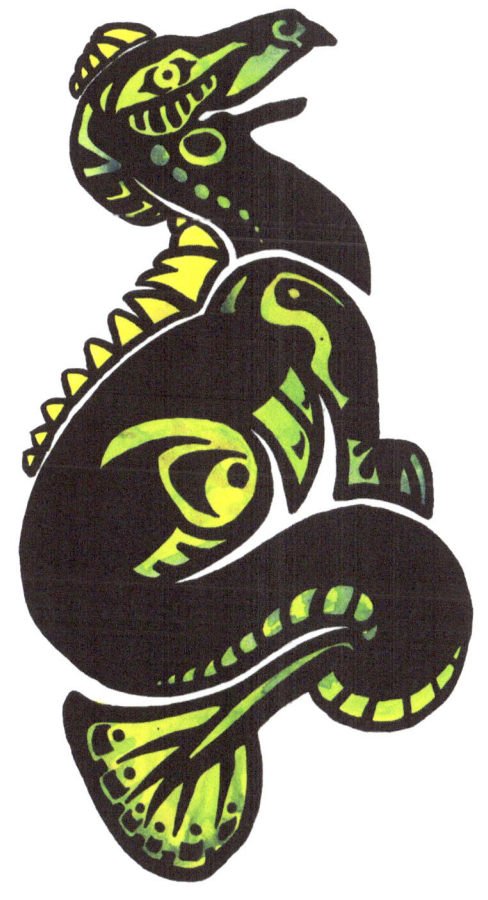

Tribal Dragon
watercolor/ink - 2011

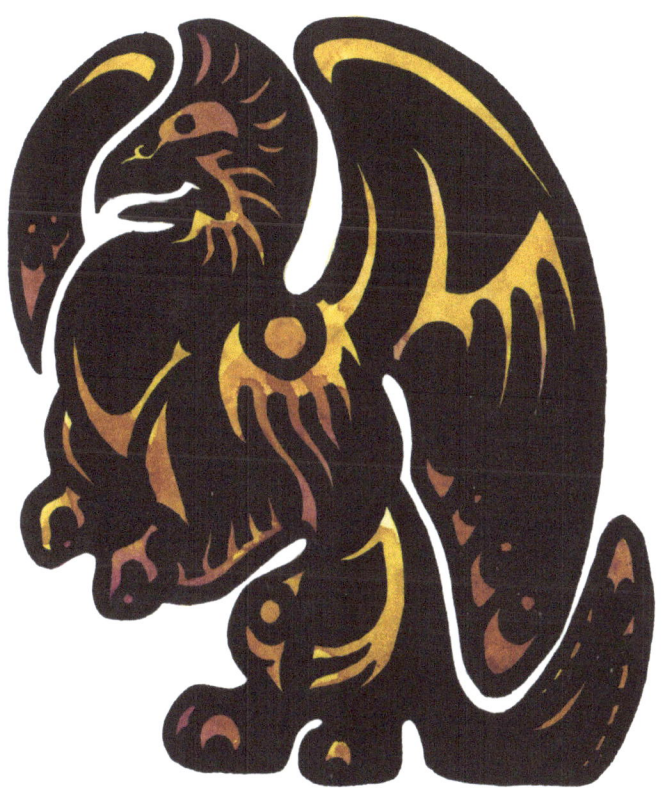

Tribal Gold Gryphon
watercolor/ink - 2011

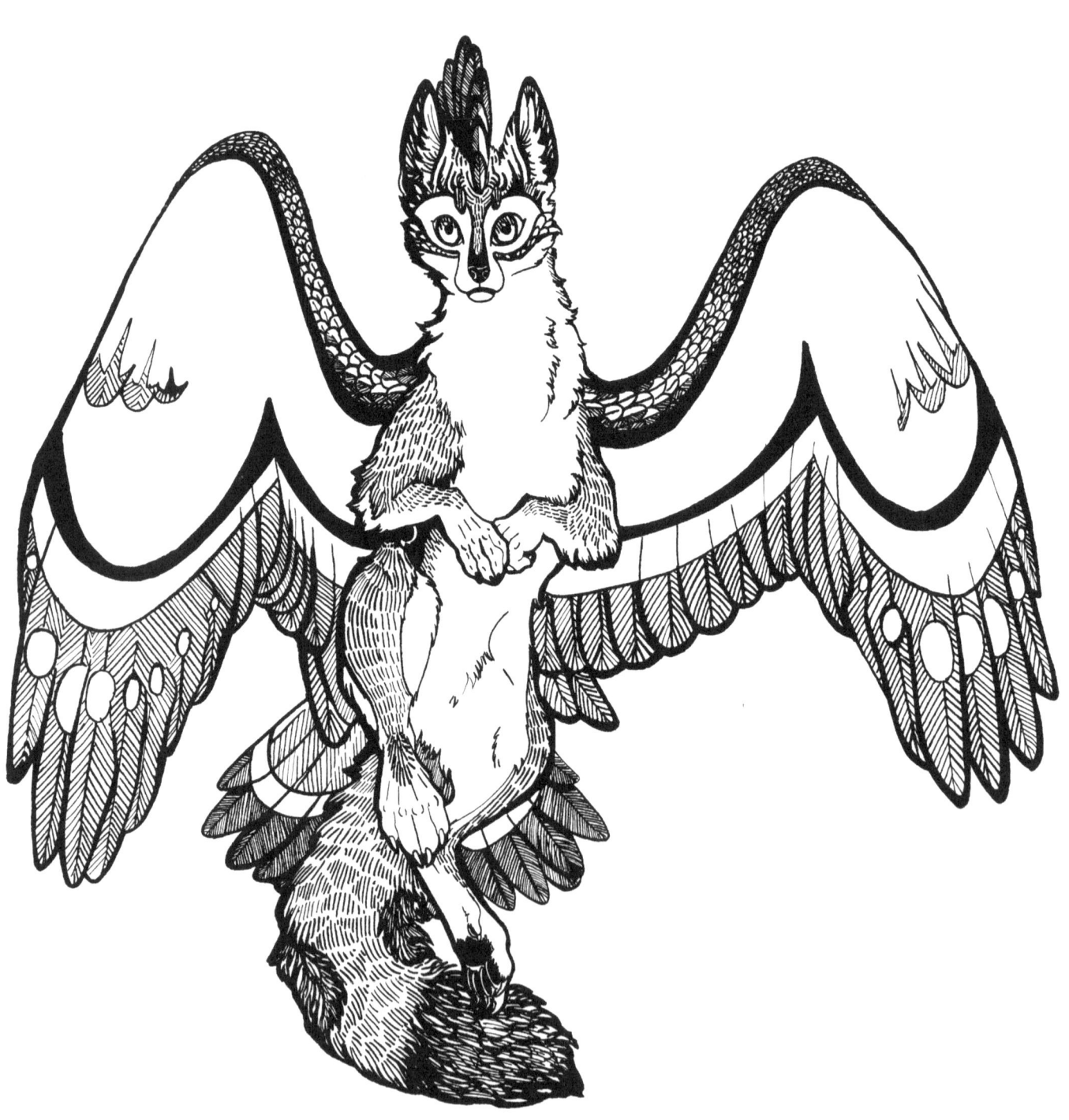

Tribal Nym – ink – 2012

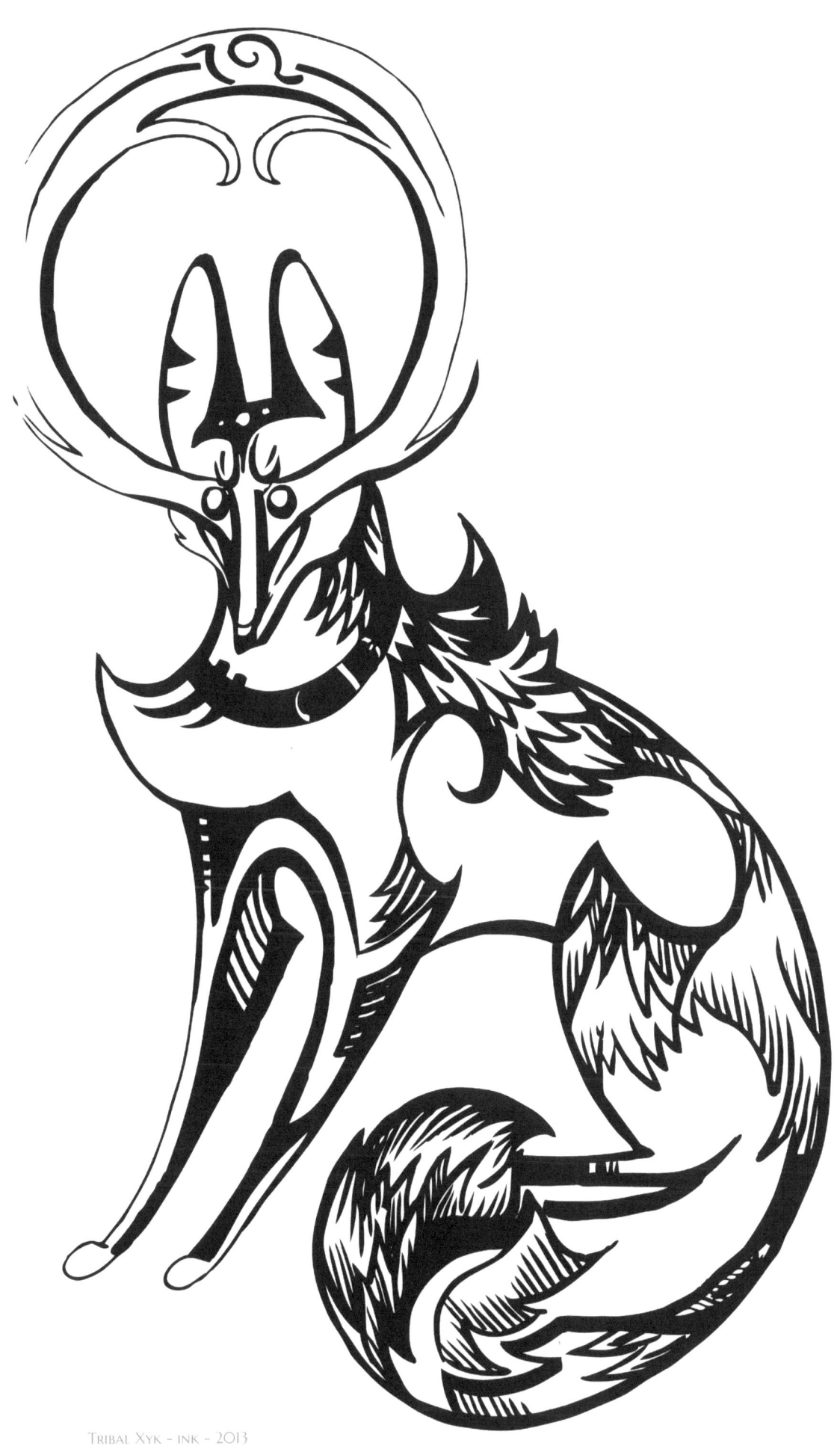

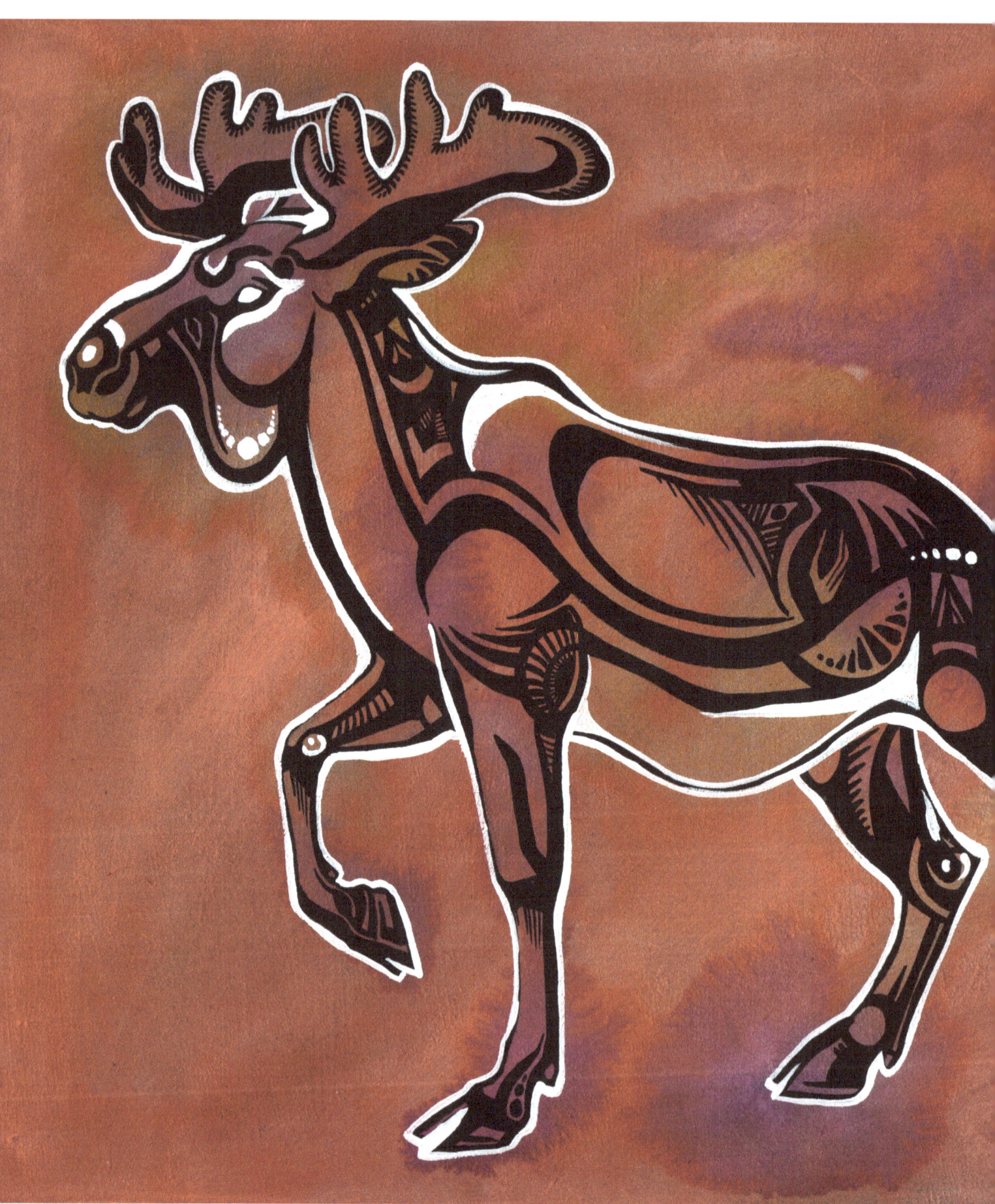

Tribal Moose Sunset - watercolor/ink/acrylic - 2013

Tribal Puffin - watercolor/ink/acrylic - 2011

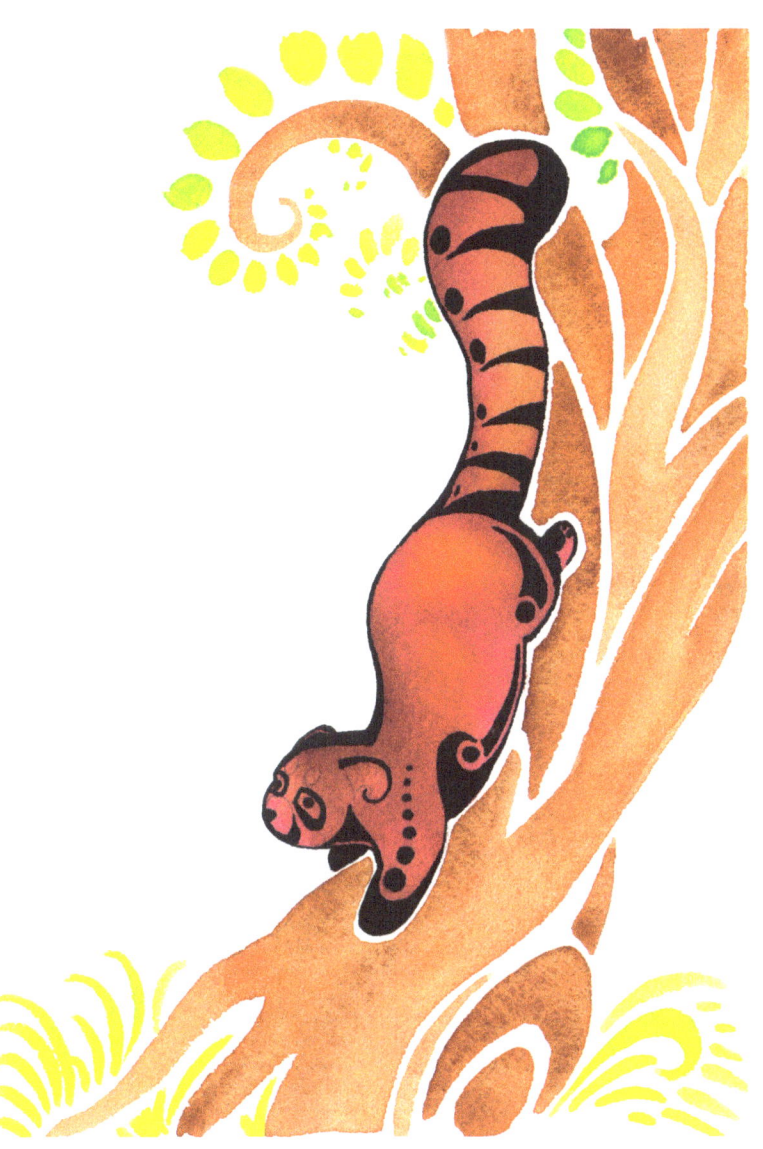

Storybook Red Panda - watercolor/ink/acrylic - 2011

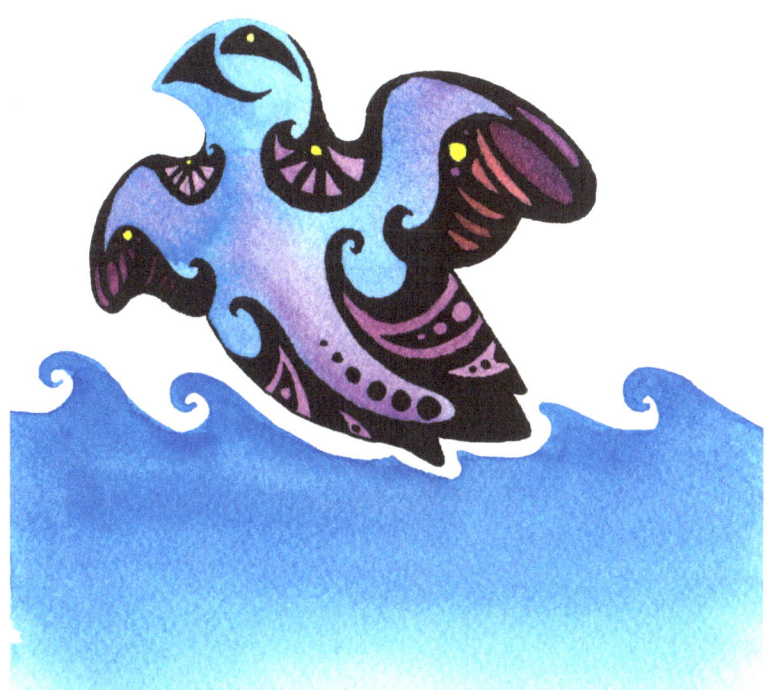

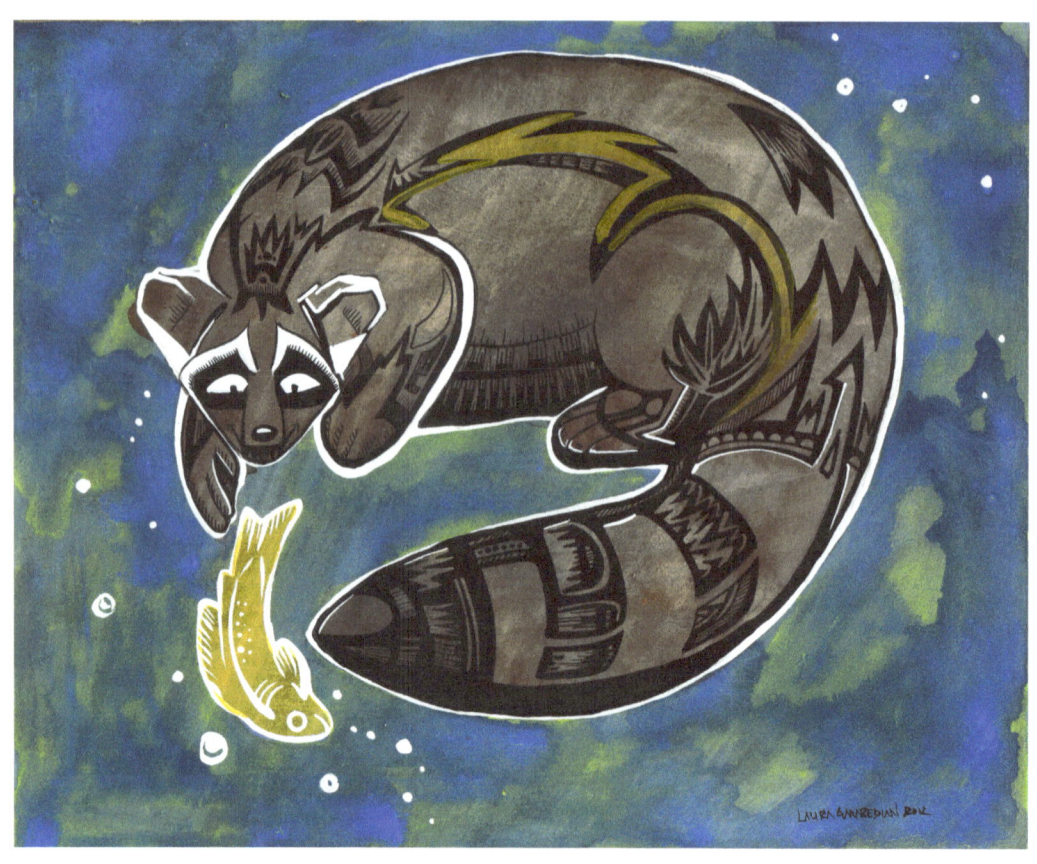

Tribal Raccoon "The Fisher" - watercolor/ink/acrylic - 2012

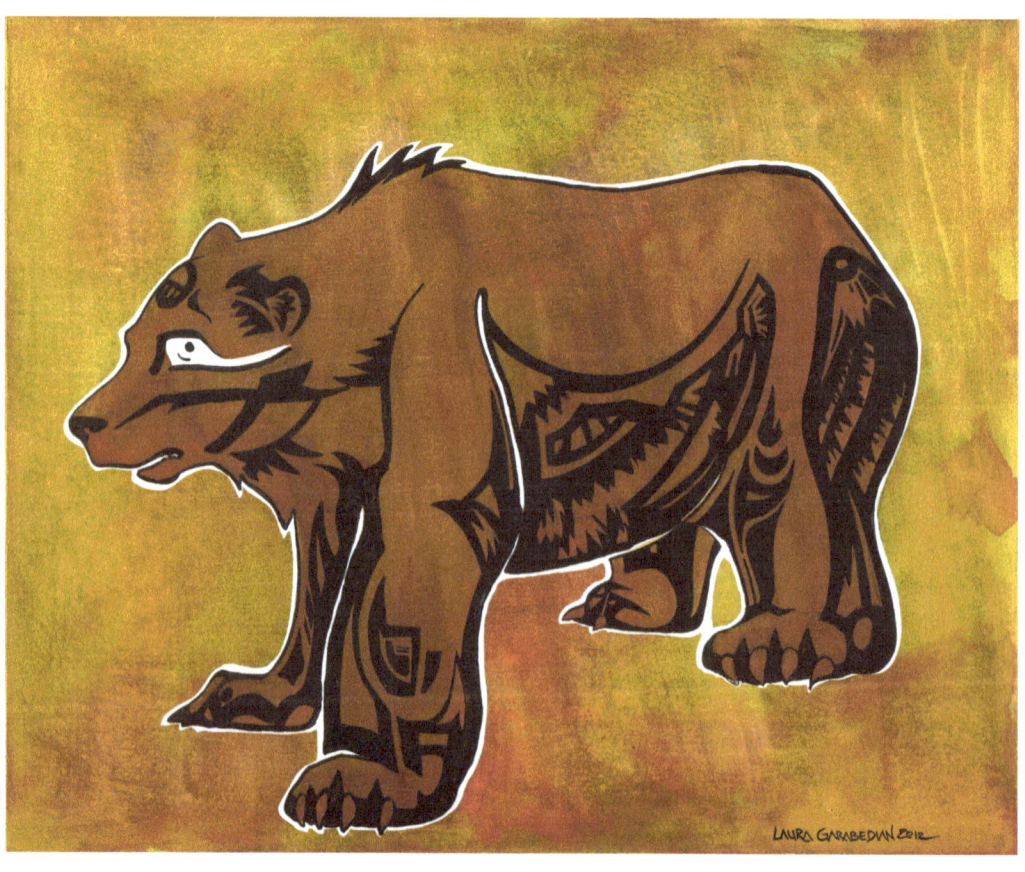

Derp Bear - watercolor/ink/acrylic - 2012

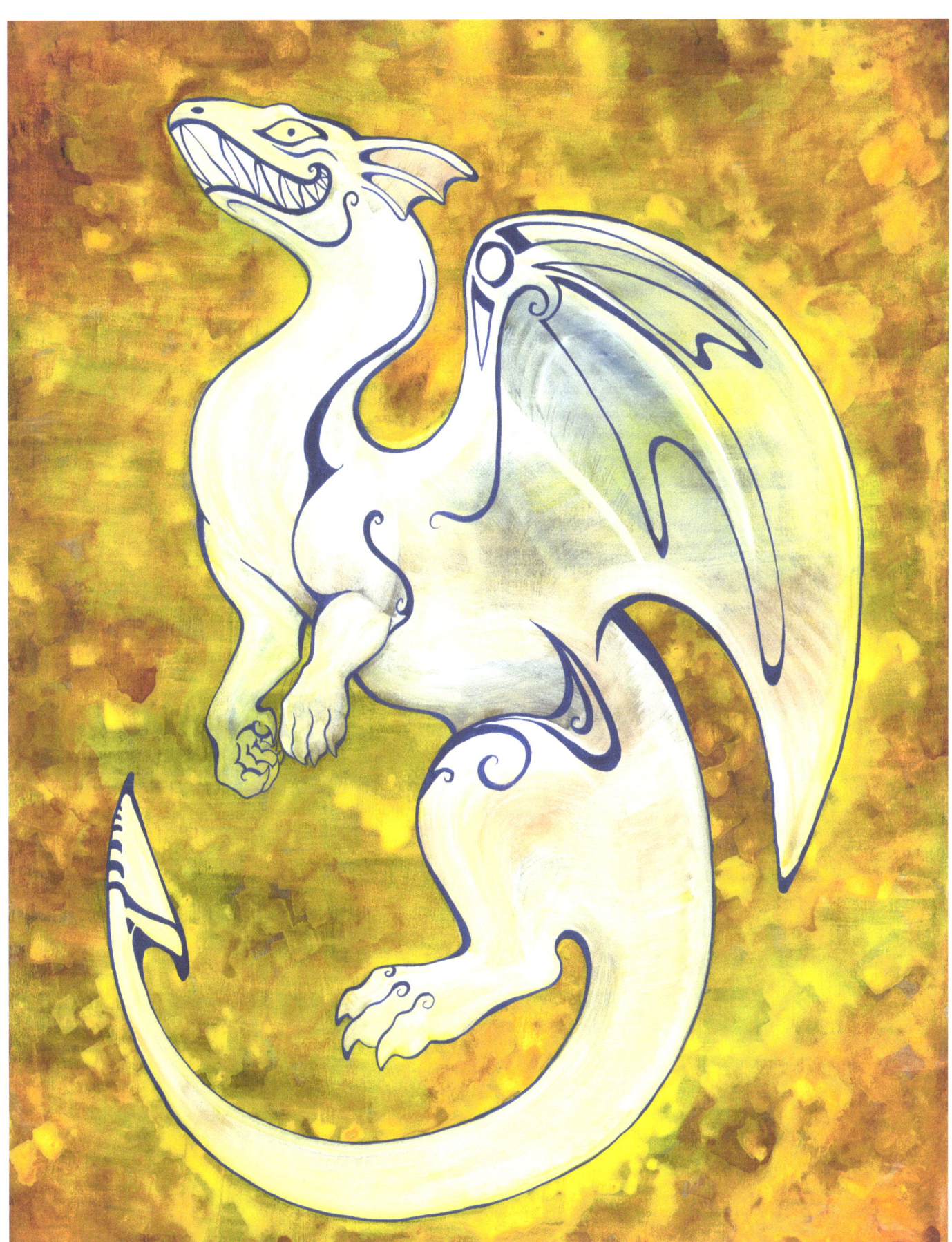
The LuckBearer – watercolor/ink/gouache/acrylic – 2012

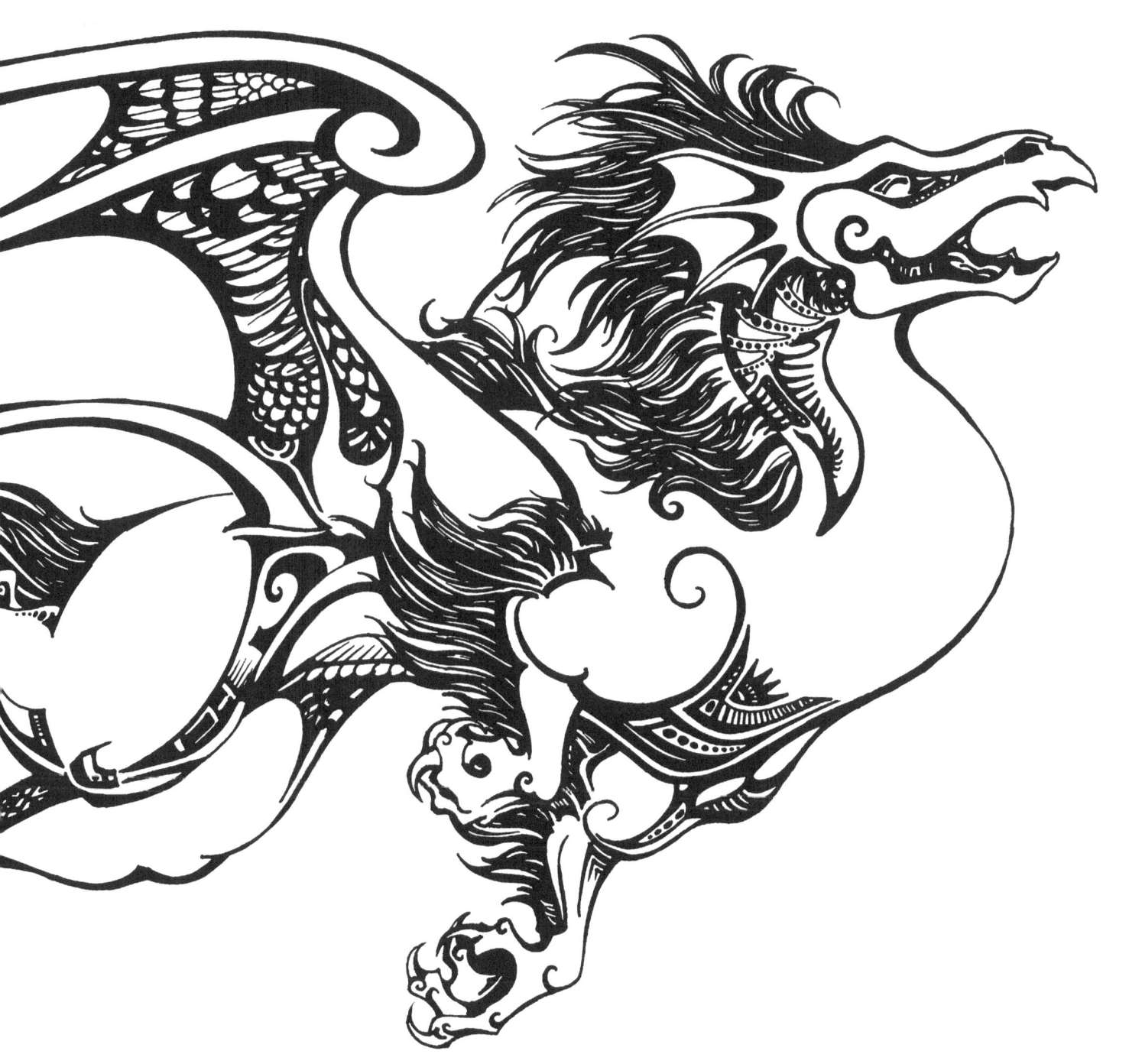

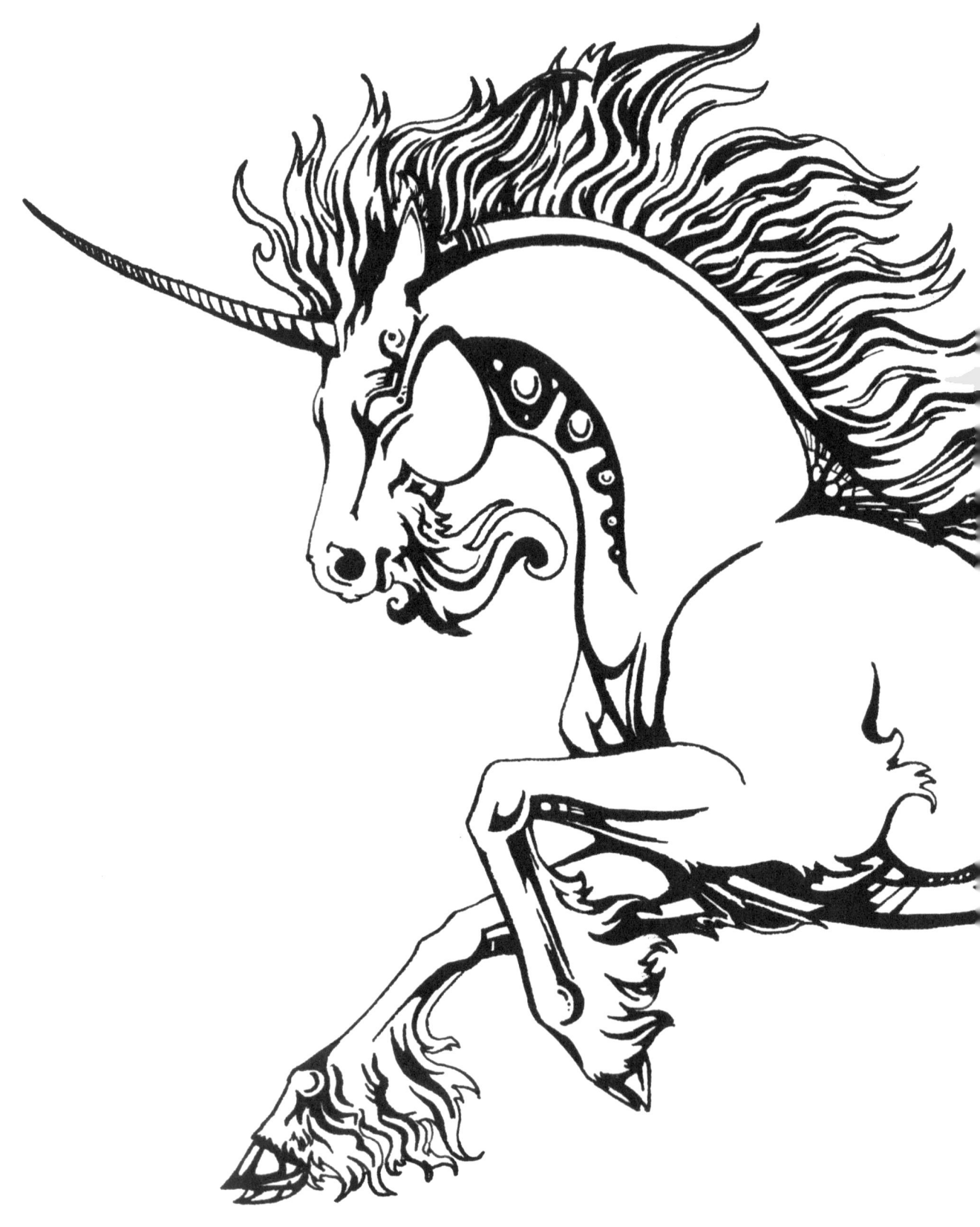

Tribal Unicorn - ink - 2012

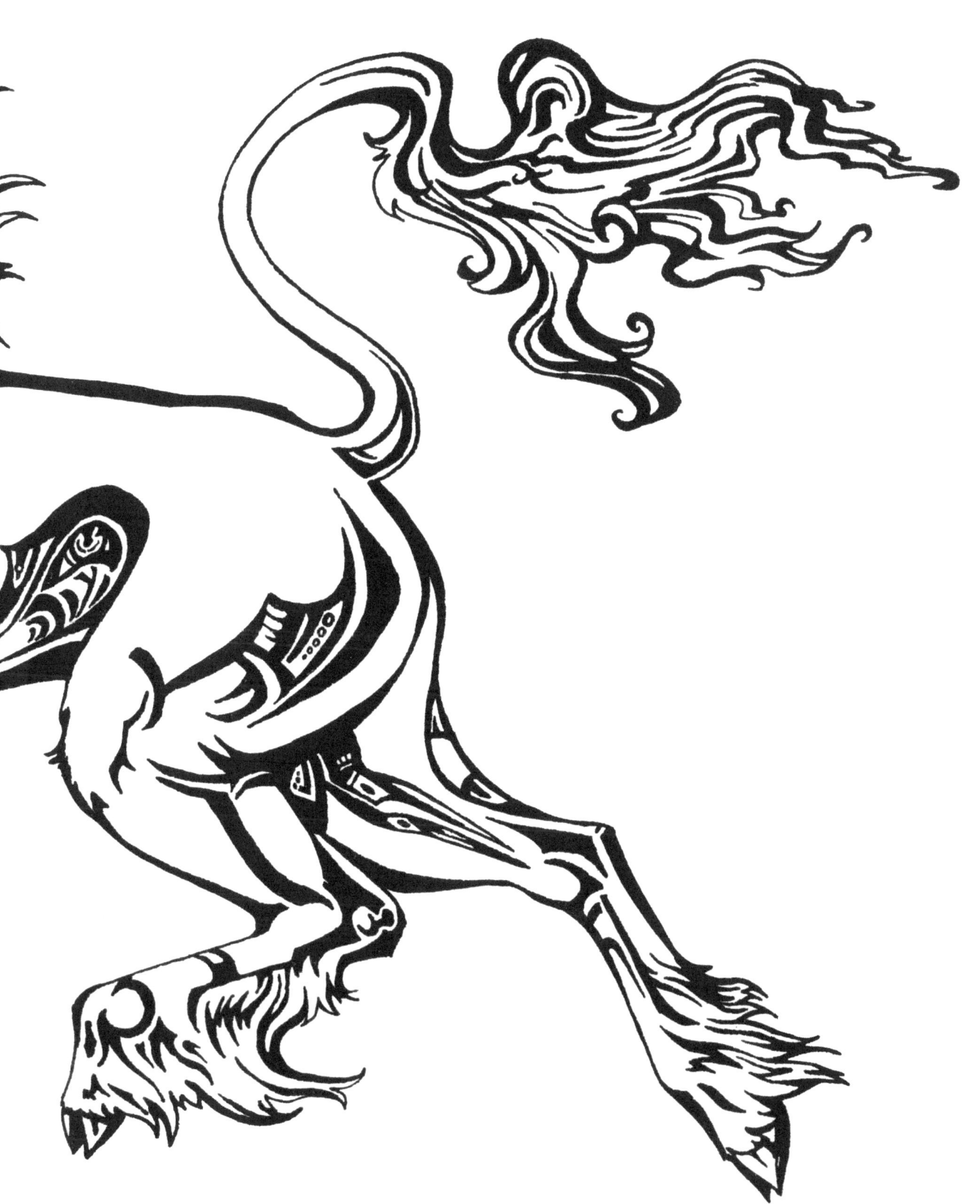

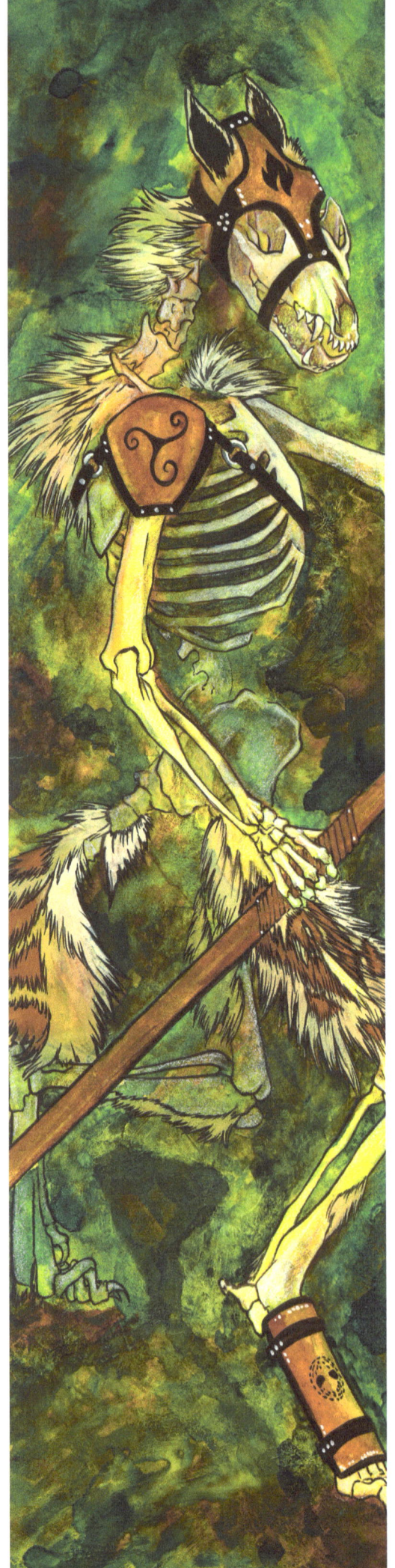

Land of Living Bones

There is a land, full of dark chasms and dry plains. Filled with the silent swarming crystal wastes, and the dark, sharp caves of onyx. It is a land where the bones walk, and where they sing deep echoing songs to hard clattering dances. There the quiet clink of bone is heard, not as a sign of departing dead, but as the approach of a friend or, perhaps, an enemy.

Here is where the bones walk.

Anatomy has always fascinated me, drawing me to the wild and fantastic and towards creating new and novel creatures. This fierce land of the Bone-Kin has been growing more and more evolved with every new painting I begin. There is a strange and somber life in this world. It is both wild, and yet oddly cultured. I don't think I will ever know its full story, but perhaps you will hear some of the new stories as you explore these paintings. If you do, and you repeat them on the dawning of the night when there is no moon in the sky, doors may open.

Or so the bones say...

Skeletal Warrior - watercolor/gouache/prismacolor - 2012

A Murder of Bones
watercolor/conte/gouche - 2012

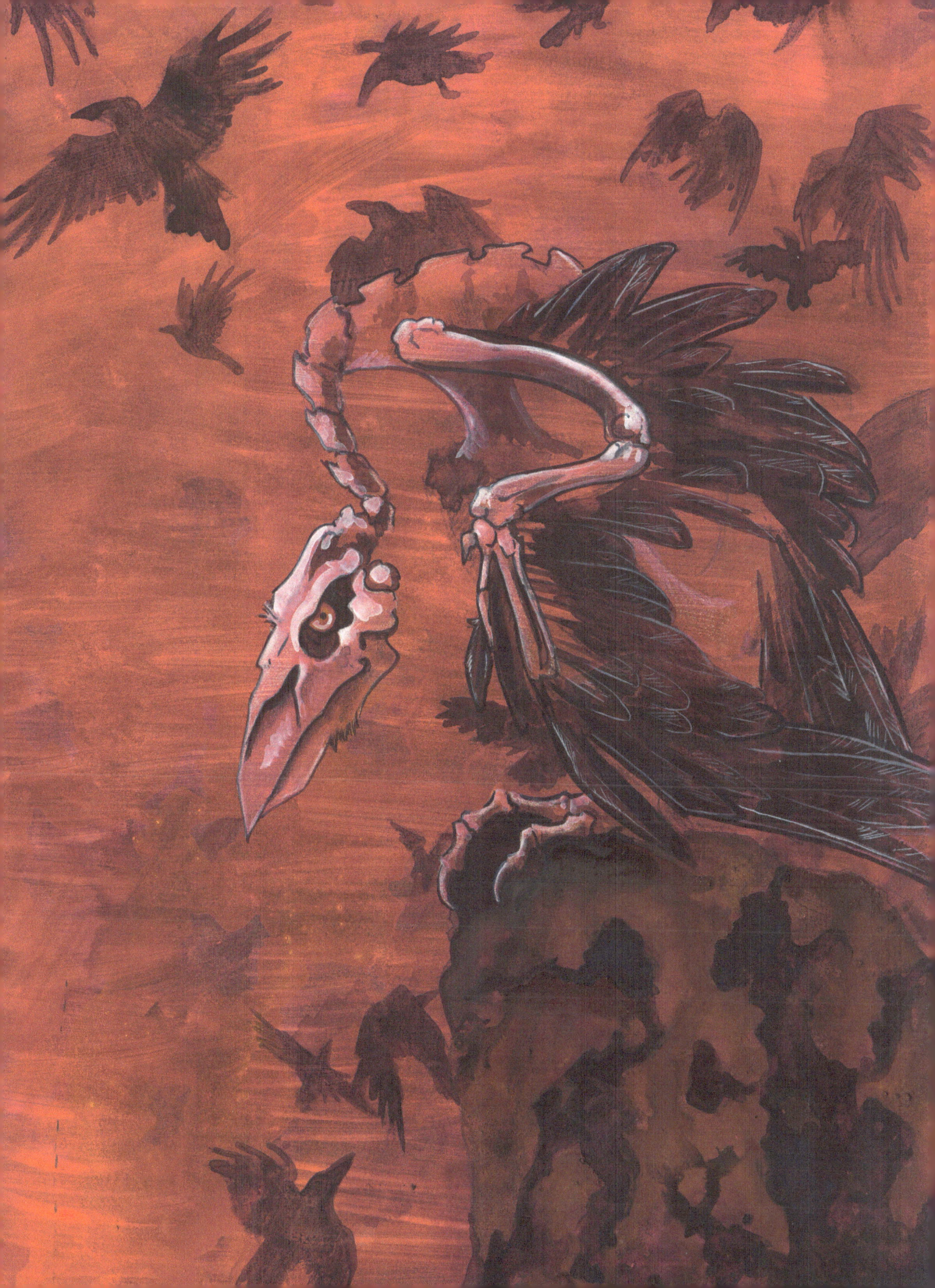

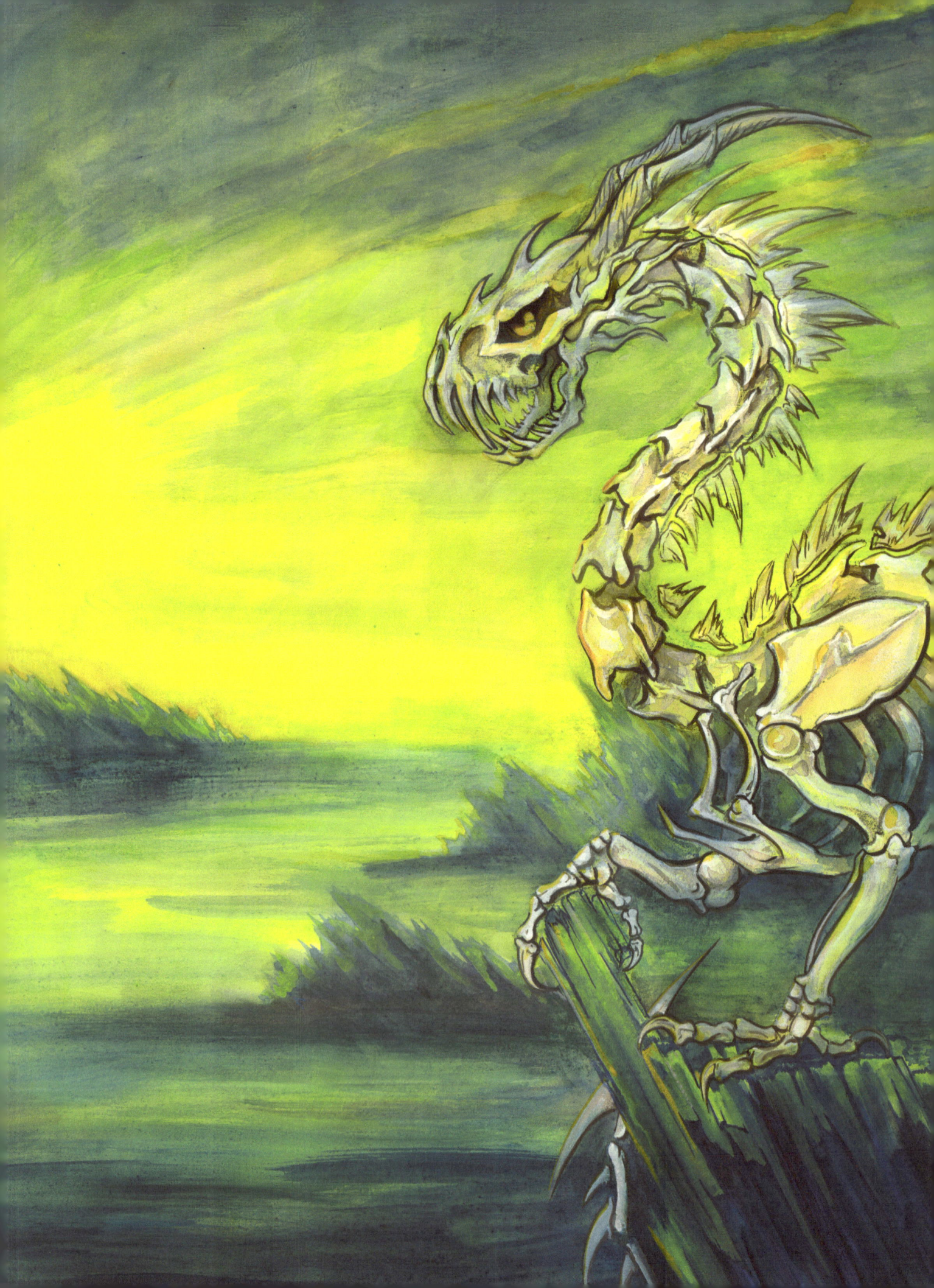

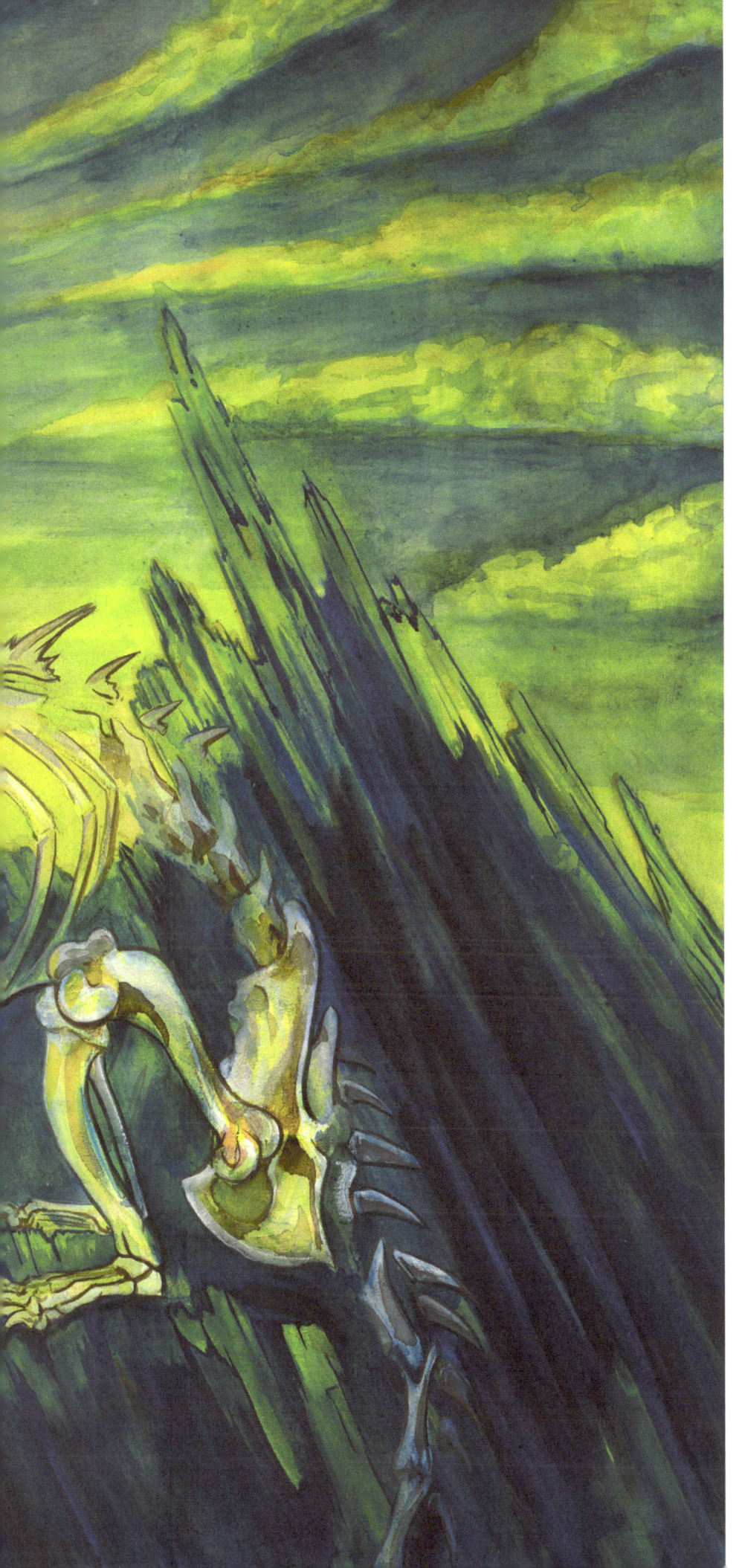

King of the Crystal Wasteland
watercolor/prismacolor/gouache – 2013

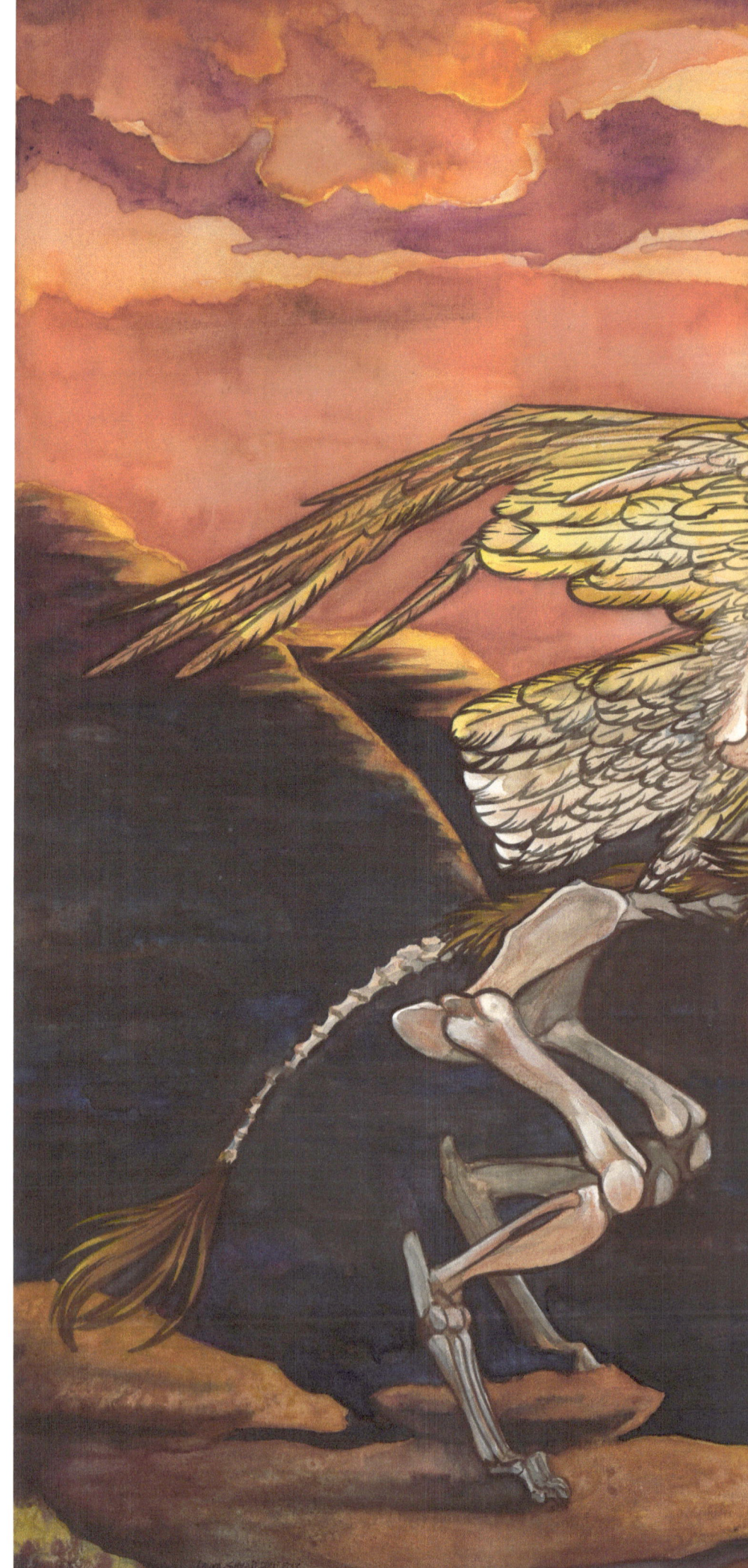

Lord of the Sunset Cliffs
watercolor/prismacolor/gouache
2013

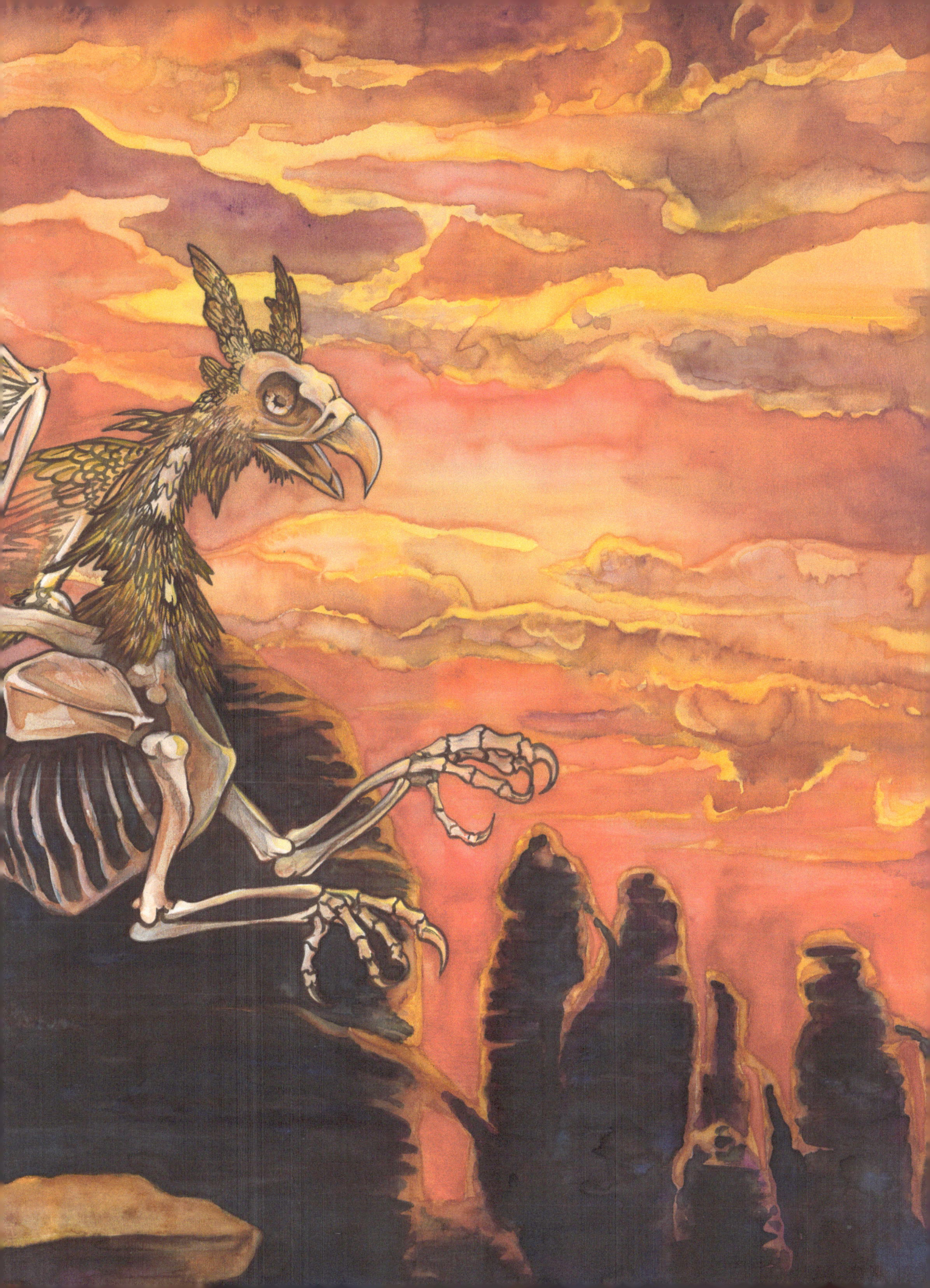

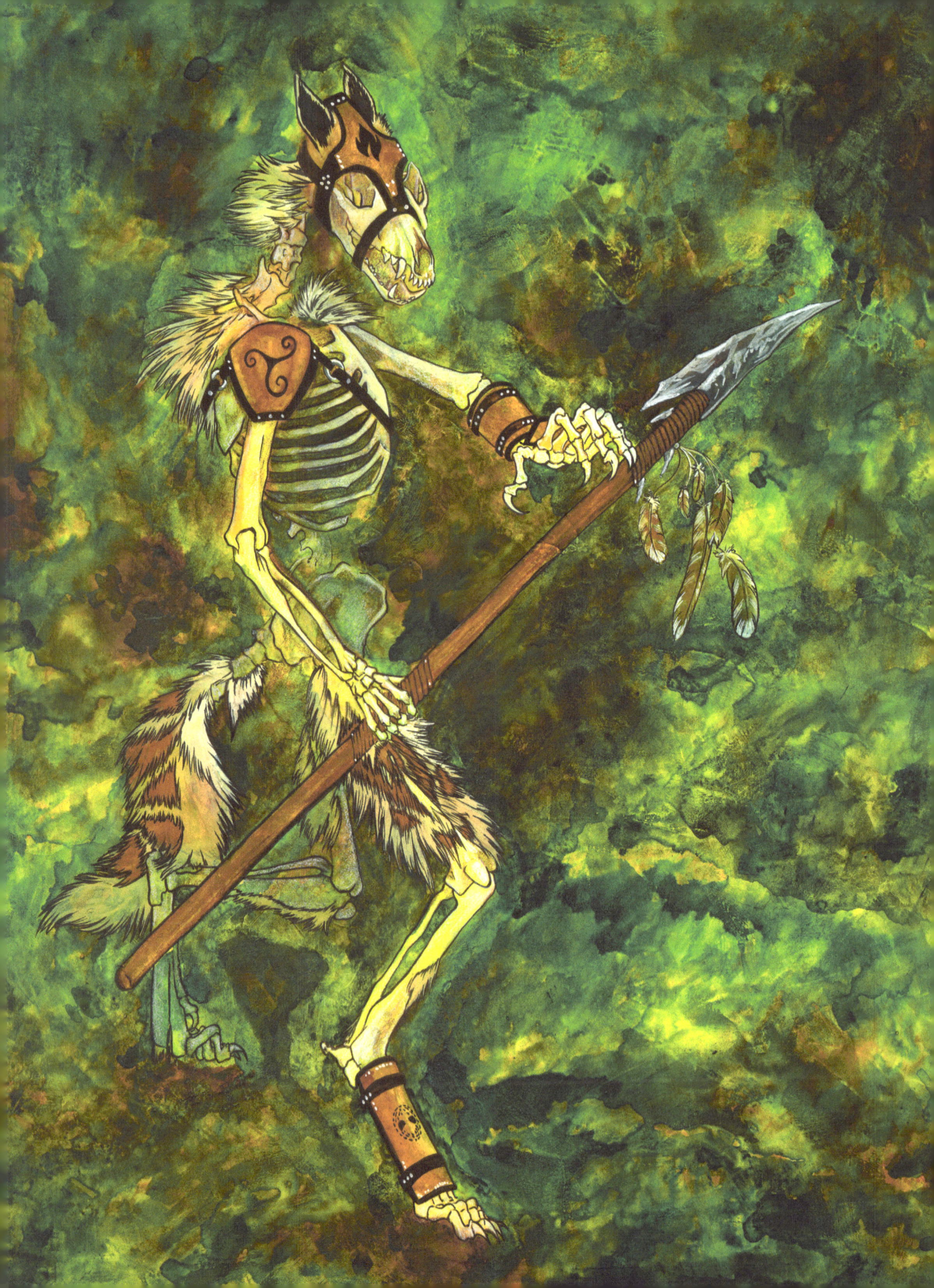

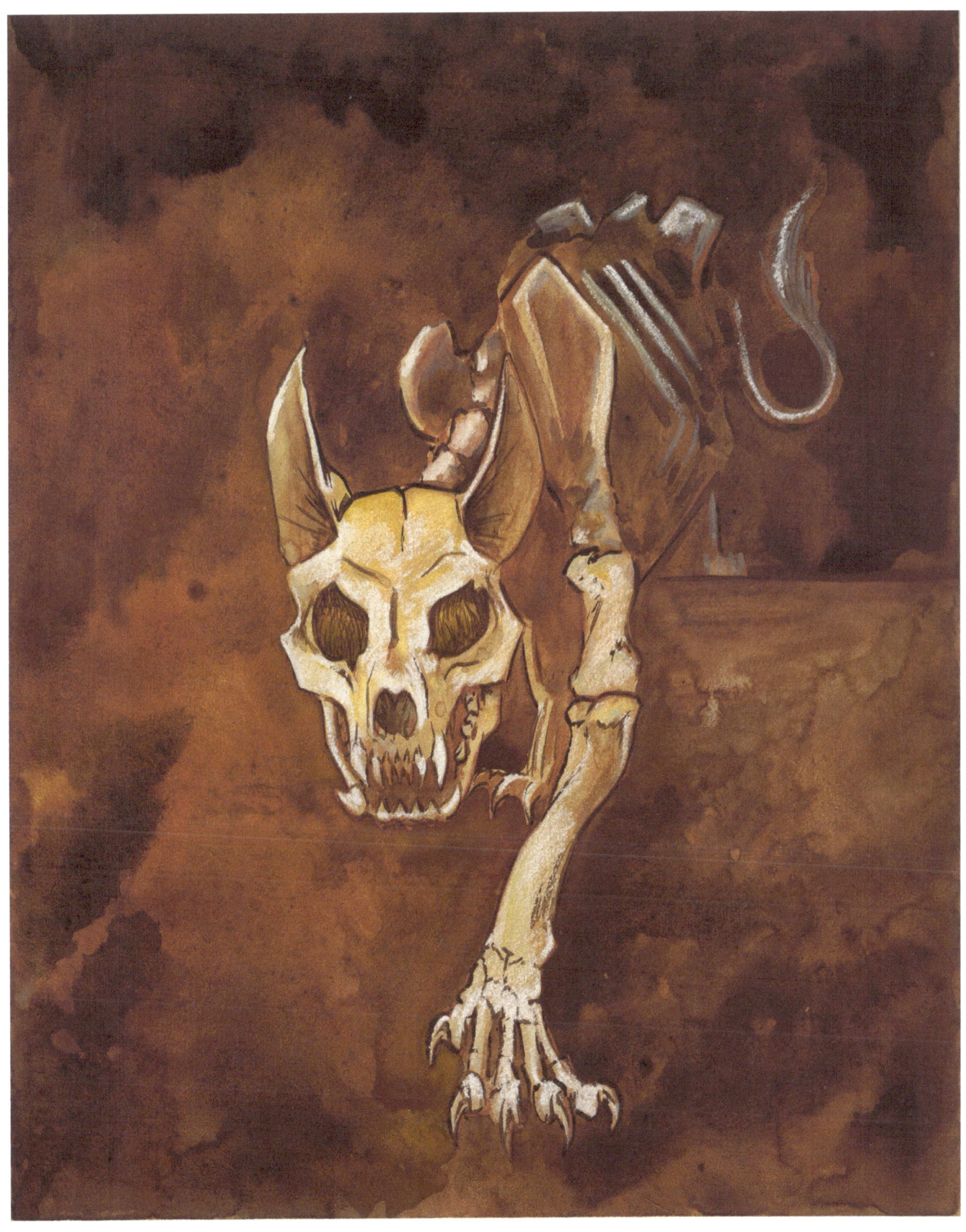

Skeletal Stalker - watercolor/gouache/prismacolor - 2012

Skeletal Warrior - watercolor/gouache/prismacolor - 2012

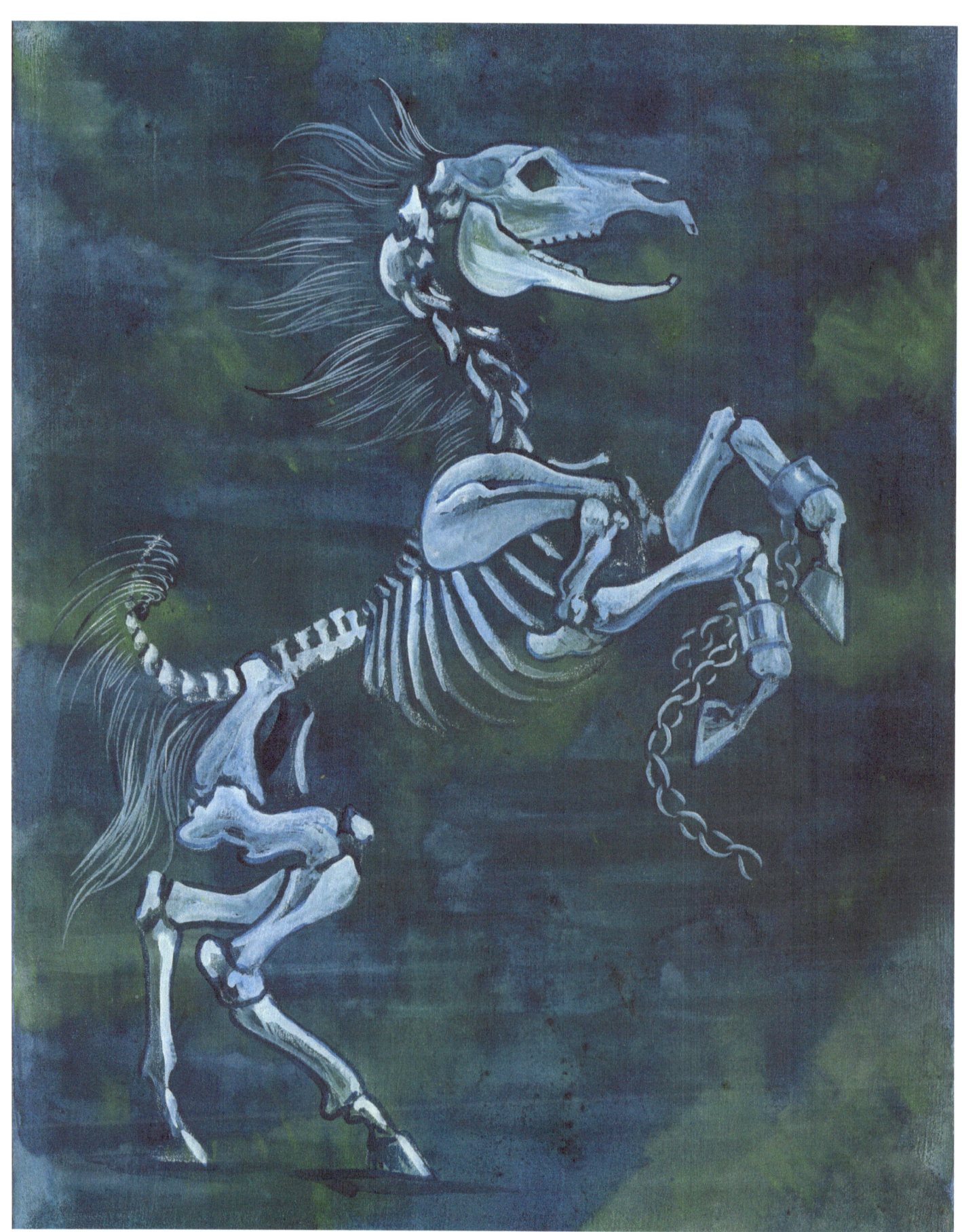

Free From Chains - watercolor/prismacolor/gouche - 2012

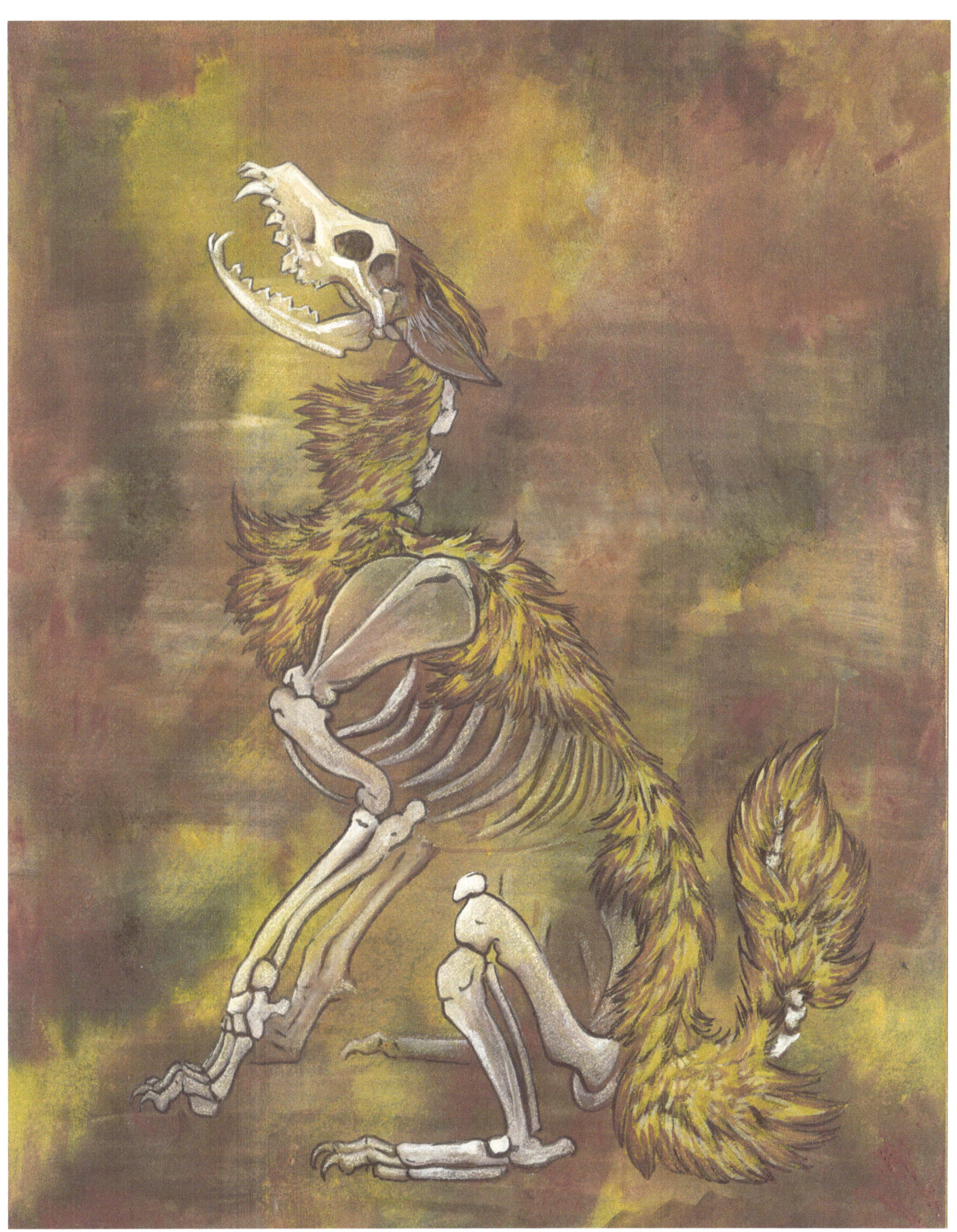

Howling Bones - watercolor/prismacolor/gouche - 2012

Sketches, Studies, and Graphite Work

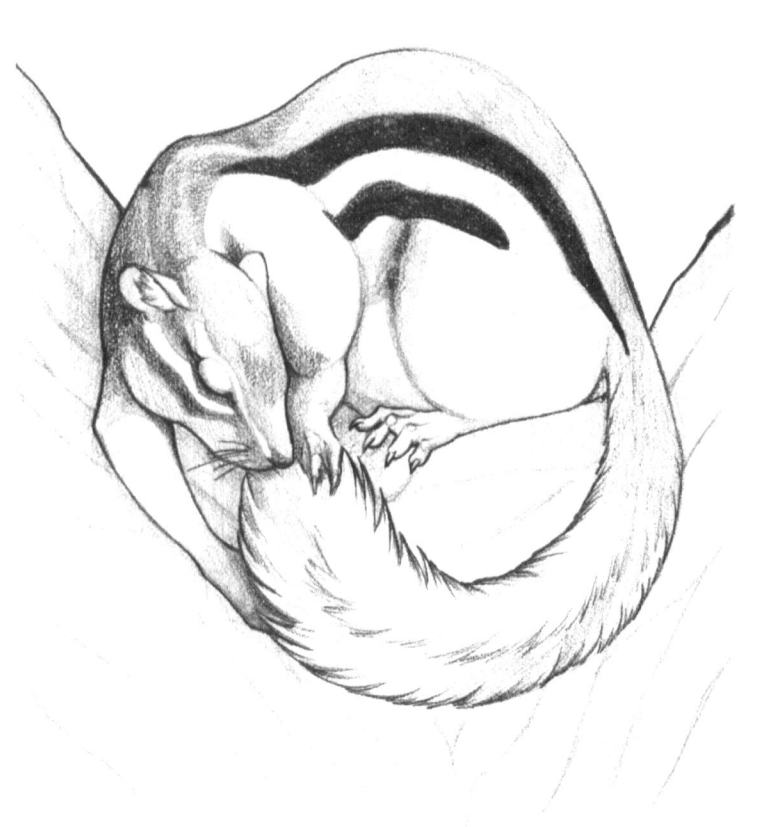

Sweet Dreams - pencil - 2013

While paint will always be my calling, its splattering pigments singing to my soul, there is something incredibly satisfying about the simplicity of pencil and paper. That soft, simple, straightforward motion of graphite. The honesty of it all.

In addition to my painted work, and all of the finished work that I post, I tend to go through a couple sketchbooks a year, and the cosmos only knows how many bar napkins, loose sheets of typing paper, and random scraps I find around the house. From studies to fully rendered drawings, this section is all about drawing.

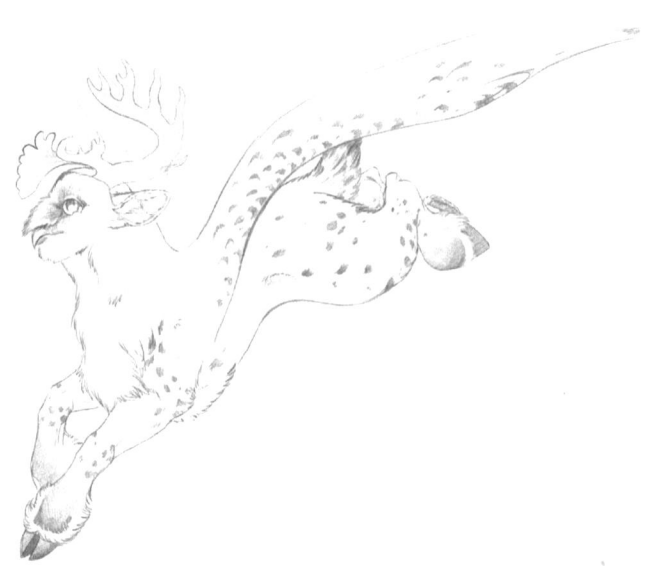

Owlibou - pencil - 2013

SkulKlan Portraits - pencil - 2013

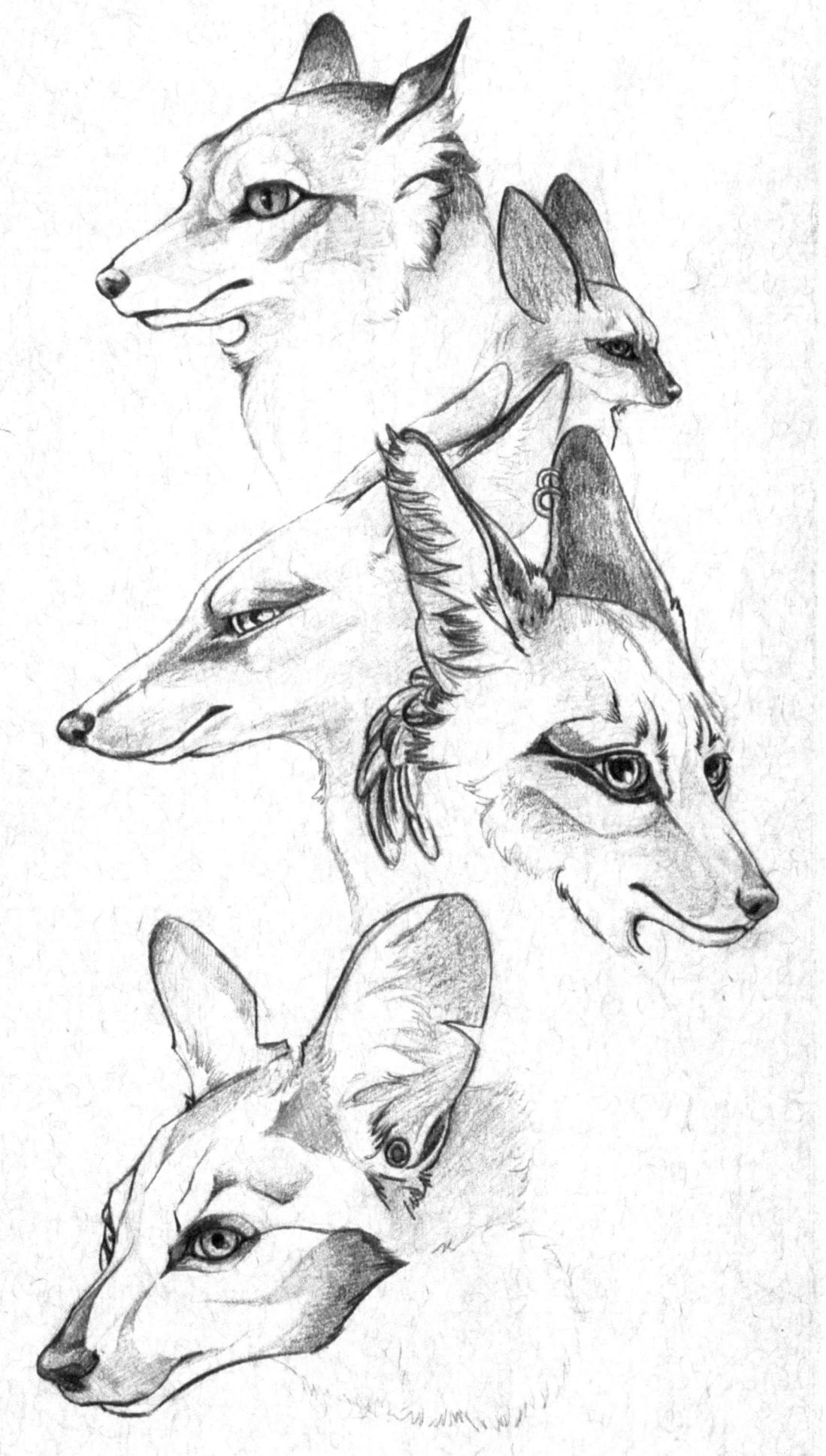

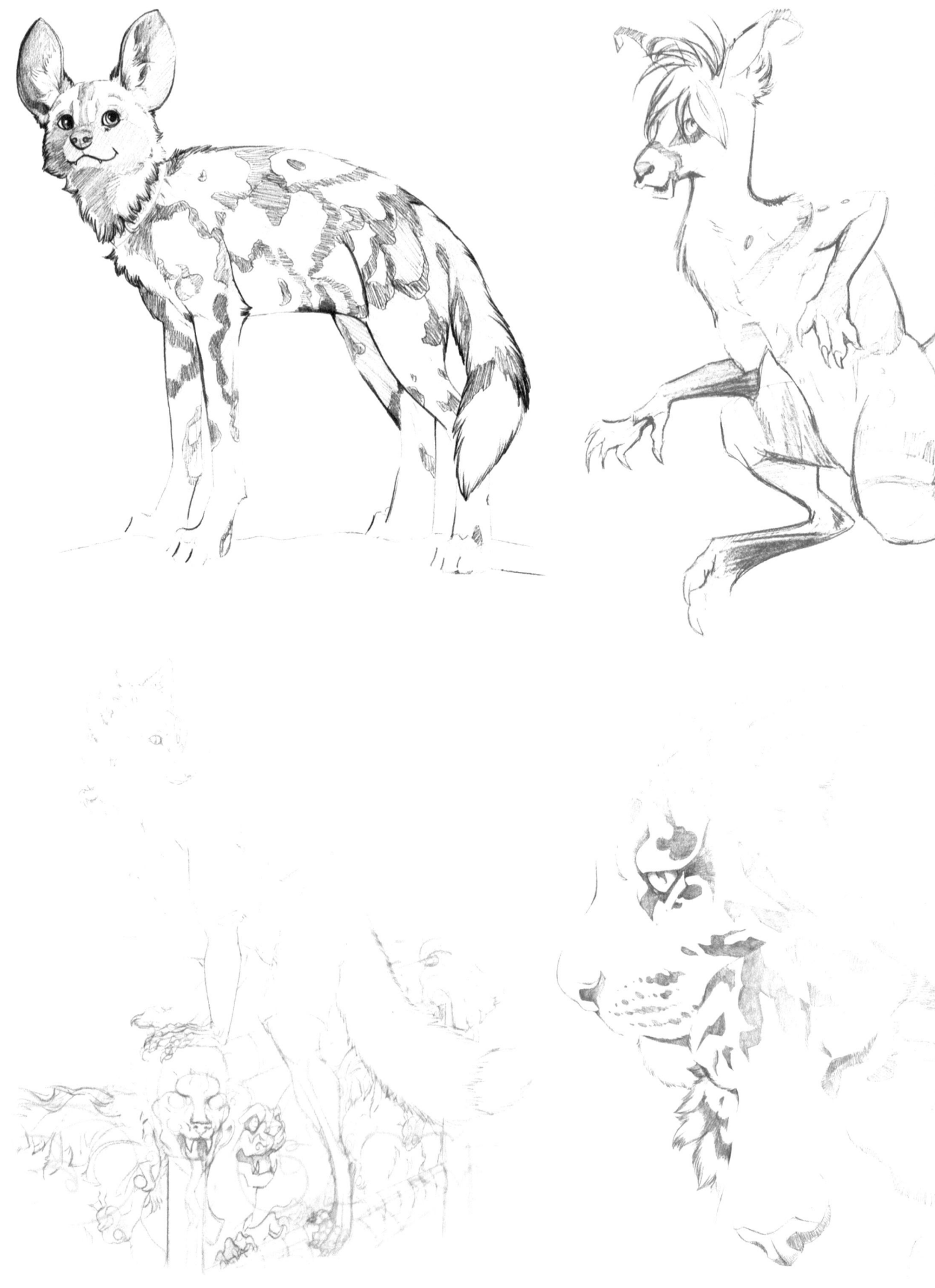

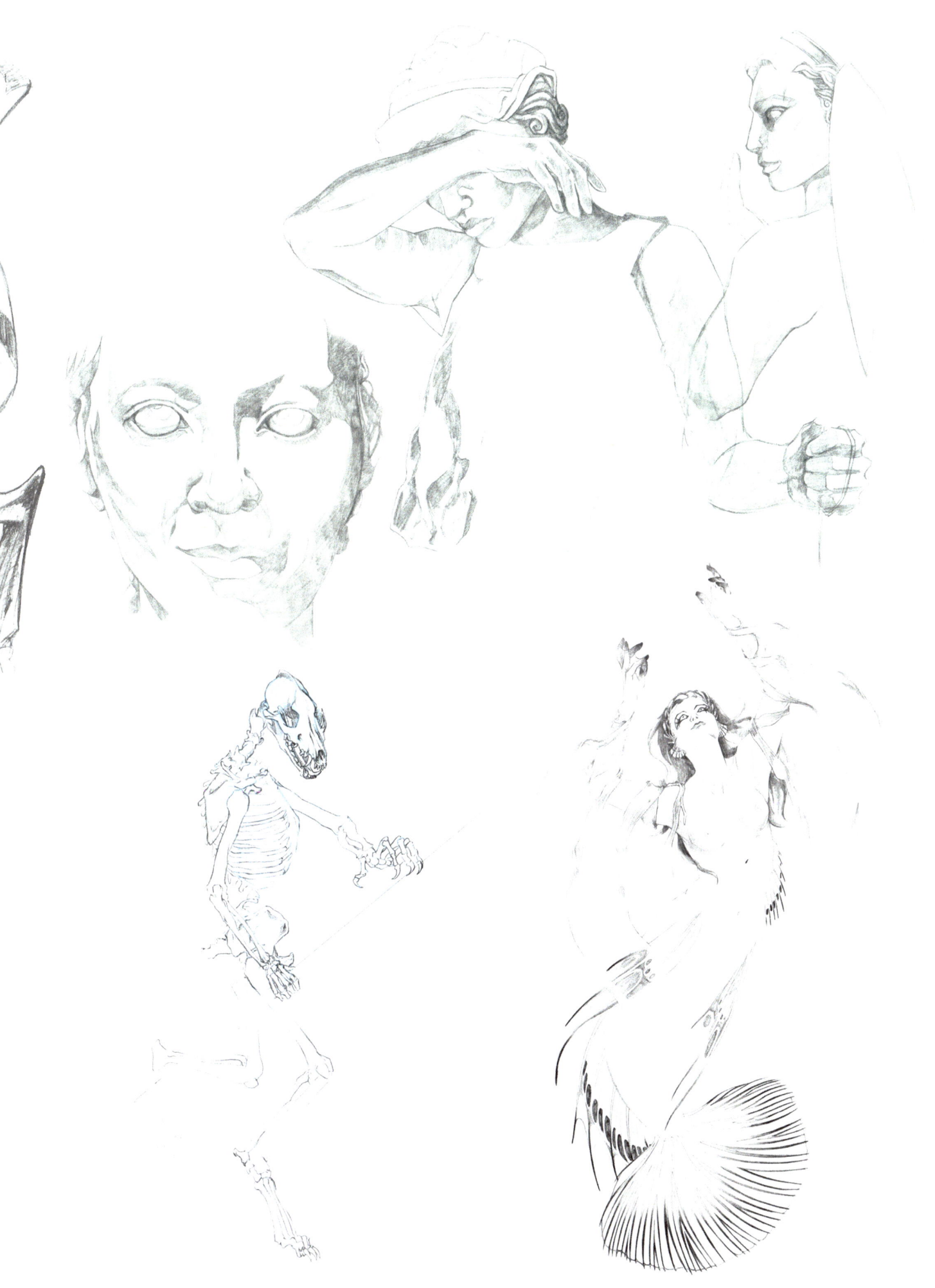

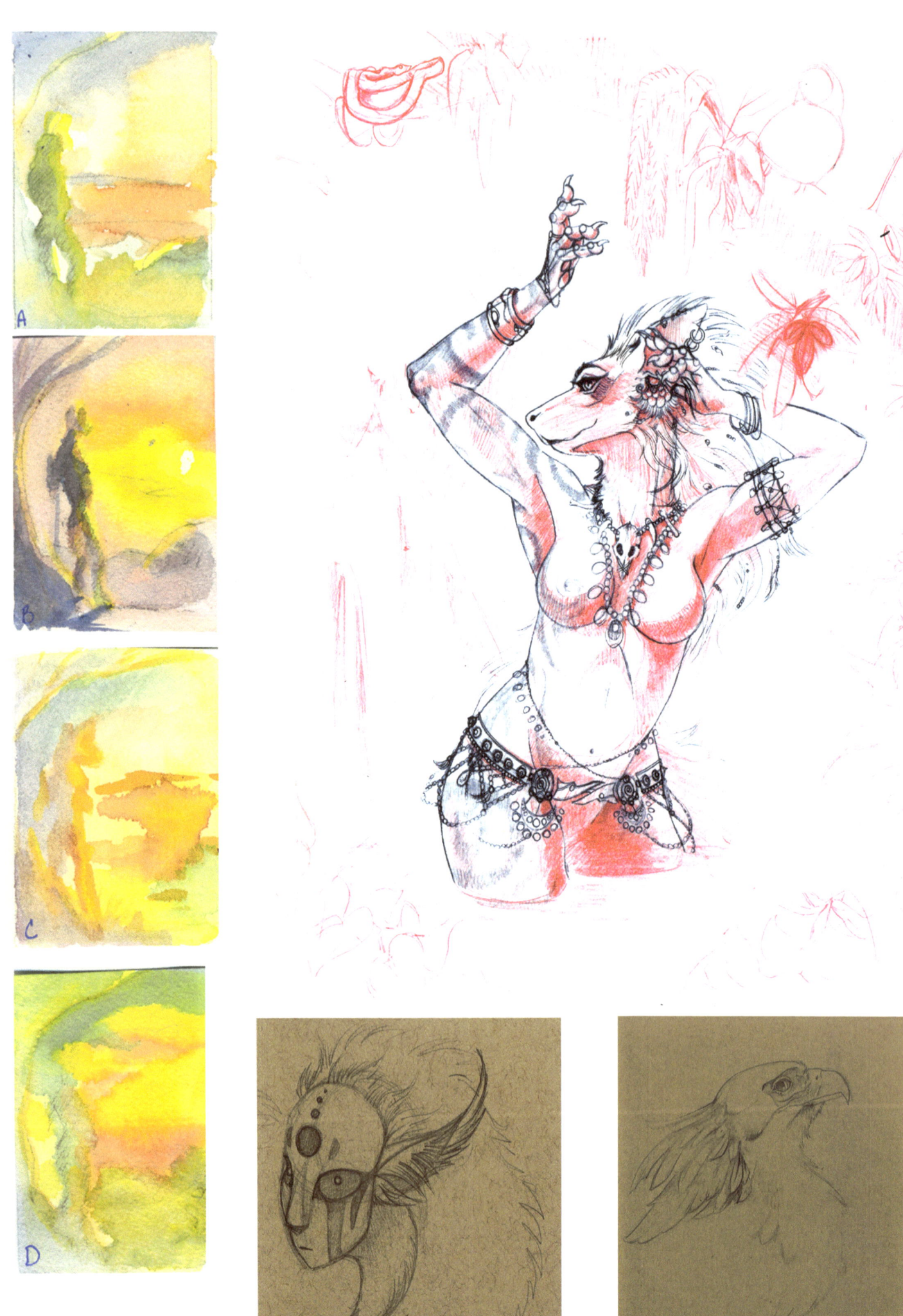

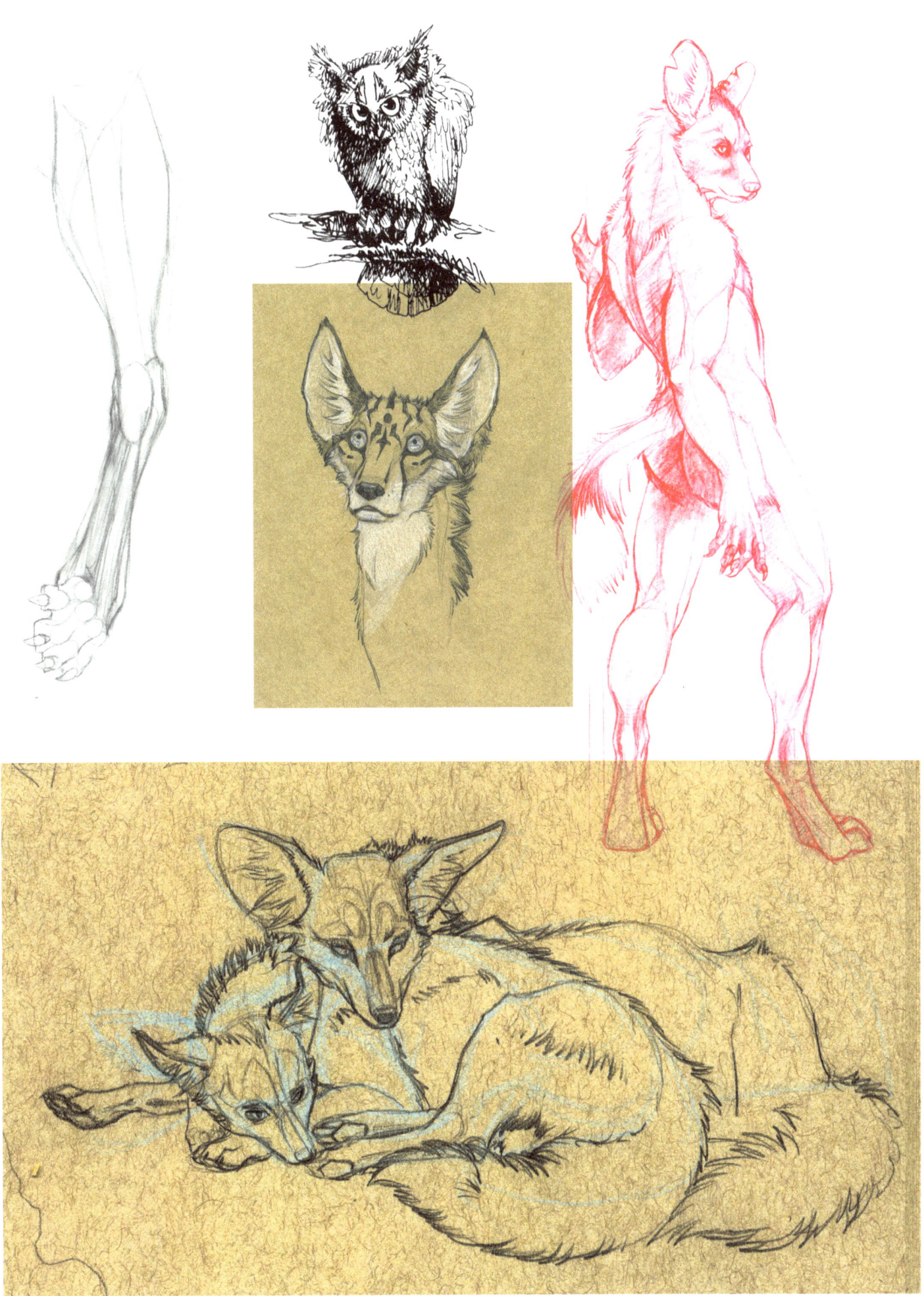

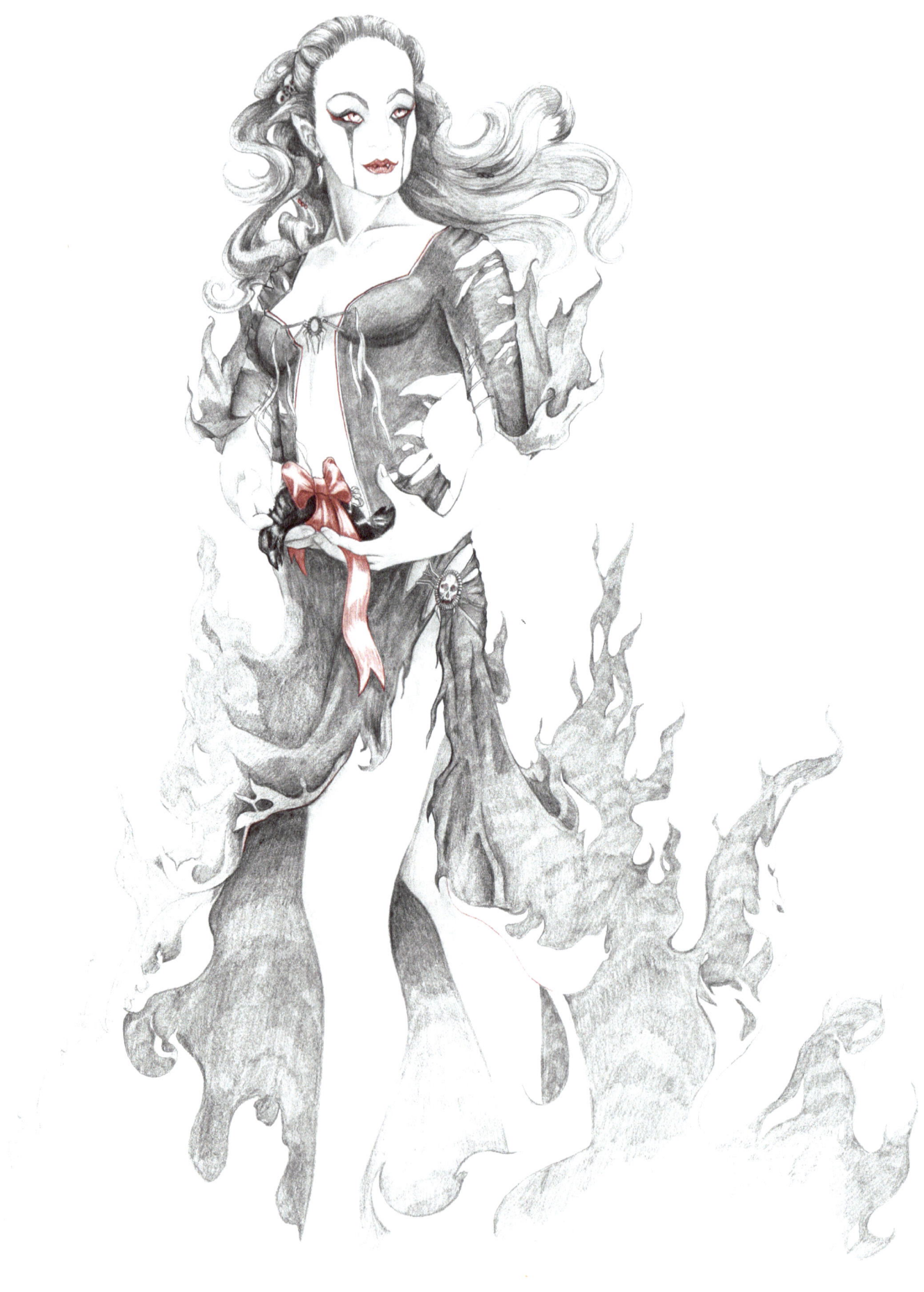

The Gift - pencil/ink - 2013

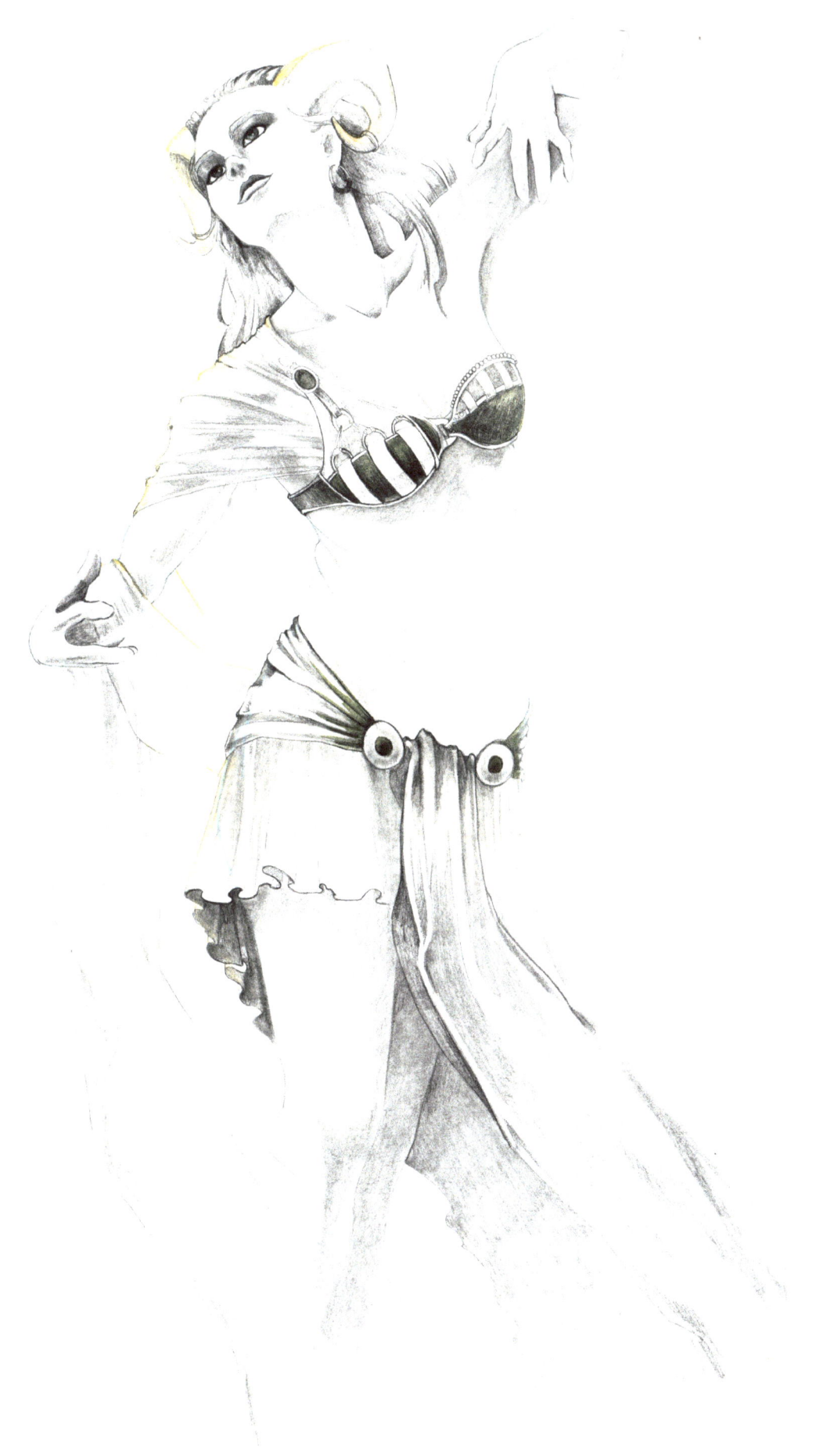

Creation

How others bring art to life has always fascinated me; indeed, the process pages of other art books are often some of my favorite to peruse, when artists include them. In view of that, I though you, the reader, may also enjoy a snapshot of my creation process.

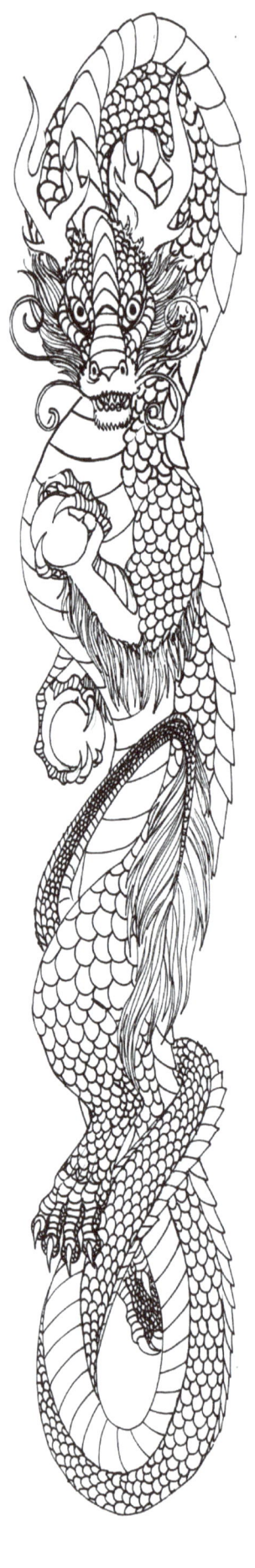

Start with a finished linework or sketch (I don't always ink them, just did for this piece.)

Print out on archival paper, and adhere to a wooden panel. Then use gesso and absorbent ground to prep the surface.

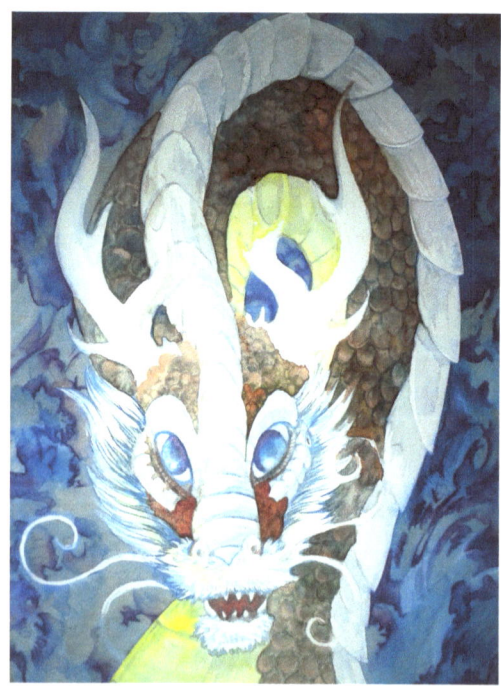

Apply base coat (the general color that each section will be) over the shadow layer.

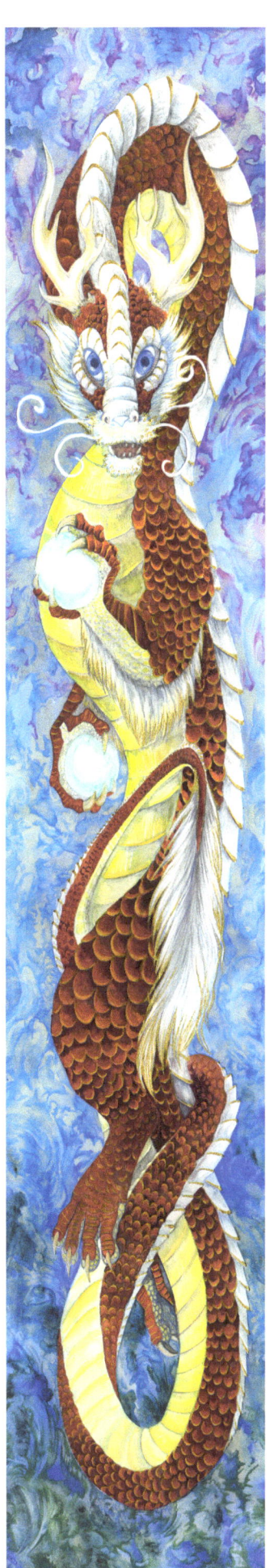

Apply a loose watercolor wash to the background, here I used about 3-5 shades of blues, greens and violets, and detailed with prismacolor.

Go into the shadows, normally with a complimentary color to the final.

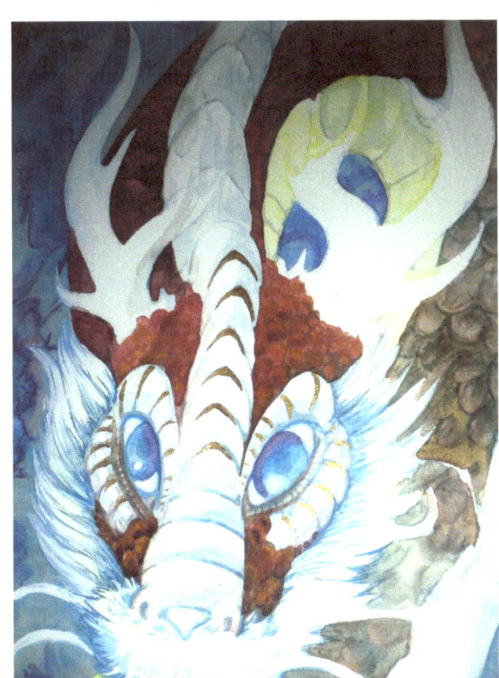
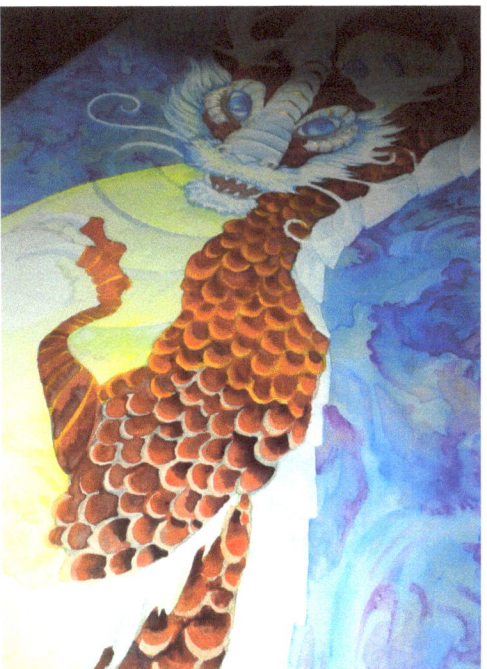

Go over each individual scale/section with the high intensity color of each section.

Apply highlights of whatever color you need for the piece (in this case new gamboge).

Lather, rinse, repeat, until the piece is finished!

Acknowledgments & Citations

My most sincere thanks go out to everyone who helped make this book possible. To the wonderful people at FurPlanet, to my commissioners, to my friends, and my family. Without you I would never be able to push through the hard times and just keep painting. Thank you all.

Listed below are the commissioned works featured in this book and their collection information.

	
A Pirate's Meeting, The Student, The Teacher	Private Collection of James Walter Vaughn-Foster
DreamDance	Private Collection
Evening Watch, Exotic, Family Outing	Private Collection of Edwin Trump & Jenene Kimich Herreid
Origins, Tribal African Wild Dog	Private Collection of Edwin Trump & Jenene Kimich Herreid
FoxHill, Red Shouldered Hawk Wings	Private Collection of Heather Kloning
Golden Re-Tree-Ver	Private Collection
King of the Crystal Wasteland	Private Collection
Lord of the Sunset Cliffs	Private Collection
Mare and Foal	Private Collection of Taylor Nelson
NeverMint Roo (Roo in Sketches)	Private Collection of Mary Neesham
Owl & Guitar	Private Collection
Owlibou, Tribal Corgi	Private Collection
Red Tail over the Mountains	Private Collection of Paul Pennyfeather
Skeletal Warrior	Private Collection of Andrew Miller
SkySinger	Private Collection of Dave Bryant Archives
Soaring Skies	Private Collection
Stray (Wild Dog in Sketches)	Private Collection
The Gift	Private Collection of Andrew Brown
The Wise One	Commissioned by Jeff Gamble for Skylar
The Wise One	Collected in Private Collection
TreeBuck	Private Collection
TreeFox and Hare	Private Collection of Adam Sorice
TreeJackRabbit	Private Collection
TreeLion	Private Collection
TreeLion Face	Private Collection
TreeLion In Fall	Private Collection
TreeSkull	Private Collection
TreeStag	Private Collection
Tribal Bud the Bunny	Private Collection of Beth Jetter
Tribal Nym, Steampunk Nym	Private Collection of David Hopkins
Tribal Xyk	Private Collection of Alex Aznavour
Vantid Portrait	Private Collection
Winter TreeWolf	Private Collection of Victor Coelho

Character rights reserved by client